VERMEER
and His
Contemporaries

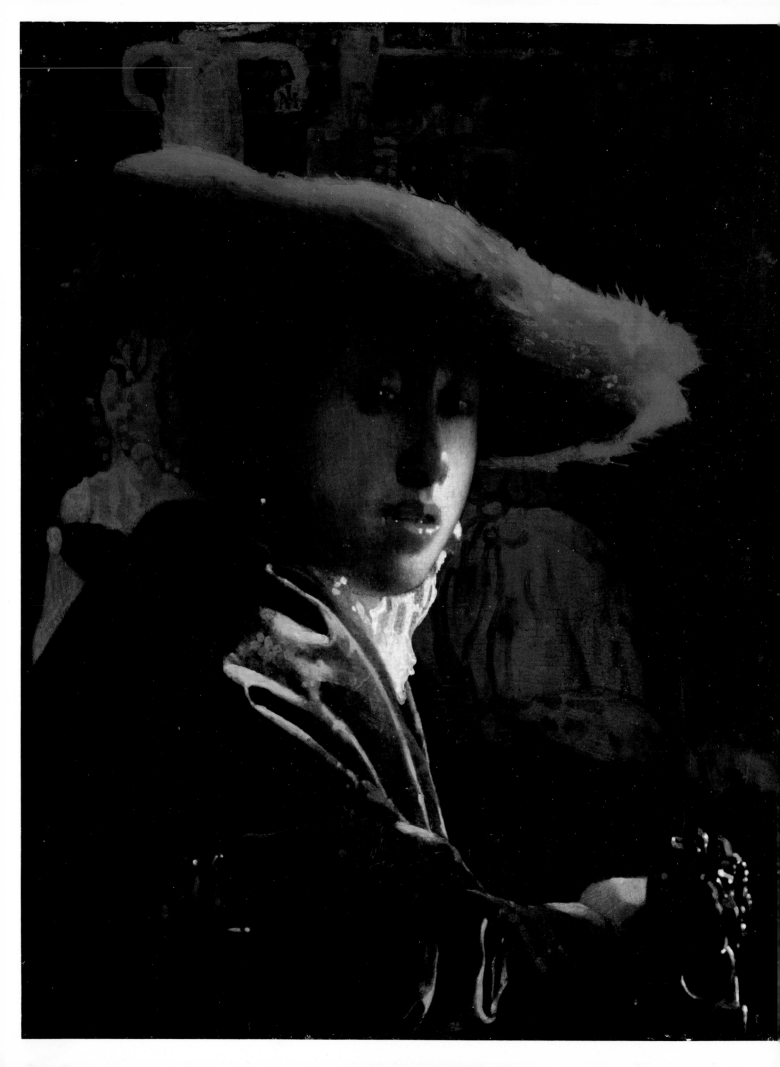

VERMEER
and His
Contemporaries

By Leonard J. Slatkes

Abbeville Press · Publishers · New York

On the front cover:
Sleeping Girl, c. 1656–7
Commentary page 24

Facing the title page:
Girl with a Red Hat, c. 1671–2
Commentary page 96

ISBN: 0-89659-195-6 (cloth)
ISBN: 0-89659-156-5 (paper)

Library of Congress catalog card number: 80-66525

Design: Roy Winkler Editor: Mark Greenberg

CONTENTS

INTRODUCTION

Johannes Vermeer, the "Sphinx of Delft," as E.J. Théophile Thoré called him in 1866, in many ways remains almost as much of an enigma for us today as he was when Thoré wrote those first monographic articles under the name William Bürger. While in recent years the archives have begun to provide small bits of information about the man, his family, his finances and the city in which he spent almost his entire 43 years, still nothing certain is known of his personality, training, teachers, patronage or method of working.

On the other hand, an unusually large number of the 35 paintings reasonably assigned to him appear to be traced back with confidence; an extraordinarily high percentage of his total production has survived. Twenty-one Vermeers, most of which are still known today, seem to have been in one collection, that of Jacob Dissius, a Delft publisher and bookseller. Given this unusually high survival rate, it seems unlikely that this unique artist produced many additional works in the twenty-two years between 1653, when he joined the Delft artists' guild, and 1675, the year of his death. The fame of no other post-Renaissance artist rests on so small an artistic base. Still, the unusual fact of the Dissius collection, and the scattered but enthusiastic comments made about individual paintings before Vermeer achieved the fame he now enjoys, indicate that certain collectors sought out his works with what must have been considerable passion.

Given this extraordinary situation, it is odd that Vermeer attracted no biographer in his own time; essential information, easily obtainable for many of the most minor seventeenth-century Dutch artists, is absent from the growing but still sketchy outline of his life. It is possible that his limited production, (as well as the efforts of a few early collectors) prevented his work from being as broadly known as that of his less talented but more prolific contemporaries. Nevertheless, among Dutch genre artists of the second half of the seventeenth century, Vermeer's impact and influence is clearly felt and it is obvious that other painters knew individual pictures a remarkably short time after he finished them. Since he is rarely documented outside of his native Delft, (and then only on a short visit to the nearby city of The Hague) and since few of his works appear to have left his hometown during his lifetime these artists must have come to Vermeer. No pupils are recorded in his studio and, although specific elements of his style were quickly borrowed, his idiosyncratic method of painting died with him. Given this unusual situation, it is amazing that he ever managed to achieve the fame now so universally awarded him.

The year of Vermeer's birth, 1632, was a significant one for The Netherlands, although it could not have been foreseen at that time. Both Vermeer's and Anthony van Leeuwenhoek's names appear on the same page of the baptismal records of the Nieuwe Kerk of Delft. And in the same year, in Amsterdam, Baruch Spinoza was born. All three achieved universal fame in fields of endeavor they pursued as avocations: Leeuwenhoek was a cloth merchant who became known as the father of microbiology and perfector of the microscope; Spinoza was a lens grinder who became one of the most important seventeenth-century philosophers; and Vermeer

may have run a tavern in addition to his painting. The situation was not a unique one in seventeenth-century Holland where scientists, painters, philosophers and poets often earned their living working at some unrelated commercial activity. But it is significant that the varied interests of Spinoza and Leeuwenhoek can be related to the more unusual aspects of Vermeer's method of painting.

It has been often suggested that at some point in his development Vermeer began to use an optical device known as the *camera obscura*. Known since antiquity, this instrument, essentially the forerunner of the modern camera, was closely linked to the science of optics and to the art of perspective, as well as to a number of different scientific areas.

Since Holland was an important center for the art of grinding lenses, as both Spinoza's and Leeuwenhoek's activities indicate, superior lenses were readily available there, making possible the use of the *camera obscura* in fields outside the natural sciences. Indeed, a number of earlier seventeenth-century Dutch artists are known to have utilized this device for their work, although apparently in ways rather different from that eventually adopted by Vermeer. Although it is not possible directly to link Leeuwenhoek and Vermeer during the Delft artist's lifetime, the fact that the pioneering microbiologist was the executor of the painter's estate after Vermeer's death in 1675 may be taken as evidence of some earlier contact between the two men.

Vermeer's father, Reynier Jansz, was a master silk weaver who in 1631, the year before Johannes' birth, registered with the Delft artists' guild as an art dealer. Thus the future painter was almost certainly born into a household surrounded by art. Although there is no indication that Reynier Vermeer ever picked up a paint brush, his contacts with a number of painter-art dealers in Delft was most likely important when it came time for the young Johannes to receive his training.

It was common during the sixteenth and seventeenth centuries for a son to follow his father's profession, including painting, regardless of his talent. Thus we find, to cite only a few examples, three generations of Bruegels, van Manders and van Loos, all painting with greater or less success. Since the ideal educational program, established by the great sixteenth-century philosopher Erasmus of Rotterdam, was still followed in Holland at the time—7 years of play, 7 years of education, and 7 years of advanced training—and since Vermeer entered the Delft Guild of St. Luke in 1653, at the age of 21, he must have undertaken his first education and probably artistic training around 1639.

There has been much speculation as to where, and with whom, Vermeer received this first training as an artist. Unfortunately, there is no firm documentation on this important point. Several artists seem likely candidates for the role of first teacher. Although other names have been suggested, Leonaert Bramer still seems a leading candidate. In the first place, he was clearly one of the more important Delft artists of the time. In addition, it seems likely that he had long connections with Reynier Vermeer, and may even have been the "Brammer" present at Johannes' baptism in 1632. He seems also to have been involved in art-dealing activities within the circle of Vermeer's father and is later, after Reynier's death, linked with Johannes by numerous documents, especially at the time of the young artist's marriage, indicating that he took more than a casual interest in the welfare of the young man. Bramer, who had spent many years in Italy working with, among others, the famous Italian perspective specialist Agostino Tassi, was in a position to instill in the younger Vermeer the interest in perspective and optics which would eventually determine the course of his future development. Despite these connections, however, Vermeer's only three surviving youthful works,

from 1656 and earlier, demonstrate no apparent relationship with any known works of Bramer, raising questions which are by no means unique. (For example, a similar developmental phenomenon can be demonstrated with Vermeer's great but older contemporary, Rembrandt.)

Recent archival information has also revived another possible artistic link for Vermeer, Hendrick van der Burch, who was suggested as Vermeer's teacher by several earlier historians. We now know that he was born in 1627, only about six years earlier than the Delft artist, and thus could hardly have been his first teacher. In addition, since van der Burch's work remains obscure, and since the most critical paintings are attributions rather than firmly documented and dated works, this thesis has not been seriously considered by the most recent Vermeer scholarship.

Nevertheless, the discovery of a document indicating that Reynier Vermeer was renting his Delft house from a certain Hendick van der Burch in 1635-7 now makes the possibility of some later contact much more likely. But the situation is still extremely complex and somewhat uncertain, as the relevant document does not mention the critical patrinomic middle name. Furthermore, it lists van der Burch as an Amsterdam merchant. Yet this does not preclude his being an artist: one recalls that various documents also call Rembrandt a merchant, and that Vermeer himself is mentioned only as an expert on Italian art in 1672. In addition, a painter named Hendrick van der Burch joined the Delft guild in 1638. What remains to be discovered is the relationship between this artist and the one born in 1627. Indeed, his financial status as owner of the large house that he rented out, "The Mechelen," may indicate that he was a faiencer rather than a painter. The broad fame of Delft ceramicware made this group of craftsmen the financial elite of the Guild of St. Luke. The timing of the contact between van der Burch and the Vermeer family is also fortuitous, for the young artist must have undertaken his first training shortly after 1638. It may also be taken as significant that in 1649 the younger van der Burch was admitted to the Delft guild as a "foreigner." This latter painter's close contacts with Pieter de Hooch, as early as 1652, when that artist also moved to Delft, and the evidence of an ongoing contact between Vermeer and de Hooch (another important contributor to the blossoming of the Delft style) makes Hendrick van der Burch, if not a candidate for Vermeer's teacher, at least an artist who was in a position to have contributed to his early development.

Artistic education was a complex affair in seventeenth-century Holland and many young artists were wisely exposed to a number of different teachers and approaches before they settled down to their field of specialization, be it history, genre, landscape, still-life or portrait painting. Furthermore, many artists in the end produced works quite different in both style and subject, from those of their teachers. Rembrandt, Pieter de Hooch and Carel Fabritius, the latter two active in Delft, are all prime examples of this, and there is no obvious reason to exclude the possibility of Vermeer having developed in a similar manner. Whoever provided the artist with his early training, it is clear that Vermeer followed a completely independent path after a few years of youthful experimentation.

A third name frequently linked with Vermeer's is that of Carel Fabritius. A history of the city of Delft, published in 1667, records the former Rembrandt pupil's connection with Vermeer, although the writing is both too vague and too poetic to be considered as firm documentation:

"Thus did this Phoenix, to our loss, expire,
in the midst and at the height of his powers.
But happily there arose out of his fire
Vermeer who trod his path like a master."

The poem refers to Fabritius' death in the terrible explosion of the Delft municipal arsenal on October 12, 1654. The tragedy, the second in Delft's history, destroyed a large section of the city, killing numerous people, including several artists who lived nearby. Fabritius' studio was among those destroyed, apparently with many paintings, making the work of this young and innovative master even rarer than that of Vermeer.

If this poetic reference were not also supported by stylistic evidence of a link with Vermeer, one would dismiss it as merely rhetorical praise for two leading Delft artists. In 1667, when the book was published, not only was Vermeer at the heights of his creative powers, but many of the other contributors to Delft's artistic blossoming during the 1650's had left for the economically booming city of Amsterdam. Thus, of the most significant early contributors to Delft's artistic renaissance only Vermeer continued to live and paint in his native city. Nevertheless, it does seem most likely that Vermeer had more than informal contact with Fabritius, the artist most responsible for the shortlived but influential Delft style of painting. It may also be considered significant that both the younger Hendrick van der Burch and Fabritius moved to Delft from Amsterdam at about the same time, 1649. Indeed, Fabritius is recorded living in Delft by 1650, although he did not become a member of the artists' guild there until 1652. This important fact has often been noted since guild rules would have officially prevented him previously from either selling his works in that town or—significantly for his relationship with Vermeer—taking on students. However, since he certainly was painting in Delft before 1652, and since another recent resident of the town, Pieter de Hooch, also executed numerous works before he joined the guild in 1655, it may be taken for granted that these protective regulations were not strictly enforced. It therefore seems possible that Vermeer spent

some short period of time working in Fabritius' studio, as, for example, the young Rembrandt spent about six months "finishing" with Pieter Lastman after his longer, official training in the workshop of a more obscure Leyden artist. Like Vermeer, Rembrandt displays only the influence of his last teacher in his youthful works, and were it not documented, we would find it difficult to name Swanenburg as the man who first taught the great master his craft, let alone his art. After stating all of this, it still must be noted that nothing in Vermeer's artistic pedigree in any way explains his unique method of working after about 1658, except perhaps indirectly, through encouraging his special interests.

Both Fabritius and Bramer were known to have been actively interested in illusionistic perspective and, almost certainly, in the related field of optics. Bramer's early training with Agostino Tassi had brought him into contact with the specialized field of providing the perspectival frameworks for the large decorative fresco cycles which were favored in Italy. Indeed Bramer, who is one of the very few Dutch artists to have worked in this medium, actually executed several architectural frescoes in Delft. Unfortunately these have all disappeared, although a later drawing after one has come down to us. His activity within the Tassi circle (which included many Northerners, including Claude Lorrain) also could have brought him into contact with the enigmatic master, probably of Franco-Flemish origin, known only as Cecco del Caravaggio. An exponent of the Northern caravaggesque style in his independent work, as his Italian nickname indicates, Cecco (apparently short for Francesco) was the first Northern artist to utilize the illusionistic device of a curtain or drapery painted as if it covered part of the canvas. This work, an *Eros Drinking at a Spring*, may be seen as a natural outgrowth of an interest in both the realistic style fostered by Caravaggio, and in the kind of perspectival

illusionism that Tassi made his special field. Thus Bramer was in a position to have introduced these concepts and devices into Delft and specifically to Vermeer, who used them in his *Girl Reading a Letter* (c. 1659) in Dresden. This is not to belittle the role played by Rembrandt, and by his Leyden pupil Gerrit Dou, in propagating this unusual motif about 1646, but only to note that Vermeer, through his contacts with Bramer and Fabritius, was prepared to make use of it. Indeed, it became an interesting adjunct to Dutch architectural painting, a field in which both Bramer and Fabritius made significant contributions.

Like Bramer, Fabritius was also interested in artistic specialities which today seem quite exotic. Fabritius, and Samuel van Hoogstraten, his fellow Rembrandt student, built what are known as *perspective boxes*. These consisted of six small paintings, each of which used special perpective formulas similar to those used by Tassi. The six panels were then assembled into a box, with the paintings on the inside. When viewed through a small hole (or occasionally, as in Hoogstraten's London work, through two holes, one on each side) which provided the fixed point from which the perspective produced the desired effect, the painted interior appeared life sized and three dimensional. Both Fabritius and Hoogstraten are documented as having constructed a number of these odd devices. Only what is believed to be part of one of these by Fabritius, the tiny *View of Delft*, in London, survives from his hand; however, an example by Hoogstraten, also in London, has luckily remained intact. These constructions must have caught the imagination of numerous younger artists—although they, instead of building similar perspective boxes, applied similar ideas and related architectonic structure to their paintings of genre interiors. Thus both Fabritius in Delft and Hoogstraten in Dordrecht seem to have inspired a number of younger masters to create an important new style of genre representation. Not only Vermeer and de Hooch in Delft, but Nicolaes Maes and Cornelius Bisschop in Dordrecht produced significant contributions to this new style. Since Hoogstraten is known to have left Holland in 1651, only returning to Dordrecht in 1654, the year of Fabritius' death, the critical innovations must have taken place before the year 1651.

The interest in perspective, illusionism and optics fostered in Delft by Bramer and Fabritius may have brought about Vermeer's decision to experiment with the *camera obscura*, primarily as an aid to proper perspective. Indeed, since the time of Brunelleschi and Alberti, Italian artists had used the proto-camera to that end. Thus it might have been an interest in perspective that first enticed the great Delft master to observe the images projected by the *camera obscura*. Perhaps van Leeuwenhoek's return to Delft in 1653 or 1654 provided Vermeer with the additional scientific motivation and know-how, as well as with the lenses necessary to construct the device. And while it must be noted that there is no documentary evidence that Vermeer used such an instrument, the visual evidence of his mature and late works is extremely convincing. The significant shift in both style and execution, as well as a reorientation of subject matter that is signaled by the *Soldier and the Laughing Girl* (c. 1658) in the Frick Collection, are hardly explainable unless we posit a radical change in working procedures. Some elements of this shift are already present in the slightly earlier *Sleeping Girl* (c. 1656/7) in The Metropolitan Museum of Art, but the numerous changes throughout the canvas make it difficult to assess Vermeer's possible use of the *camera obscura* at this early date. The changes do, however, support the idea that Vermeer was involved in an ongoing search for new artistic means.

Essentially, the image provided by a *camera obscura* is the same as a photographic one.

Naturally, without the means of capturing the image on a light-sensitive film emulsion, human beings as viewed through the device were no more stable than their poses. Thus the unusually immobilized quality of the poses often struck by Vermeer's models might have been partially dictated by the requisites of this device. This hypothesis has the additional advantage of explaining one of the more puzzling aspects of Vermeer's development after about 1658.

Also inherent to the image of the *camera obscura*, like that of the modern photograph, is a certain amount of distortion in the size relationships between near and far objects. One late seventeenth-century writer actually complained that the image provided by the device was "striking but false." Interestingly enough, this comment parallels the observation of the French writer Maxime du Camp when he first viewed Vermeer's *View of Delft* in 1857. Surprisingly, especially for modern sensibilities, du Camp found the visual impact of the canvas "brutal" and even "exaggerated." This strong statement, quite different from the way we view the picture today, becomes understandable only when one takes into consideration that du Camp was writing at a time when the photographic image was still rare and exotic. Today, familiarity with photographic distortions has to some extent desensitized our perceptions of them (granted, of course, that these distortions have been minimized by modern improvements in the quality of lenses). The fact is that we have come to view photographic images as "real" and thus accept these distortions as part of "reality." Du Camp, however, writing in an age nearer to the commentator who complained about the *camera obscura* image, provides us with an insight as to how the Delft artist's contemporaries might have felt about his work.

Perhaps the clearest example of the impact the *camera obscura* had on Vermeer's style is to be found in the *Soldier and the Laughing Girl*. The size relationship between the two figures reveals the same type of spatial distortion commonly found in early photographic images in which one figure is very close to the apparatus. Other elements of the painting also seem independently to support the assumption that Vermeer utilized some sort of optical device. Both the unusual merging of highlights, most discernible around the girl's hands and the glass, and the halo effect around her head, preserve optical phenomena not visible to the naked eye but clearly observable in *camera obscura* images. Vermeer's unique application of paint in small dots, or *pointilles*, also seems to be an attempt to capture the specific visual qualities of the projected image of the *camera obscura*. Indeed, he seems to be the only painter who attempted to do so.

This attitude may explain something of the unusual position Vermeer occupied during his own lifetime. Other artists seem to have carefully examined his few available works, but then extracted for their own use those innovations which were based on tradition. Jacob Dissius, with his many acquisitions, seems to have been exceptional in his sense of the significance of what Vermeer was attempting. Perhaps his early advocacy helps to account for the high survival of Vermeer's few pictures.

As the modern discovery of Vermeer coincided with the development of photography, it may be that the gradual acceptance of the photograph as an art form facilitated the acceptance of Vermeer's works, previously considered as "exaggerated" or even "brutal." Although it is quite normal for contemporary art forms to create a taste for similar styles in earlier works of art, the case of Vermeer may be the first example of photography influencing our vision of painting, thus signalling a new phase in the history and criticism of art.

VERMEER
and His
Contemporaries

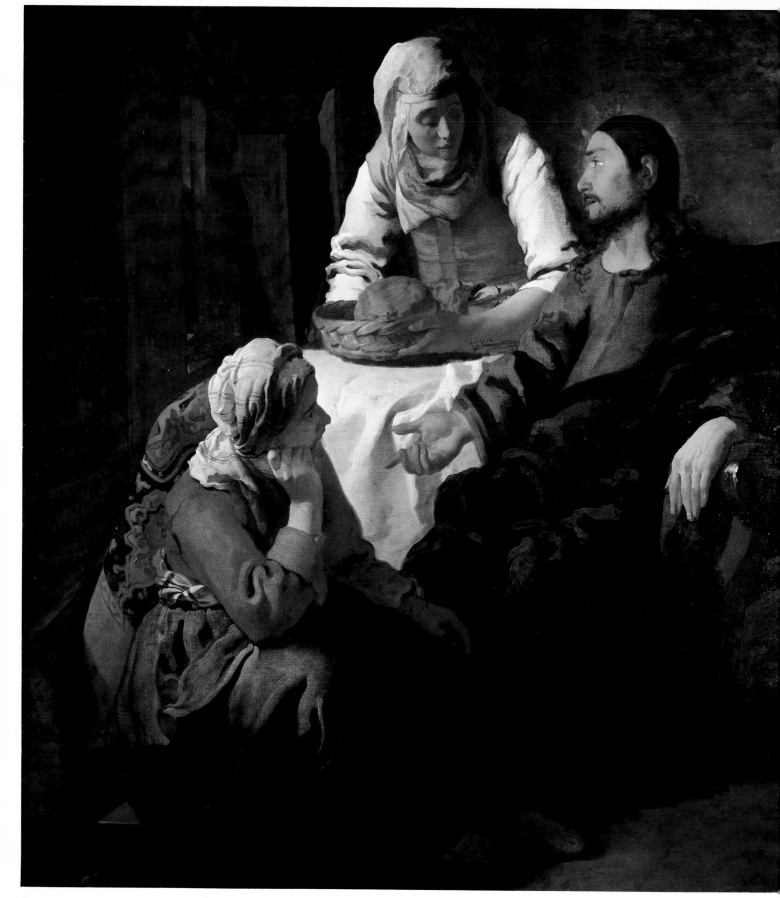

Canvas, 63 x 55¾ inches (160 x 142 cm.) Edinburgh, The National Gallery of Scotland

VERMEER

Christ in the House
of Mary and Martha

c. 1654-5

Despite an authentic signature, critics have not always been willing to accept this striking canvas as Johannes Vermeer's earliest known work. The subject matter (it is the master's only surviving biblical painting, although a number of other pictures contain religious and moral messages), style, and various Italianate influences raise numerous still unanswerable questions about the development of this enigmatic Delft artist. One would expect an artist's early or youthful works to reveal some trace of his teacher's style. Although Vermeer's early production does show various influences, there is no certain indication of where he learned the art of painting. Unfortunately, contemporary sources are also mute on this critical point, although he can be linked through various documents with several Delft artists. Neither of the two most frequently cited painters, Carel Fabritius and Leonaert Bramer, can be directly connected with either the style or the execution of this canvas, and thus one must presume that Vermeer learned his craft (rather than his art) from some minor and as yet unidentified Delft master. The situation, as we have noted, is not a unique one in Holland. The work of the young Rembrandt reveals no trace of his first teacher, Jacob van Swanenburgh; and we are uncertain where Frans Hals acquired his virtuoso painting technique.

Vermeer's lifelong connection with the widely travelled Leonaert Bramer could explain some of the Italian influences present in this work. Bramer spent many years in Italy and may have introduced the young Vermeer, who, like Rembrandt, seems never to have travelled outside of Holland, to Italian art. Indeed, some of Bramer's numerous drawings after other artist's works are preserved in a large sketchbook in Amsterdam. In addition, beginning in 1631, Vermeer's father was an art dealer, as well as a member of the Delft artists' guild, and thus the young Johannes must have been exposed to a variety of painting styles. The numerous influences, Italian as well as Northern, often cited in relation to this picture are typical of a young painter and may be a product of his father's eclectic art trade rather than of training in some minor Delft painter's workshop.

Interestingly enough, this canvas and one other early work, *Diana and her Companions*, in The Hague, are Vermeer's only works belonging to what seventeenth-century art theorists and critics considered the first and highest category of art, history painting. This category consisted of themes based on the Old and New Testaments, on mythology and on ancient and modern history. The young Vermeer must have been indoctrinated in this theoretical approach by his teachers and was apparently exploring the possibilities of various types of subject matter before selecting his special area. Nevertheless, after these few youthful essays he turned his hand and brush, with two notable exceptions—the *Allegory of Painting* in Vienna and the *Allegory of Faith* in the Metropolitan Museum of Art—to genre painting, dealing with the world of seventeenth-century Holland, and to townscapes.

If one looks carefully at this work one can discern, despite the numerous obvious differences between this and Vermeer's mature production, certain precocious characteristics that anticipate his later style. For example, the sensitivity to subtle effects of light and shade, a hallmark of his later development, is clearly present here, especially in the rendering of the faces of the two sisters, Mary and Martha. These effects, which must derive from the Utrecht followers of Caravaggio, are especially well observed in the way Mary's shadowed profile is isolated against the brilliant white of the table cloth. Additionally, the young artist has blended the old, traditional means of representing thought with a depiction of a naturally observed situation. Yet Mary's pose, for example, can remind us of such varied works as Dürer's *Melancholia* and Rodin's *The Thinker*, for all the naturalistic qualities of the composition as a whole.

Other details of this picture can also be pointed to as motifs which become essential elements of Vermeer's development; we may recognize, for example, the brightly patterned oriental rug which serves as a table covering. Recurrent devices of this type—rugs, tapestries and richly patterned materials—may derive from early exposure to (or perhaps even training in) his father's primary profession. Reynier Jansz Vermeer was, among other things, a *caffa* worker, a highly skilled craftsman who wove patterned silk, velvets and satins. In addition, the open doorway which provides a glimpse into another room is the first appearance of a spatial device which Vermeer, along with other Delft artists, was to popularize during the following decade.

In his depiction of this New Testament story, Vermeer has chosen to render the pregnant moment favored by most seventeenth-century artists, when Christ says to Martha, "Mary has chosen that good part, which shall not be taken away from her" (Luke 10:42). Unlike sixteenth-century Northern artists, who filled their pictures of this subject with still-life details and numerous objects of everyday life, Vermeer concentrates only on the psychological exchange by focusing his composition on the three protagonists: the contemplative Mary, who listens at Christ's feet; Martha, who continues to serve and whose active role is stressed by the basket of bread she holds; and Christ, whose gesture and expression indicate that he is explaining the meaning of the situation to the worldly Martha.

After this youthful experiment with what might be termed the psychological mode, few Vermeer works can be said seriously to explore the interaction of personalities. Isolation, silence and a meticulous examination of light striking physical surfaces completely dominate his mature production.

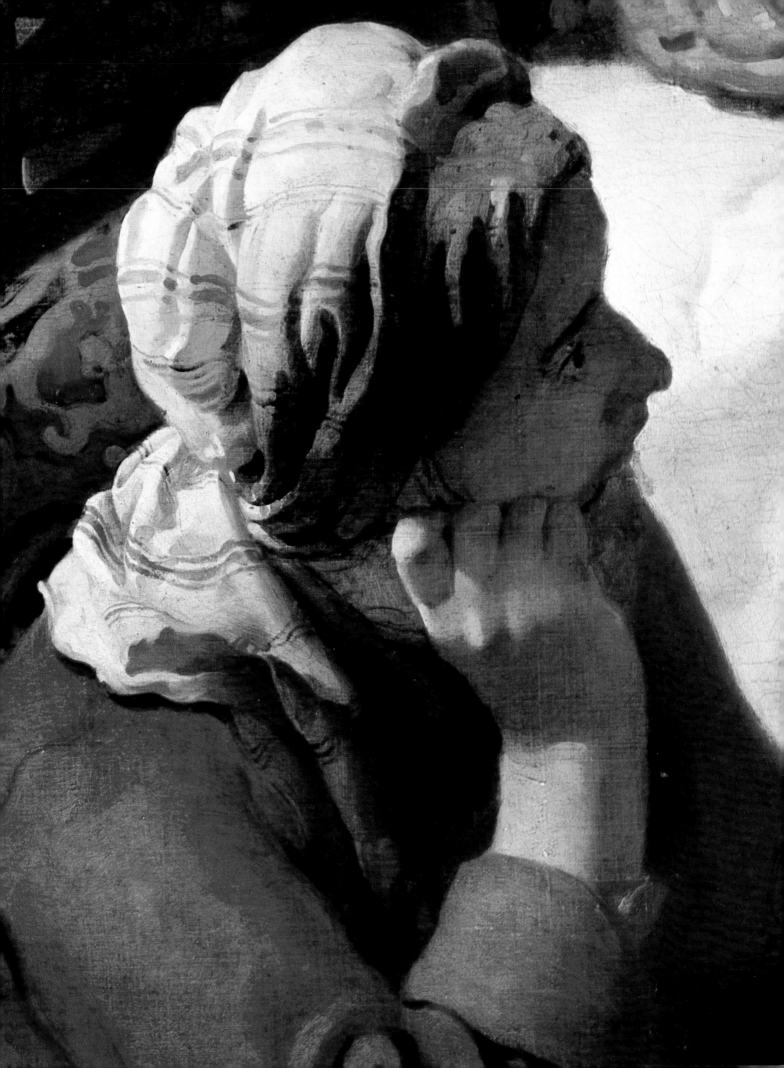

VERMEER

Diana and
Her Companions

c. 1655-6

Even after the false "N. M." (for Nicolaes Maes) monogram and the date of 1650 were removed, this canvas was not immediately recognized as an early work of Johannes Vermeer. As late as 1895 the signature, now difficult to read, was taken for that of the minor Utrecht painter Jan van der Meer, and it was not until 1907 that it was properly restored to the great Delft master. The nineteenth-century confusion, however, is somewhat understandable, for even today this work is Vermeer's only known mythological painting, as well as the only figural composition for which he provided a landscape setting.

As in his other early history painting, *Christ in the House of Mary and Martha*, in Edinburgh (see pp. 14-17), the young Vermeer seems to have been trying his hand at one of the popular painting styles of his day. This time, however, rather than depicting a religious theme he turned to the modish Flemish and Italianate mythological subjects, much admired in elegant Dutch artistic circles, especially in the courtly atmosphere of the nearby capital city of The Hague. Vermeer's direct model for this composition was the work of the Franco-Dutch genre painter Jacob

van Loo, who had painted exactly the same theme in a similar manner some seven years earlier. Moreover, the shimmering surface textures, especially in better-preserved sections such as the kneeling young woman, suggest that the young Delft artist took more than a passing interest in the work of Peter Paul Rubens' favorite assistant, the Flemish court painter Anthony van Dyck. And it is clear from other early works, such as the Edinburgh picture and the Dresden *Procuress*, that Vermeer was also interested in the Utrecht followers of Caravaggio. Rather than the dramatic candlelight contrasts favored by Gerrit van Honthorst, however, he turned to the brighter and cooler light often used by Dirck van Baburen and by Hendrick Terbrugghen. The latter especially must have served as a source of inspiration for this picture as Terbrugghen was one of the earliest Northern artists to render successfully the effects of natural daylight in his canvases. Yet despite these varied influences, the sense of color here, quite different from van Loo's, and the rendering of light effects are highly original.

The linking, for the first time, of clear daylight and an atmospheric softening of the edges of the forms, indicates some of the reasons for the reevaluation of Vermeer's work that took place in France during the middle of the last century. The two major tendencies of French painting at that time, Realism and early Impressionism, can both be seen as preparing the way for a fresh view of the great seventeenth-century Delft master's art. Indeed it was only in 1866 that Thoré-Bürger

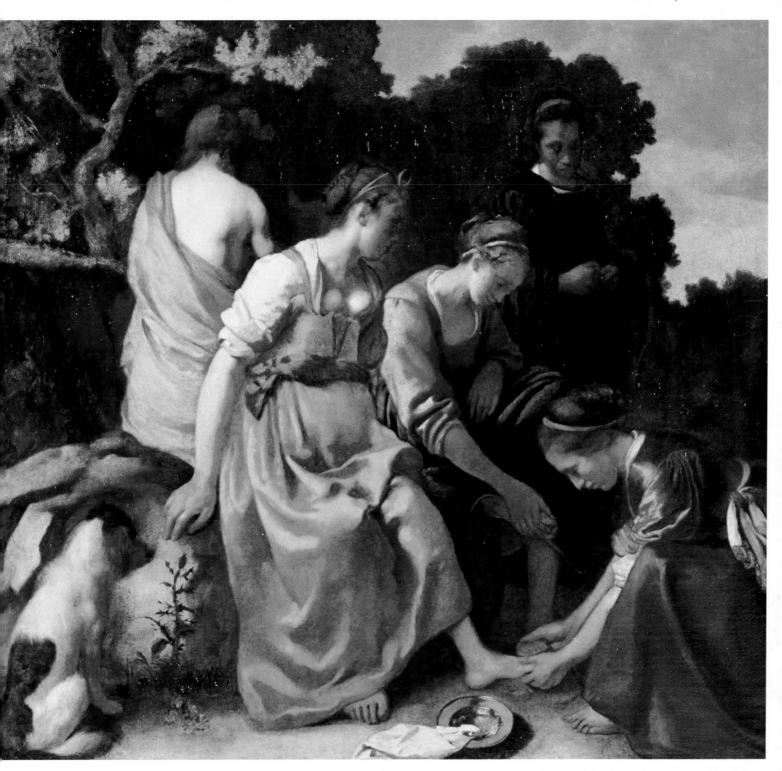

Canvas, 38¾ x 41⅓ inches (98.5 x 105 cm.) The Hague, Mauritshuis

first wrote of Vermeer for the French periodical *Gazette des Beaux-Arts*.

The nineteenth-century Vermeer revival is indeed striking. Compared to his Dutch contemporaries, such as Rembrandt and Hals, Vermeer's production is incredibly small. Only some thirty-five works can be assigned to his hand today. Thus his modern reputation rests on an extremely limited production of, for the most part, quite small pictures. Thus what is amazing is not that Vermeer had to wait so long to be recognized as a great master, but that the recognition took place at all! For that we must thank the perceptive Thoré-Bürger, whose writings first brought "the sphinx of Delft" to public attention.

VERMEER

The Procuress

1656

As early as 1860, and before his major publications on Johannes Vermeer, the perceptive Thoré-Bürger recognized that this signed and dated work, then still variously assigned to the Utrecht artist Jan van der Meer or the Haarlem painter Vermeer, was actually a youthful work of the great Delft master. This was no small feat when one considers that the young Vermeer—chameleon-like—changed elements of both his style and his subject matter with every new picture. Thus while Vermeer's previous works dealt with themes that belonged to the highest category of classical and Italianate art theory, history painting, for this third canvas he turned to a type of moralizing picture which can be ultimately traced back to early sixteenth-century Netherlandish prototypes. His most direct prototypes, however, were the Utrecht followers of Caravaggio, and in particular Dirck van Baburen's 1622

rendering of this very same theme. Indeed it can be shown that Vermeer's family, and eventually the master himself, most likely owned Baburen's *The Procuress*. Significantly, the Utrecht canvas, now in Boston's Museum of Fine Arts, appears hanging on the back wall in no less than two other Vermeer compositions: *The Concert*, in the Gardner Museum, Boston, and the *Lady Seated at the Virginals*, in London.

It is certainly notable that Vermeer's third surviving early effort deals with a category of subject matter distinctly different from his other two canvases. This fact lends weight to the thesis that he was self-consciously exploring the varieties of subject matter open to him as a young artist. In fact, there is some confusion as to the precise meaning of this picture. Rather than being a pure genre scene it probably represents some aspect of the biblical parable of the Prodigal Son, perhaps the Prodigal Son wasting his patrimony among the loose women. Dutch seventeenth-century writers were very much taken with this particular parable; numerous variations on it, such as P. C. Hooft's popular *The Contemporary Prodigal Son* published in Amsterdam in 1630, still exist.

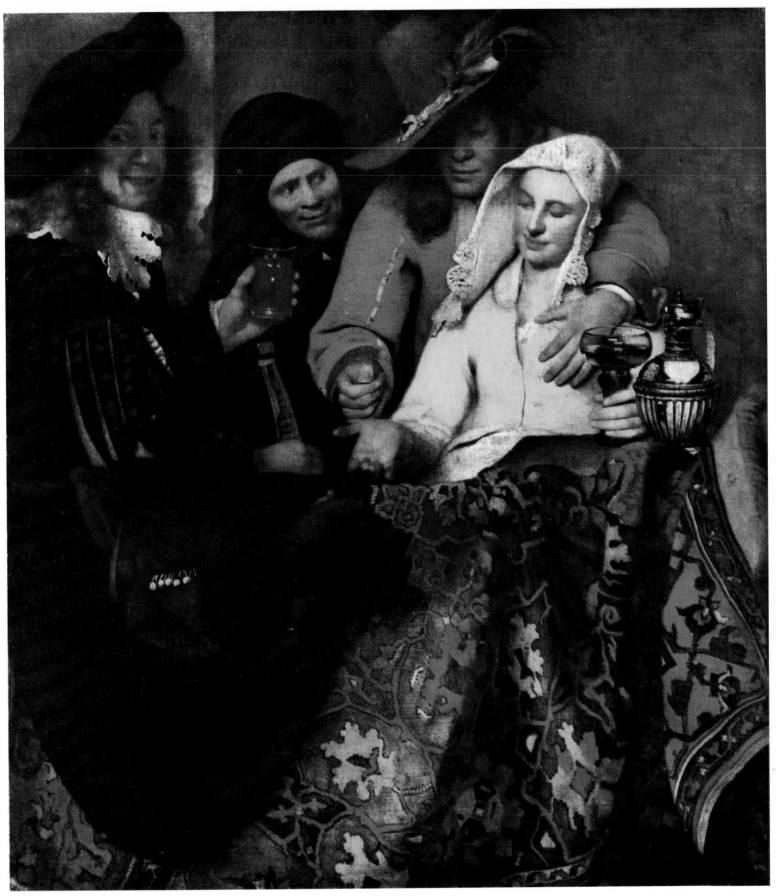

Canvas, 56¼ x 51¼ inches (143 x 130 cm.) Dresden, Staatliche Gemaldegalerie

That Vermeer had some allegorical or at least moral intention for this work, rather than seeing it merely as a genre scene recording the world around him, is underscored by his use of costumes which are clearly not usual seventeenth-century types. Such out-of-date or "Burgundian" clothing is often found in seventeenth-century theatrical and allegorical renderings, and Vermeer's use of them would be consistent with an allegorical intention in this canvas. Additional support for this view is to be found in the fact that the costume of the man with the lute and glass is similar to that found in Vermeer's later *Allegory on the Art of Painting* in Vienna.

Romantic attempts to personalize this painting into portraits of the artist and his family must be rejected out of hand. There is no doubt that Vermeer, like most of his contemporaries, used models for his various compositions. It is even possible, although far from certain, that members of his family were pressed into service as models from time to time. However, the intention here is clearly not to record specific portrait likenesses, and the moralizing nature of the subject matter makes it obvious that no autobiographical aim could have been in Vermeer's mind when he painted it.

Aside from the strong influences of the Utrecht school, immediately apparent in this work, the impact of Rembrandt and his followers—Carel Fabritius and Nicholaes Maes for example—is also felt throughout. It is clear that Vermeer must have known and even admired the works of Fabritius, and a long allegorical poem on Fabritius' tragic death in 1654 actually speaks of "Vermeer who trod his (Fabritius') path like a master." At the very best, however, Vermeer could only have studied with Fabritius for a very short time, if at all. Fabritius didn't arrive in Delft until about 1649 and was not admitted to the artists' guild there until 1652, before which date he could not have officially taken on students. Vermeer's situation may have been similar to that of Rembrandt, who studied with Jacob van Swanenburgh for three years and then spent about six months "finishing" with Pieter Lastman. Vermeer, too, could have first trained with some minor Delft master and then "finished" with Fabritius—perhaps during 1652-3 —before becoming an independent master late in 1653.

Compositionally this picture anticipates, in some secondary elements, the master's more mature production. The placement of the table covered with an oriental carpet between the viewer and the figures, and the space-creating device of the still-life elements, can be found in many of his later genre pictures.

22

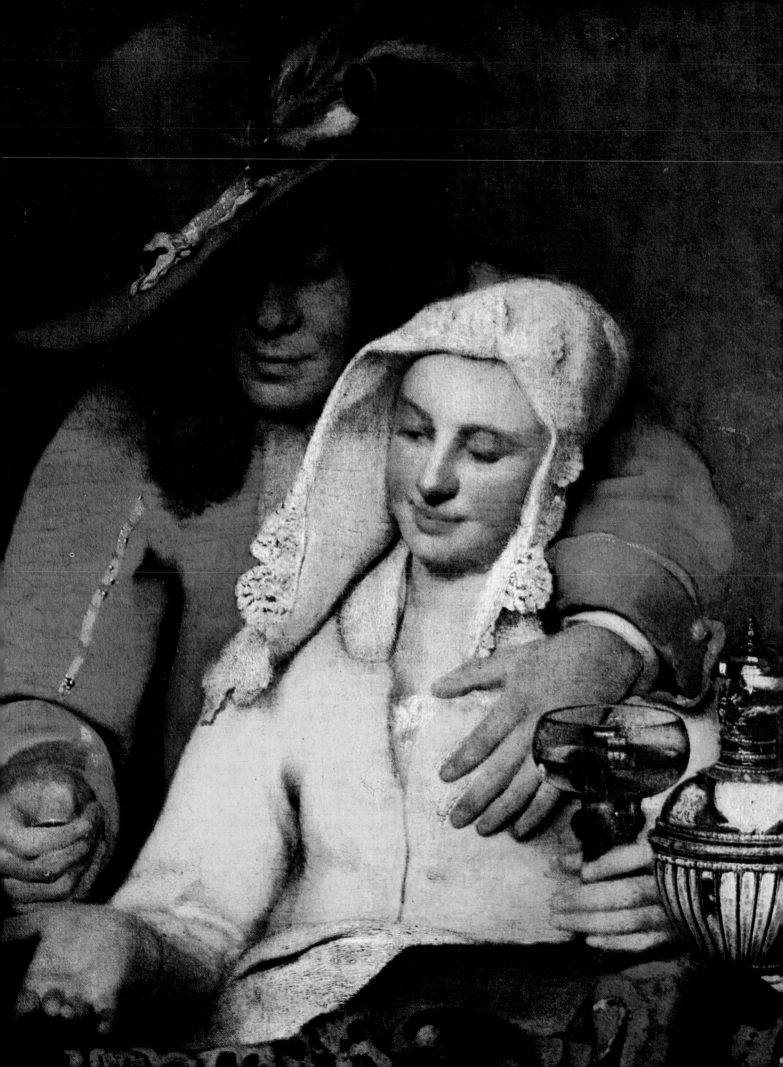

VERMEER
Sleeping Girl
c. 1656-7

This transitional work was most probably the picture sold at the important early Vermeer auction in 1696 as "a drunken, sleeping young woman at a table." The discovery of this early catalogue description has raised many questions concerning the precise meaning Vermeer intended for this picture. X-rays have revealed numerous major changes throughout the canvas, many, although apparently not all, by Vermeer himself. It is clear that a small lap dog was, at one stage, seated in the doorway and that a man once stood with his head and shoulders where the mirror in the back room now hangs. Since we are not certain why Vermeer removed these and other details, our understanding of this work remains somewhat uncertain.

Stylistically as well as symbolically, this picture has been related to Nicolaes Maes' 1655 *Sleeping Kitchen Maid* in London in which a young woman is depicted in a similar arrangement. The secondary elements in the Maes canvas, however, make it quite clear that the former Rembrandt student intended his composition to be taken, among other things, as a commentary on the relationship of servants and mistresses, as well as on one of the Seven Deadly Sins: sloth or idleness. Vermeer's picture, on the other hand, contains secondary elements which indicate that the 1696 description of the young woman as drunk must be taken literally. The wine jug and the nearly empty wine glass suggest that intemperance is the cause of her condition. Indeed, a print after a now lost 1664 painting by Frans van Mieris contains a sleeping woman related to the one in this work and is explained by an engraved passage from Proverbs 20:1, "Wine is a mocker, strong drink is raging: and whosoever is deceived thereby is not wise."

The Calvinist culture of seventeenth-century Holland saw both intemperance and idleness as cardinal sins which frequently led the way to lust. In this case, the presence of a painting of a standing Cupid above the head of the sleeping drunken woman may serve to indicate this sinful triad. Some historians have commented that the fragmentary Cupid canvas is not complete enough to serve any meaningful symbolic purpose. Nevertheless, numerous paintings, prints and emblem books, popular in Vermeer's day, would have made even this partial image immediately recognizable, and the most critical attribute, the mask of deception, is clearly rendered. Indeed, similar Cupid pictures appear in two other Vermeer compositions, and there is reason to believe that he actually owned a work of this type—possibly by Caesar van Everdingen—from which he borrowed to show the way he intended two of his later canvases to be understood.

Now that we know that Vermeer and the peripatetic Gerard Terborch were in contact in 1653, it is clear that Terborch's genre paintings were most likely one of the catalysts in the creation of the young Delft master's major style of composition. As early as 1650 Terborch had begun to paint interior scenes which anticipate this as well as other Vermeer pictures. The contemporary activities of other important artists in Delft, Pieter de Hooch, for example, could also have inspired Vermeer to create a more highly structured and architectonic framework for his paintings of everyday life. In addition, it is likely that he knew related works by Carel Fabritius, and perhaps by Samuel van Hoogstraten, which appear to have played a role in the creation of the new Delft style during the late 1650's.

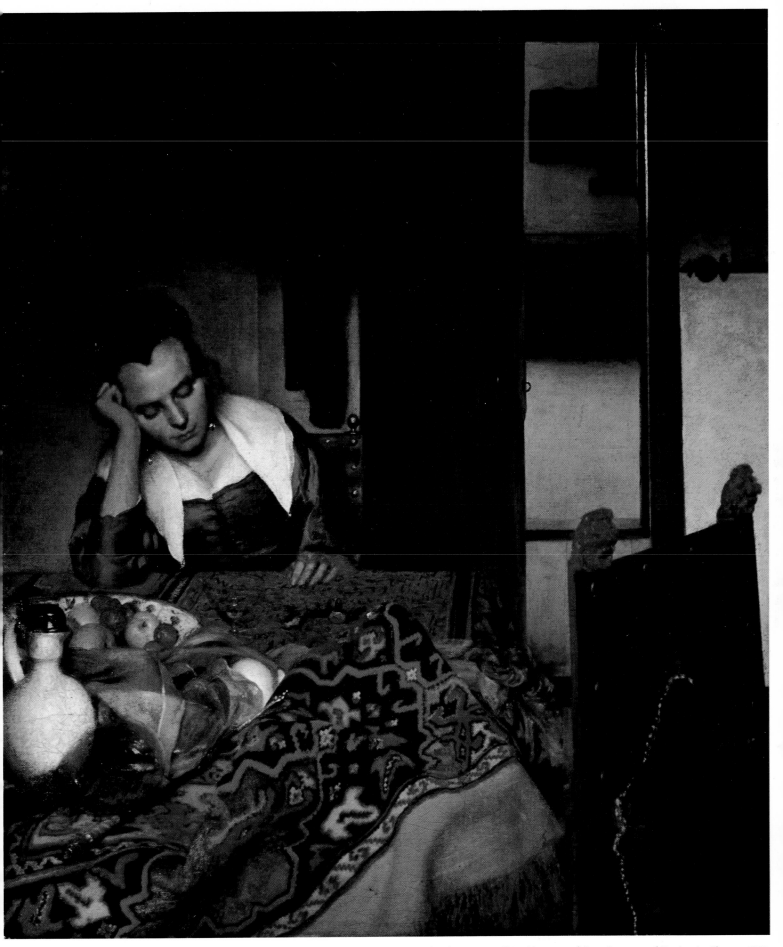

Canvas, 34½ x 30⅛ inches (87.6 x 76.5 cm.) New York, The Metropolitan Museum of Art Bequest of Benjamin Altman, 1913

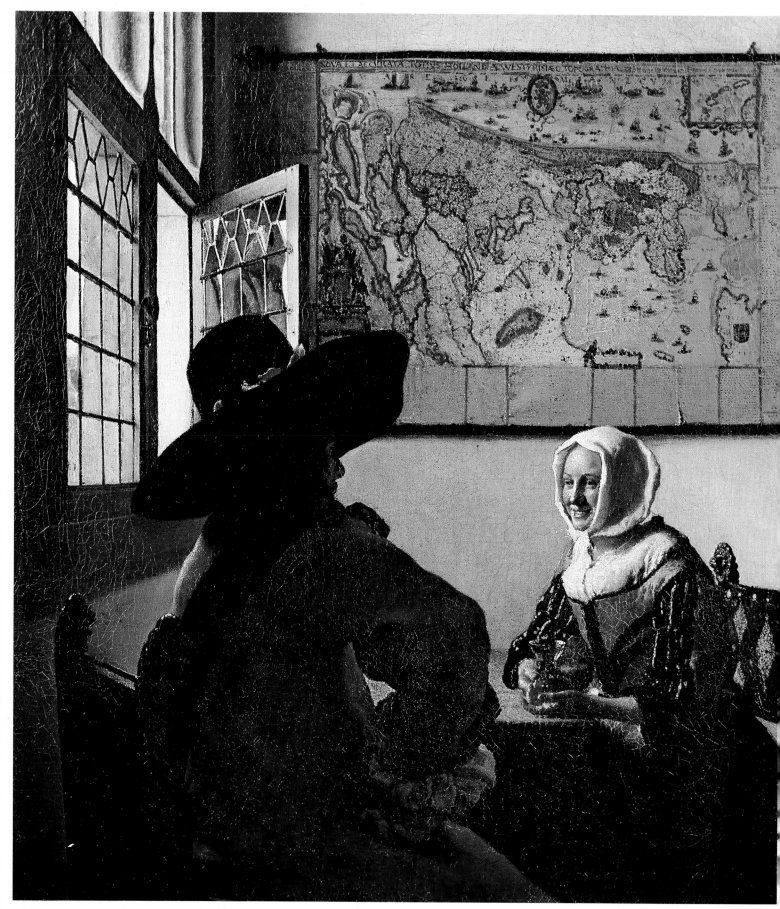

Canvas, 19¾ x 17½ inches (49.2 x 44.4 cm.) New York, Frick Collection

VERMEER
Soldier and the Laughing Girl

c. 1658

It is typical of the early study of Vermeer that even those pictures correctly identified by Thoré-Bürger did not always retain their proper attributions. This canvas, for example, was later sold in London as the work of Pieter de Hooch, even though Thoré-Bürger, in 1859, Waagen, in 1858 and the important Vermeer sale in 1696 had all properly listed it.

With this work it is clear that the young Vermeer has not only altered the nature of his subject matter again but, even more importantly, has changed his painting technique as well. Certain spatial elements of the Frick picture can be related to The Metropolitan Museum's *Sleeping Girl*. (For example, the placement of the soldier, like that of the chair, is extremely close to the picture plane and thus to the viewer.) And both works partake of a new architectonically oriented structure in their overall disposition.

Looking beyond these general similarities, however, the relationship begins to evaporate. What Vermeer has provided us with here is a rather shallow pictorial space in which the rear wall, intensified by the placement of the hanging map of The Netherlands, seems to project the figures towards the observer. This compositional mode can be basically related to that fostered by Caravaggio in Italy and subsequently popularized in the North by his Utrecht followers. Characteristically for Vermeer, real objects such as the map function in both a compositional and a symbolic role, seen here and in such pictures as the Amsterdam *Woman Reading a Letter*. Thus it is rendered in enough detail to be specifically identified as a work of the well-known Dutch cartographer Balthasar Florisz van Berckenrode. Iconographically such hanging maps appear to replace the globes that earlier artists used as a symbol of worldly concerns. But even more important than these small symbolic changes is the way in which Vermeer's artistic alchemy has here transformed what had been elegant but empty conversation pieces with early Delft painters such as Anthonie Palamedesz into his own work of high art.

Due to a paucity of biographical data historians have speculated more broadly than usual, suggesting numerous paths Vermeer might have followed in order to achieve the significantly new elements which suddenly appear in this canvas. Recent archival discoveries linking the young Vermeer and Gerard Terborch during the critical year 1653 make it clear that this painter of elegant portraits and

genre subjects must have been an important factor in Vermeer's early development. During the late 1640's, for example, Terborch executed a number of works that must have startled the young Delft artist by their magnificent technique as well as by their new approach to subject matter. Terborch, like Vermeer, was not only an admirer of the work of Anthony van Dyck but had actually been to England, where van Dyck was active, in 1635. Thus the subtle investigation of light effects on shiny fabrics and other surfaces, apparent here as well as in other Vermeer pictures, may also owe something to Vermeer's early contact with Terborch. Even the subject of this important early work is closely related to Terborch's *Soldier and Girl* (c. 1650) in the Pushkin Museum, Moscow.

Yet, despite the obvious similarities with the work of Terborch, this Vermeer canvas differs from those of his contemporaries in two significant elements: the quality of space, and certain aspects of physical execution, such as the brush work. It is possible that Vermeer was strongly influenced in these areas by the use of the *camera obscura*. This early optical instrument, known since antiquity, is essentially the forerunner of the early view camera, lacking only a light-sensitive film on which the image could be preserved. Since the Renaissance, artists had known the *camera obscura*, using it as a perspective aid, and perhaps in other ways. Several earlier seventeenth-century Dutch artists had also made use of the instrument, but Vermeer seems to be the only one who utilized it in a manner which captures, on canvas rather than on film, the unique and photographic quality of its image. Exactly how Vermeer used his *camera obscura* is still uncertain, and much debated. Nevertheless, the small points or dots with which he applied his colors, and the subtle halos of light which often outline his forms, suggest that he viewed the projected image through an apparatus which may have used mirrors to correct the image and which may

have had a ground-glass viewer very much like an old-fashioned view camera. Inherent in the use of an uncorrected *camera obscura* image, or any photographic image for that matter, is the exaggerated size of the foreground elements—as in this painting—and the merging or blending of highlights—as in the hands and glass of the laughing girl in this work. Vermeer's attempt to capture the visual impact and aesthetic of the photographic image supplied by the *camera obscura* must, at least in part, account for the strikingly modern qualities of his work, while at the same time, it must explain also why nineteenth-century critics often found his work so exotic. In our own time, surrounded as we are by photographs, we have come to accept the spatial distortions of the camera as natural and even real. The nineteenth century, less accustomed to the photographic image than we are, was more sensitive to its (and thus Vermeer's) odd distortions. Indeed in 1857 the French critic Maxime du Camp found certain of Vermeer's paintings visually "brutal." Today, however, this quality has all but disappeared from our view of his art.

Vermeer's use of this proto-camera may account also for his extremely limited production as well as for the rather small size of most of his pictures. The *camera obscura*, apparently used by the master for the first time in this work, may also be responsible for the dramatic shift in both his style and his approach to subject matter after about 1658. Despite stylistic differences with earlier works, this canvas can be related to the earlier Dresden *Procuress* in subject matter, and can even be seen as evidence of Vermeer's continuing interest in the Utrecht followers of Caravaggio. The open-handed gesture of the laughing girl, and the glass, both of which call for filling, suggest that the true subject of this work may be the contemporary Prodigal Son theme favored by many seventeenth-century Dutch artists. Certainly the prominent wall map asserts the worldly nature of the canvas.

Canvas, 33¾ x 25⅜ inches (83 x 64.5 cm.)
Dresden, Staatliche Kunstsammlungen.

VERMEER

Girl Reading a Letter

c. 1659

As Vermeer's interest in capturing the natural effects of the world on his canvases developed, he was led, understandably, to use the purely illusionistic devices often favored by Dutch artists in the second half of the seventeenth century. From the middle 1640's painters began to introduce into their work illusionistically painted dust curtains similar to those found on real pictures in Dutch homes of the period. The motif seems to have been popularized, although not invented, by Rembrandt, who rendered both an illusionistically painted frame and a partially drawn dust curtain as part of his 1646 *Holy Family* in Cassel. Two young artists in Rembrandt's studio during the 1640's, Carel Fabritius and Samuel van Hoogstraten, also took up various *trompe-l'oeil* and illusionistic elements for their own work. Vermeer is known to have owned paintings by Hoogstraten; Fabritius, sometimes even said to have been one of Vermeer's teachers, was a major artistic force in Delft until his death in the "Delft thunderclap," the famous gunpowder explosion that levelled much of the city on October 12, 1654. Fabritius' tiny *Goldfinch*, in The Hague, painted the year of his death, as well as his 1652 *View of Delft* in London, indicate that elements of illusionism were well established in his Delft-period works. Artistic illusionism is naturally accompanied by a related interest in both perspective and optics. Therefore it seems reasonable to suggest that Vermeer's use of the *camera obscura* may have led him to explore these other odd but closely related artistic areas. It

is certainly also significant that Leonaert Bramer, another Delft artist closely linked to Vermeer by many documents, had worked, while in Italy, with the important specialist in perspective, Agostino Tassi. Tassi, who included many Northern artists in his entourage, created the illusionistic architectural frameworks favored by many Italian painters for their fresco decorations. Thus Delft during the 1650's was an important center for all the specific artistic devices which begin to appear in Vermeer's pictures.

Other unusual details also link this work, in specific motif if not in style, with Rembrandt. About 1646 Rembrandt created his greatest portrait etching, *Jan Six*. This etching helped popularize the motif of a casually posed but intensely absorbed reader before an open window which has a curtain carelessly draped over it. Indeed, Rembrandt repeated the motif during the 1650's, in the early stages of another graphic portrait. Nevertheless, despite this provocative relationship, Vermeer's canvas most closely recalls some of the genre works of Terborch and Maes, rather than those of the great Amsterdam master.

Interestingly enough there is a classical prototype for an illusionistic curtain of the type found here and in the works of other seventeenth-century Dutch artists. Pliny the Elder records a popular anecdote about a competition between two famous antique artists, Zeuxis and Parrhasios. Zeuxis submitted a basket of grapes so realistically painted that a bird flew down and tried to peck at them. Parrhasios, for his contribution, presented a picture which appeared to be covered by a cloth. When the impatient Zeuxis tried to remove the covering, he discovered, of course, that it was painted. Naturally Parrhasios was declared the winner for, as Pliny writes, "Zeuxis had deceived only the birds of heaven, but Parrhasios had deceived Zeuxis."

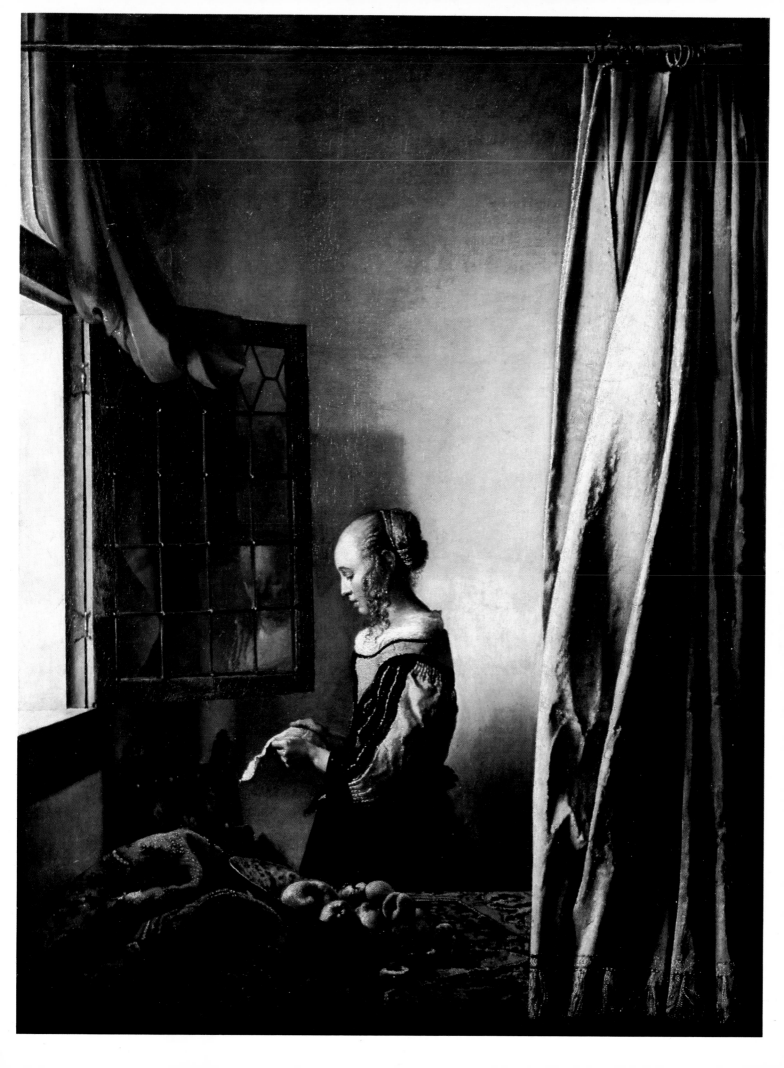

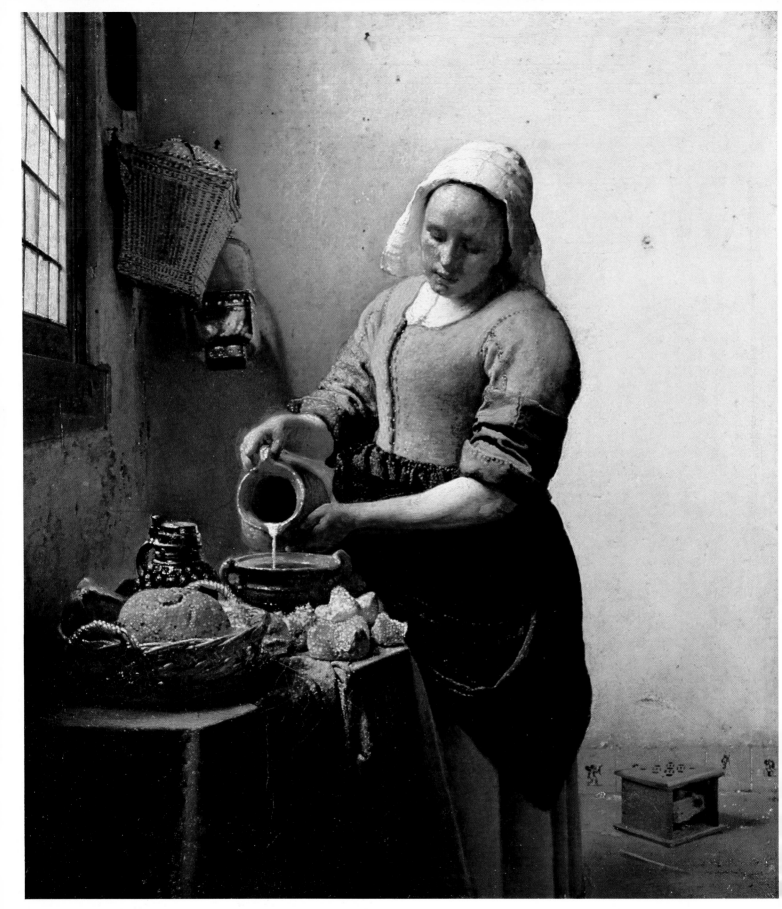

Canvas, 18 x 16¼ inches (45.5 x 41 cm.) Amsterdam, The Rijksmuseum

VERMEER
The Milk Maid

c. 1659–60

This canvas has been one of the Delft master's best-known and most admired works since the 1696 sale of Vermeer pictures, where it was described as "a maid pouring milk, exceptionally well painted." Indeed, it must have been greatly admired since only the larger *View of Delft* which sold for 200 guilders, brought a higher price than the 175 guilders paid for this work. Clearly then, some special virtue was attached to both the subject matter and the execution of this work. Through numerous sales during the eighteenth and nineteenth centuries, this canvas remained in the public eye, unlike most other Vermeers. It was mentioned, for example, by the great English painter, Sir Joshua Reynolds, in his diary recording his reactions during a 1781 journey to Flanders and Holland. Although slightly confused about the artist's name—he calls him D. van dermeer—Reynolds was not confused about the high quality of this picture, to which he called special attention.

Unlike his usual subjects, which almost always deal with elegantly dressed people in beautifully appointed surroundings, Vermeer has given us, in this loving treatment, what appears to be a sturdy maid going about her household chores in a simple kitchen setting. The painting's great popularity during the nineteenth century—when it was perceived as a symbol of domestic virtue—appears to have resulted from a coinciding of Victorian morality and seventeenth-century Dutch ethics. Despite the mistaken historical framework, the nineteenth-century view seems to have been essentially correct about the meaning of this deceptively simple picture. Even today, without supporting iconographic material, the apparently uncomplicated action seems to depict the very essence of homely virtue. For the seventeenth century, the moral basis of this action would have been re-enforced by numerous symbolic representations of Temperance, traditionally rendered as a female figure pouring a liquid from one vessel to another. Utrecht followers of Caravaggio, such as Baburen and Terbrugghen, often included such "Temperance" warnings disguised as genre figures in their Prodigal Son/ Procuress scenes. Vermeer, in a further permutation of the Utrecht type, renders an isolated genre figure carrying out the activity traditionally associated with symbolic personifications of Temperance. But rather than imparting a warning, as in the earlier Utrecht works, the Vermeer seems to serve a positive function as an appreciation of the pure idea of temperance itself.

33

Other facets of this composition, deceptively genrelike, support the idea that Vermeer was attempting to do more than capture a simple slice of seventeenth-century life. Specific details, such as the basket of bread and the woman herself, have often been related to the earlier *Christ in the House of Mary and Martha* in Edinburgh. By extension, in *The Milk Maid* Vermeer appears to elevate the role if not the person of Martha the housekeeper. Indeed, Dutch "Kitchen Pieces," as they are still called, by such sixteenth-century painters as Pieter Aertsen as well as by seventeenth-century Delft artists like Cornelis Delff and Pieter van Rijck, often implied praise for Martha as patron of housewives. Thus even Vermeer's stunning rendering of the highly polished copper pot hanging on the wall, like some secular version of similar shining metal containers found in early Netherlandish Annunciation pictures, recalls that "the vessel most clean" was a traditional symbol of purity. The apparently casual placement of the footwarmer on the floor can also be taken as a token of female virtue. The popular emblem book of Roemer Visscher presented this simple device as a favorite of Dutch women, more valued than a man. Additional support for this moral reading of Vermeer is to be found in the related use of simple household objects in the frontispiece of Jacob Cats' 1619 *Emblems of the Christian Struggle.*

Although superficial aspects of the subject matter of this canvas can be related to the works of various of his contemporaries—Gerrit Dou's *The Cook* in Paris, for example—it is clear that Vermeer's painting technique is unique in the seventeenth century. The small dots of color, or *pointillés*, which first appeared in the *Soldier and the Laughing Girl* in the Frick Collection, have here taken on an added importance. In his earlier experiments with the *camera obscura* Vermeer was at first content to use these *pointillés* only to help describe what he saw through the lens of the optical device. With his growing confidence in his new technique, as in this canvas, these shimmering points of light—or at least the paint which describes them—begin to take on a life almost independent of the objects they describe, thus contributing to the modern impact made by this picture and many of his mature works.

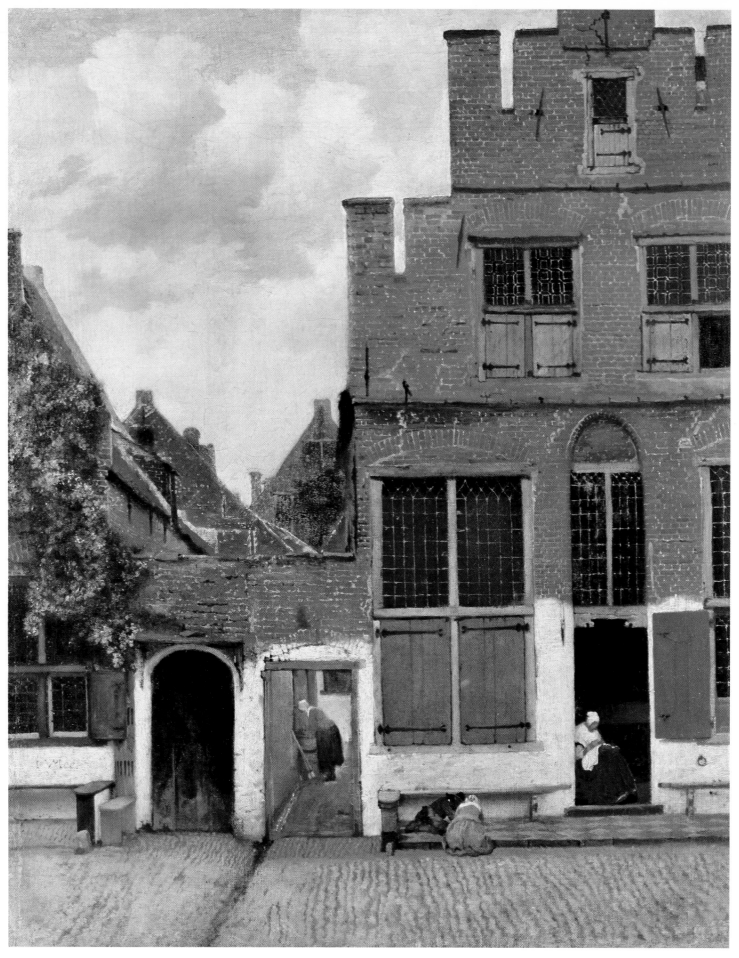

Canvas, 21⅜ x 17¼ inches (54.3 x 44 cm.) Amsterdam, The Rijksmuseum

VERMEER

The Little Street

c. 1659–60

The catalogue of the 1696 sale in which twenty-one Vermeer pictures were sold lists three works which can be classified as townscapes. Unfortunately, of these only two paintings have survived, this one and the larger and more extensive *View of Delft* in The Hague. The present work was most probably number 32 in the sale: "a view of a house in Delft." The catalogue described number 33 as containing "several houses" and this presumably is the now lost work. Despite the fact we are missing one of the three architectural subjects Vermeer executed, the 1696 descriptions do give us enough information to speculate on the sequence of events in their creation. In addition, specific qualities of this canvas and of the *View of Delft* indicate that Vermeer must have utilized the *camera obscura* for both works. Thus, if the sequence of events parallels those apparent in the early development of his other *camera obscura* compositions, he probably began the series with a close-up view of his subject and with relatively shallow space. Since the *View of Delft* is a large panoramic townscape, we can presume that the lost picture of "several houses in Delft" came between the two surviving canvases.

This developmental scheme would exactly parallel that found in his genre interiors, which also utilize the *camera obscura*. Thus, like the *Soldier and the Laughing Girl* in the Frick Collection, *The Little Street* would be his first attempt to apply the *camera obscura* to architectural subject matter. This assumption is supported by the discovery through x-rays of several small changes in the pictures. The lost picture of several houses would come next and, like the Berlin *Man and Woman with a Wineglass*, was probably an attempt to exploit better the strengths of the cameralike device. The extensive *View of Delft* can be compared to the further spatial development found in works such as the Buckingham Palace *Lady and Gentleman at the Virginals*. If this developmental hypothesis is correct, it might provide some indication as to why Vermeer painted so few works in his lifetime: the careful craftsmanship and the step-by-step compositional and spatial progression seem to indicate an unusually methodical personality, incapable of rapid work.

Architectural painting and townscapes hold a special place in Dutch seventeenth-century art, particularly in the work of Delft artists. As early as 1658 Pieter de Hooch began using architectural frameworks similar to the one found here. De Hooch's figures, however, as in his *Maid and Child in a Delft Courtyard* in London, are larger and more important than those found in Vermeer's two surviving architectural pictures. Terborch's *The Grinder's Family* in Berlin, which must date from the period when the two artists were in contact, c. 1653, also can be seen as an anticipation of this Vermeer canvas. In addition, the works of Pieter Saenredam, although not technically related to those by Vermeer, must have provided an impetus for realistic depictions of architecture—interior views as well as townscapes—at a time when few important artists specialized in this genre.

In Delft itself the two painters variously linked with Vermeer, Carel Fabritius and Leonaert Bramer, both experimented with similar architectural subject matter. Fabritius' 1652 *View of Delft* in London is, of course, next to Vermeer's, the best-known view of the town. In addition, Bramer is documented as having executed depictions of architecture and townscapes in Delft.

The building in *The Little Street* has been identified, quite plausibly, as the Old Woman's and Old Man's Almshouse, which was directly across the street from Vermeer's home. The fact that the Delft almshouse was torn down in 1661 can be used to support the date assigned to this picture (provided, of course, the identification is correct). In addition, Vermeer might have been attracted to the building because it was an almshouse and thus wanted to utilize it for a moralizing purpose similar to that also found in Fabritius' *View of Delft*. (The activities of the small figures may be a key to Vermeer's meaning. Thus the frivolous games of the two children are to be seen in contrast to the virtuous work of the two women.) It is also possible, given these varied activities, that Vermeer had in mind such traditional themes as the three ages of mankind. This latter concept would be especially poignant and meaningful for a rendering of the Delft home for the aged poor, and completely consistent with the moralizing tone of Dutch seventeenth-century art.

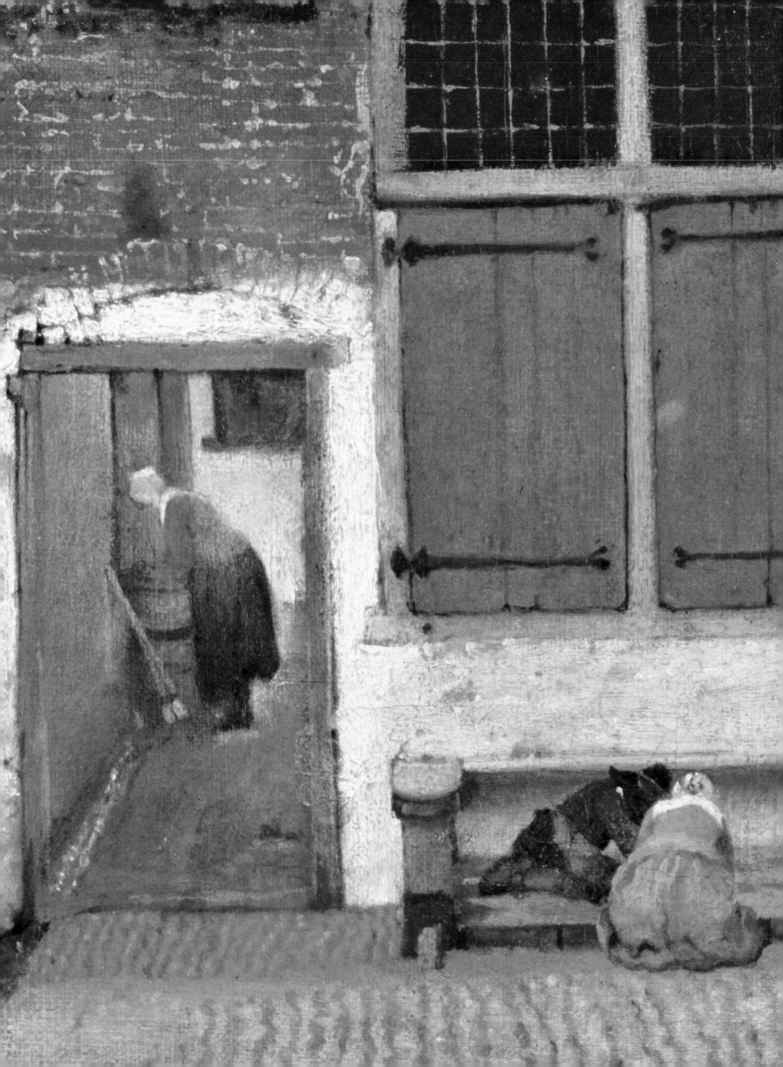

VERMEER
View of Delft

c. 1660–61

Perhaps the most universally admired of all Vermeer's works is this magnificent rendering of the town in which he spent his entire life. As early as 1682 this large canvas—large at least in terms of Vermeer's production—was in the collection of the Delft publisher and bookseller Jacob Abrahamsz Dissius, who may also have been a patron of Vermeer. It figured as number 31, "the city of Delft in perspective, seen from the South," in the important 1696 sale, presumably of the Dissius collection. It comes as no surprise that this marvelous townscape fetched 200 guilders, the highest price at the sale, and then disappeared from view. When it re-emerged in 1822, the Dutch government purchased it for 2900 guilders. The price was high, especially when one considers that Vermeer had not yet acquired a reputation as a great artist. From Maxime du Camp, who first saw it on a visit to Holland in 1857, to Marcel Proust, who first saw it in Paris in 1902, the *View of Delft* has been the object of almost total admiration.

A roughly contemporary drawing by Abraham Rademaker, depicting the same section of Delft, in the Prinsenhof, confirms the topographical accuracy of Vermeer's rendering. So do early maps, as well as the 1696 description, which even states the direction from which the town is viewed. (Today only the twin spires of the Rotterdam Gate and the tower of the Nieuwe Kerk still stand. Little else of what Vermeer saw remains.) Furthermore, not only such external evidence, but also

Vermeer's extraordinary technique, verifies the accuracy of his depiction.

All of this seems to support the assumption that Vermeer painted this unusual picture from the second floor of a house situated on the river Schie, across from the Rotterdam Gate. Technically, and especially in terms of the application of the paint, this work can be compared with the Amsterdam *Milk Maid*. Like *The Milk Maid*, the *View of Delft* presents evidence of optical phenomena available to Vermeer only through use of the *camera obscura*. The small globules of paint, or *pointillés*, seen on the bread in *The Milk Maid* and on the boats, bridge, and foliage here, appear to render the so-called "circles of confusion" which the eye does not see but which appear in the unfocused parts of the *camera obscura* image. Moreover, in both works, the *pointillés* appear independent of the substances they describe. This effect was first noted by du Camp, who wrote of the "areas of color freely applied in an impasto which stands off the canvas." Du Camp also noted the unusual perspective of the picture, which he called an "exaggerated Canaletto." The comparison, although du Camp could not have known it, is particularly apt. Today we know that Canaletto, an eighteenth-century Venetian painter of townscapes, also used a *camera obscura*, which he carried around Venice with him. Indeed, since the way Canaletto utilized this instrument is well known, his pictures provide an important contrast with Vermeer's work. The Italian townscape specialist first made numerous drawings using his portable *camera obscura*. He then assembled and "corrected" these drawings back in his studio to remove the spatial distortions inherent in the optical device. Du Camp, whose vision in 1857 was neither beguiled nor desensitized by an overexposure to photography, was struck by

the "exaggerated" and even "brutal" vision which Vermeer, unlike Canaletto, captured and preserved in his rendering: it seems likely that the Delft master painted directly from his *camera obscura* image without the intermediate stage of drawing. Significantly, no Vermeer drawings are known today.

During the 1650's Delft became an important focal point for the development of architectural painting of all sorts, and especially of townscapes. Townscapes may have gained a foothold in Delft as a result of the "Delft thunderclap," the terrible gunpowder magazine explosion which devastated the city on October 12, 1654, and cost Fabritius his life. A number of Delft artists, quick to turn disaster to advantage, produced various views of the ruined town. At least one painter, Egbert van der Poel, seems to have specialized in this grizzly forerunner of Vermeer's picture. On a more positive note, Leonaert Bramer is also known to have executed large fresco paintings of architectural subjects in 1660. Thus the primacy of Delft in townscape painting was probably the product of a particularly fortuitous interaction of several talented artists, including Vermeer, with a similar turn of mind. Moreover, unique to Delft was an especially strong sense of civic cohesion fostered in the aftermath of the terrible disaster. Therefore, although topographically accurate, it is possible that Vermeer's picture, perhaps the finest example of seventeenth-century Dutch townscape, also functioned in a broadly symbolic manner. Like Ambrogio Lorenzetti's 1340 fresco townscape in the town hall of Siena, *The Effects of Good Government*, the *View of Delft* seems to present the perfect symbol of municipal virtue, economic strength, artistic innovation—all contributing to the rise of Delft only six years after calamity struck.

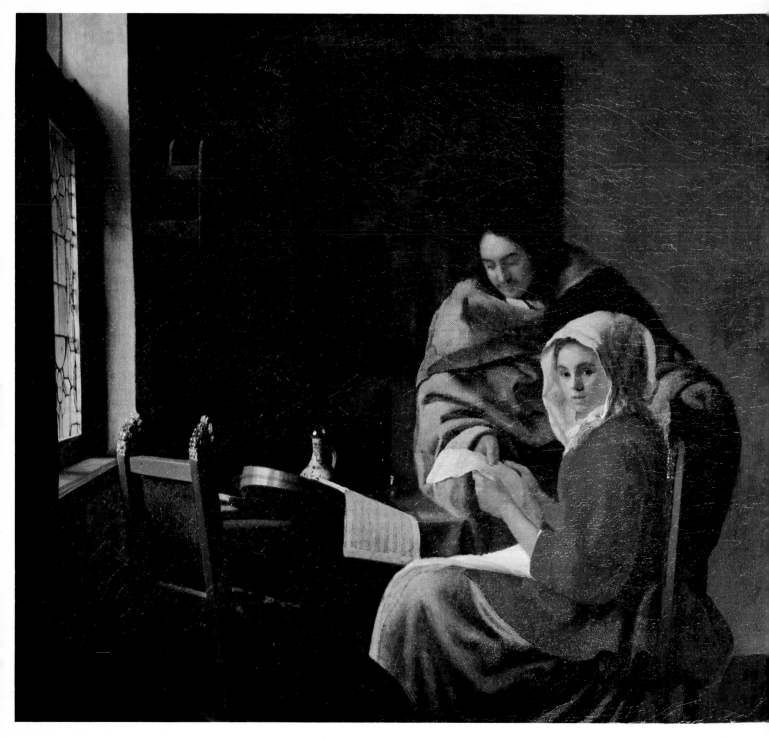

Canvas, 15½ x 17½ inches (39.3 x 44.4 cm.) New York, The Frick Collection

VERMEER

Girl Interrupted at Her Music

c. 1660

The poor condition of this subtle Vermeer composition makes it difficult to place within the artist's total development. Even the authors of the most recent catalogue of the Frick Collection admit that "the picture has suffered severely from abrasion and losses of paint film." In addition, descriptions of the picture in the catalogues of two public sales which took place in Amsterdam in 1810 and 1811 make it clear that it was radically overpainted at some earlier date. The popular interpretation of the activity depicted here as a music lesson probably derives from the fact that the painting of a Cupid figure was once totally overpainted and replaced by a violin hanging in its place on the wall. Technical evidence suggests that the bird cage is also a later addition. Despite these formidable problems there is no overriding reason to remove this work from the already short list of authentic pictures by the Delft master, as some scholars have recently done.

Compositionally, this painting can be seen as a part of the specific development which begins with the Frick *Soldier and the Laughing Girl* and reaches its artistic climax with the spacious musical compositions of Buckingham Palace and Boston. Unfortunately, the condition of the canvas makes it impossible to assess this work in terms of Vermeer's use of the *camera obscura*. His handling of depths, however, suggests that the artist was experimenting with a compositional and spatial format which would minimize the size-distortions inherent in the use of a proto-camera device. (This format is most apparent in works like the *Soldier and the Laughing Girl*.) The activity of Pieter de Hooch in Delft might also have suggested this solution to Vermeer. In any event, this composition appears to be an intermediate step between the *Soldier and the Laughing Girl* and works such as the Brunswick *Woman and Two Men* and the Berlin *Man and Woman with a Wine Glass*.

The Cupid painting hanging on the wall, although now severely abraded and somewhat difficult to see, is clearly the same one which is also found in the London *Lady Standing at the Virginals*. In the London work it is clear that this Cupid comes close to the style of Caesar van Everdingen. Significantly, this Cupid has also been associated with a specific illustration in Otto van Veen's popular book of love emblems. Van Veen's Cupid holds aloft a tablet on which the number one is written, while with his right foot he tramples on another tablet with many numbers inscribed on it. The motto van Veen provides for his emblem, "only one," suggests that Vermeer also intended his Frick Cupid to be understood as a symbol of fidelity to a single lover. The other elements in the room—the stringed instrument, music book, and wine—also have long and traditional associations with love. Unfortunately, the poor condition of the sheet the young woman holds makes it uncertain whether Vermeer intended it as a letter or a sheet of music, and on this delicate point is balanced the entire interpretation of this picture. Is this painting a warning to the absent lover to be faithful, or is it a celebration of the harmony of faithful love, symbolized by a sheet of music?

VERMEER
Man and Woman with a Wine Glass

c. 1660–61

Unlike the development of some other, more prolific painters of the seventeenth century, Vermeer's compositional and technical development seems to have reached maturity relatively quickly. A canvas such as this one, apparently painted before the artist was thirty years old, can be seen as part of an unusually rapid maturing process which began with the *Soldier and the Laughing Girl* (c. 1658) in the Frick Collection. Thematically, however, this work and two other closely related paintings, the Frick *Girl Interrupted at Her Music* and the Brunswick *Woman and Two Men*, probably depend upon the earlier Dresden *Procuress*.

Despite the apparent logic of Vermeer's compositional growth, certain questions remain unanswered. For example, what role did Vermeer's use of the *camera obscura* play in this development? Unfortunately, the poor condition of the Frick *Girl Interrupted at Her Music* makes this question difficult to answer. Logically, the *Girl Interrupted at Her Music* should precede this canvas and be seen as Vermeer's attempt, by putting figures in depth, to minimize the size distortions inherent in the *camera obscura* image. However, the *pointillés*, or dots of paint usually associated with Vermeer's early *camera obscura* technique, are almost entirely missing from the Frick *Girl Interrupted*, possibly as a result of the later overpainting or the poor condition, or both. Nevertheless, the present picture can be seen as growing out of the composition of the *Girl Interrupted*, with an even greater use of depth on the artist's part.

Vermeer's Delft contemporary, Pieter de Hooch, had begun to render figural groups in similar rooms as early as about 1658. Works such as the present one may thus be seen as both a reduction and a concentration into one corner of de Hooch's spacious interiors. As he withdraws spatially from the figures—at first apparently only to dilute the distortions of the *camera obscura*—Vermeer also begins to withdraw from the personalities of his sitters and from the earlier sense of psychological interaction. Compositions such as this one seem almost *too* perfectly balanced and arranged, like some seventeenth-century Dutch still-life painting. The crowded and rather boisterous mood of the early *Procuress* has been distilled out of the work of the mature Vermeer and we are left with a timeless sense of silent perfection. These qualities as well as Vermeer's reticence are certainly among the reasons Thoré-Bürger called him "the Sphinx of Delft." Since we know virtually nothing of the personality of the artist, it is impossible to speculate on the reasons for this withdrawal. It cannot have been due to lack of recognition or professional status, since shortly after this work was painted, Vermeer was elected head of the Delft artist's guild.

Perhaps these characteristics are only due to the demands of the *camera obscura*. Unfortunately, we are uncertain exactly how Vermeer utilized this device in his studio. Nevertheless, it is clear that the poses assumed by his models would have to be more stable than normal. Since no certain Vermeer drawings are known, it also seems likely that he somehow used the projected image directly. Thus, despite the almost photographic realism of works like this one, the silent perfection of a specific moment captured for eternity is more like some carefully posed daguerreotype than a modern snapshot.

As one looks closely at a number of Vermeer's works, it becomes evident that many of the same elements appear over and over: the chairs, tapestries, still-life elements, and even, sometimes, the clothing. The colorfully decorated stained-glass window found here also appears in a closely related composition in Brunswick. Recent research has revealed two things about these window decorations. First, that the central section is the family coat-of-arms of Jannetje Vogel, who died in

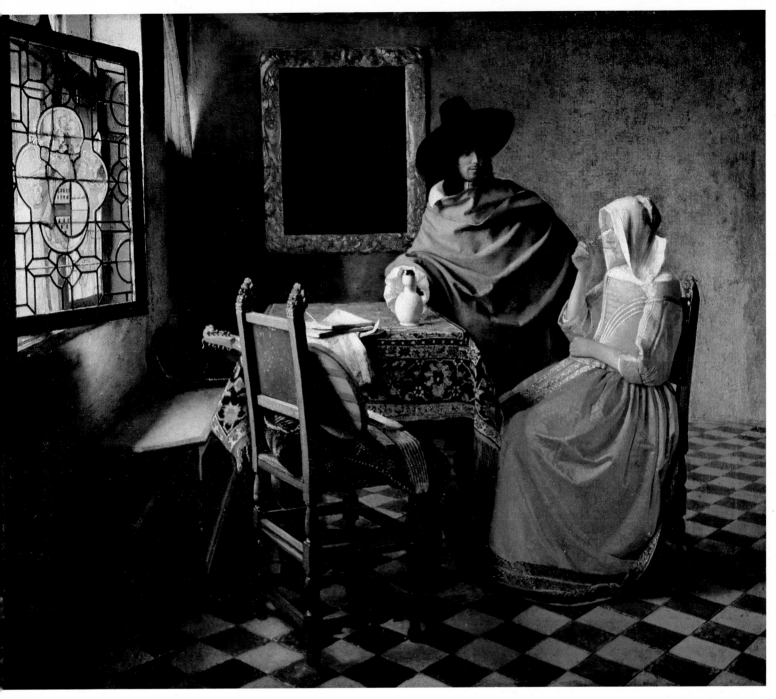

Canvas, 26¼ x 30⅛ in. (66.3 x 76.5 cm.) Berlin, Staatliche Museum Preussischer Kulturbesitz

Delft in 1624, and who had perhaps lived in the house Vermeer occupied at this time; and second, that the female allegorical figure has been associated with an illustration of Temperance holding the attributes of measure and restraint in Gabriel Rollenhagen's 1613 emblem book. Like Rollenhagen's emblem, Vermeer's allegorical figure holds an architect's right-angle ruler (measure) and a bridle and bit (restraint). A seventeenth-century English version of the motto of this emblem makes its meaning clear: "Doe not the golden MEANE, exceed, In WORD, in PASSION, nor in DEED." Apparently then, this personification implies a moral comment on the activity Vermeer renders both here and in the Brunswick canvas. Other elements in this composition—the music book, the stringed instrument, the velvet cushion and the wine—all suggest that Bacchus (wine and music) and Venus (love) often went hand in hand in seventeenth-century Delft, as in classical Rome.

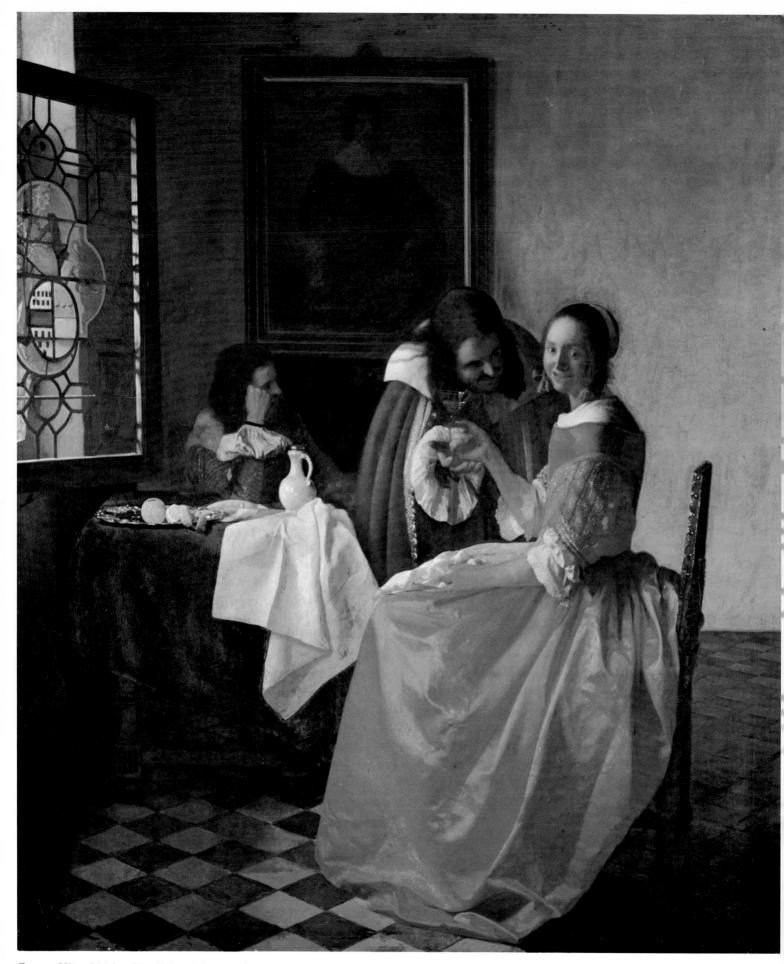

Canvas, 30¾ x 26½ in. (78 x 67.5 cm.) Brunswick, Herzog Anton Ulrich-Museum

VERMEER

A Woman and Two Men

c. 1661–62

Compositionally as well as technically, this canvas is closely linked with the *Man and Woman with a Wine Glass* in Berlin. Since it also features the prominently open window with the allegorical figure of Temperance on it, and the same coat of arms, the subject matter of the two works must also be seen as closely related. This painting was probably number 9 in the 1696 Vermeer sale, where it was described as "a merry company in a room." The term "merry company" (*vrolijk gezelshap*) seems to have been the generic Dutch descriptive phrase used for everything from Utrecht *Prodigal Son* scenes to elegant interiors like the present one.

In this work Vermeer appears to come closer to his contemporaries than at any other time in his career. The marvelous rendering of the shining satin material of the woman's dress recalls the meticulous craftsmanship of Gerard Terborch, while the overly gallant relationship between the man and woman is related to that found in several works by Frans van Mieris, for example his *Oyster Meal* of 1661 in The Hague. Indeed, the pretentious manner in which the young woman holds the glass of wine here is also found in the van Mieris and seems to have been a popular and elegant social convention at this time. But the sexual overtones in van Mieris' picture, conveyed by the oysters, long an erotic symbol, are only suggested in the Vermeer by the overly solicitous attitude of the man and, of course, by the rather silly expression on the woman's face.

Vermeer's superb rendering of the two oranges—more subtle tokens of love than oysters—and of the polished silver tray on which they rest, echoes the work of such seventeenth-century Dutch still-life specialists as William Kalf. (These details also recall similar elements which appear in the Metropolitan Museum's *Woman with a Water Pitcher*.) The simple white Delftware wine jug, found in other Vermeer compositions, completes the subtle grouping of the elements which suggest the cause of the man's melancholic posture: during the seventeenth century, and even earlier, wine and love were believed to be among the prime causes of melancholia. Thus Vermeer seems to be presenting, along with the allegorical figure on the window with the attributes of restraint and measure, another warning about the main activity presented in this picture.

It has recently been suggested that the portrait of a man hanging on the back wall may be one of the family portraits mentioned in the inventory of Vermeer's wife after her death. This seems reasonable, given Vermeer's well-known predilection for using works he owned in his paintings. The stark manner in which the man in the portrait is dressed, as well as his pose, suggests a painting from the late 1620's or the early 1630's. Perhaps the simple dark clothing is meant as a contrast to, and thus a comment on, the dandified costumes affected by the men in this "merry company."

VERMEER
Woman with a Water Pitcher
c. 1662

Considering the mastery apparent here, it seems appropriate that Vermeer was elected head of the Delft artist's guild during the year in which he likely produced this work. Even so, despite its characteristic style and high artistic quality, this deceptively simple painting has not always been recognized as a work of the great Delft painter. Indeed, it was first exhibited in London in 1838 under the name of Gabriel Metsu. It was not until forty years later, after the Vermeer revival of the 1860's, that it was identified properly at the Royal Academy Winter Exhibition in London. Nevertheless, for some reason this correct identification did not stick, and in 1887 Henry G. Marquand purchased it from a Paris art dealer for only $800, and as a work of Pieter de Hooch. In 1888 Marquand presented it to the Metropolitan Museum, making it the first Vermeer to enter an American public collection.

Stylistically, this painting represents a critical point in Vermeer's mature artistic development. It can be dated to about the same time as the Brunswick *A Woman and Two Men*, and probably just after the Berlin *Man and Woman with a Wine Glass* of *c.* 1660–61. Indeed, it is the last of the "open window" pictures by the artist, sharing the same configuration of glass mullions found in both the Berlin and Brunswick works. Significantly, the tell-tale figure of Temperance found in the other two works is replaced here with a reflection of the sky.

Clearly in this radiant picture Vermeer has been more interested in capturing the quality of the light entering through the still partly open window and its reflection on the superbly rendered metal surface than in describing the exact physical action of the woman. Indeed, the model has been completely immobilized—perhaps due to the requisites of the *camera obscura*—by the window, the table, and the map. Secondary elements—such as the shadowed window wall and the chair—also help fix her tightly in space. Her movements, if that term can be used in relation to this static picture, are never clearly explained. Neither the magnificently rendered pitcher and basin, nor the jewel box containing a barely visible necklace with a blue ribbon, immediately suggest a unified action. Perhaps, however, there was some thematic or iconographic connection between this canvas and a now lost picture which was described in the 1696 Vermeer sale as representing "a gentleman washing his hands in a room." Both the act of washing and the utensils associated with this action, such as the pitcher and basin, have long associations with spiritual as well as physical purity. Several Dutch genre painters, Gerrit Dou for example, used these same objects with this precise meaning, and Vermeer may have intended these elements to carry the same moral association. This reading is supported by the woman's modest dress and the beautifully captured reflection of the sky in the window. In addition, she turns her back on the worldly map, which, unlike his works which function as warnings, fails to touch her.

Stylistically, this light-filled composition introduces what have been called Vermeer's "pearl pictures." Both the jewel box and the pearl necklace become significant motifs, although, together with the work as a whole, their meaning is not always clear to the modern viewer. The pearl pictures, however, earn their name not only from the presence of this jewel but also, as here, from the cool, luminous pearl-like tonality which dominates.

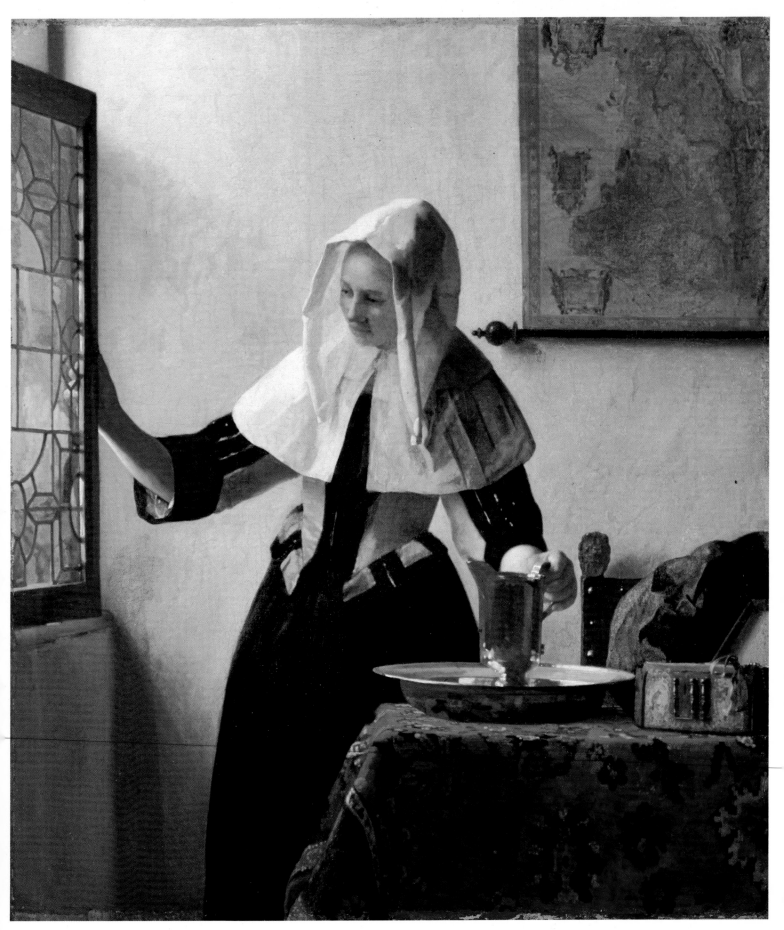

Canvas, 18 x 16⅛ inches (45.7 x 42 cm.) New York, The Metropolitan Museum of Art

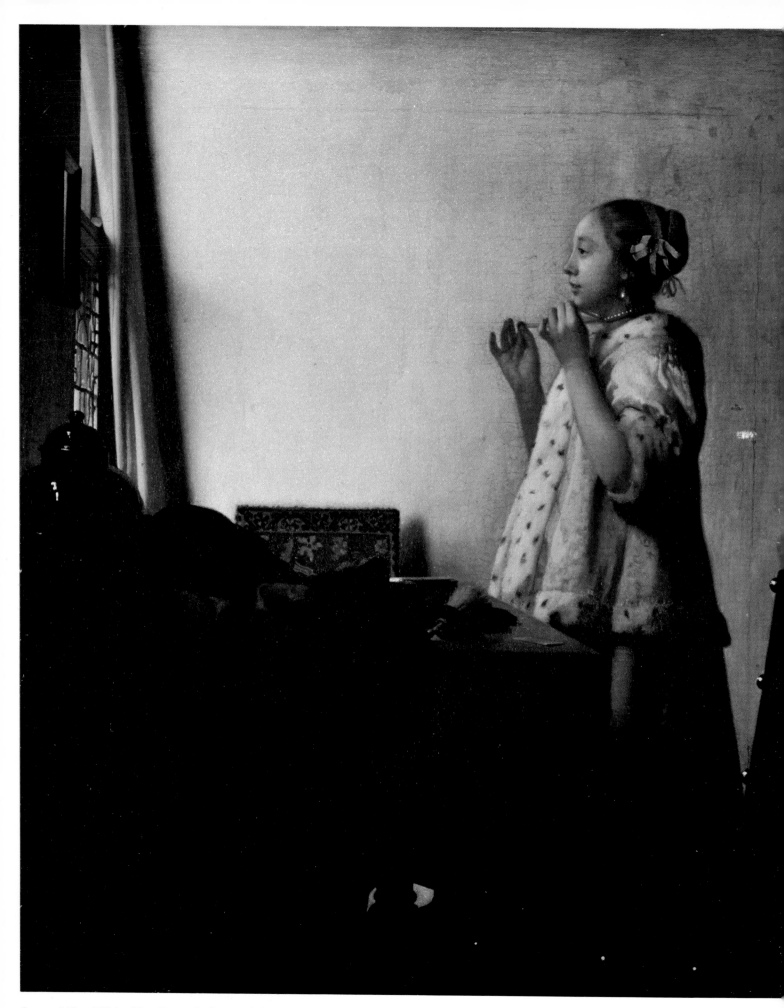

Canvas, 21½ x 17¾ in. (55 x 45 cm.) Berlin, Staatliche Museum Preussischer Kulturbesitz

VERMEER
The Pearl Necklace
c. 1662

This charming picture, which was once in the collection of Thoré-Bürger, was probably the one described at the 1696 sale as "a young woman adorning herself, very beautiful." In basic compositional structure it too can be related to the Dresden *Girl Reading a Letter*, with its profile positioning of the model and the use of various elements—such as the table—to define the spatial position of the young woman. Furthermore, the marvelously rendered light effects depend upon innovations found in the Metropolitan Museum's *Woman with a Water Pitcher*. Additionally, the pearl motif, both jewels and tonality, which first appeared in the Metropolitan Museum picture, and then in several subsequent Vermeer canvases, is here explored to its fullest. Optically and coloristically, this canvas is certainly one of the artist's most subtle and beautiful explorations of the physical world.

Typically for Vermeer, the action here takes place in one small corner of a room and against an unadorned, silvery grey-white wall. Although the action is incomplete—the woman is still pulling tight the ribbon around her neck in order to fasten the necklace—Vermeer has in no way stressed the ongoing motion, the progress in time, but has given us a perfectly balanced moment which seems to eternalize the act rather than capture it. Only the numerous small changes observable around the hands and fingers reveal traces of his struggle to achieve this end.

Despite its inclusion of several relatively obvious secondary elements, scholars have not always been willing to read traditional moralizing into this canvas. The pearl symbolism is often ambiguous, representing at various times either virtue or vice, depending on the context. In this case, Vermeer has focused on the act of physical adornment. Traditionally, however, all such acts which decorate and glorify the body, and which take place before a mirror, are associated with that all encompassing seventeenth-century theme: *vanitas*. The few secondary elements on the table appear to support this reading of the picture. The cosmetic box and powder brush suggest that cosmetics as well as jewelry are to be considered as worldly vanities and thus are part of this subtle warning against seduction by the physical delights of this world. (Additional support for such an interpretation is to be found in a picture of *A Young Woman Before a Mirror* by Vermeer's Leyden contemporary Frans van Mieris, now also in Berlin. Although clearly dependent upon this Vermeer composition, the less subtle van Mieris makes his meaning more obvious by draping the luxurious jacket over a foreground chair, thus adding it to the other elements of physical adornment.)

In addition, Vermeer's closely related *The Goldweigher* in Washington, one of the painter's more obvious symbolic compositions, includes both the mirror, in much the same position, and the pearls on the table. Since the Last Judgment painting on the wall in the Washington picture makes the negative implications of these secondary elements abundantly clear, the same associations would seem to hold true for this more reticent but beautifully couched warning.

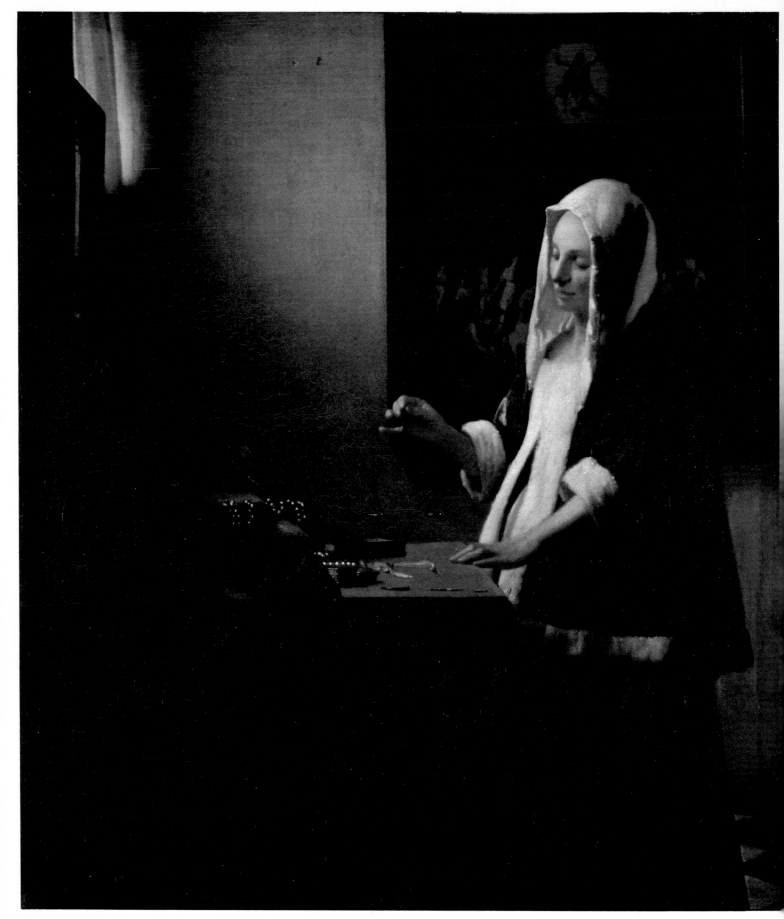

Canvas, 16½ x 14 in. (42 x 35.5 cm.) Washington, D.C., The National Gallery of Art

VERMEER
The Goldweigher

c. 1662–63

"A young woman weighing gold, in a small case . . . uncommonly well painted" was the way this canvas was described when it was auctioned in 1696. The judgment was supported by the sale price of 155 guilders; of the twenty-one Vermeers sold that day, only the *View of Delft* and *The Milk Maid* went for more. Indeed, the fact that it was listed as being in a small case rather than an ordinary frame suggests that either its owner—the Delft bookseller Jacob Dissius—or Vermeer himself especially valued this work. An earlier inventory of Dissius' collection indicated that three of Vermeer's works were treated in this manner, though we have no indication of which paintings the other two were or what the small cases were like. Otherwise there is no evidence that this picture, or any other Vermeer, was part of an optical construction or perspective box, as has sometimes been suggested.

Compositionally and technically, the various elements of this painting can be related most particularly to Vermeer's *The Pearl Necklace* in Berlin. The most important of these are the pearls and the small mirror hanging on the wall. Combined with a coolness of tonality, these elements make this one of the so-called pearl pictures. Additionally, like the *Woman Reading a Letter* in Amsterdam, the model here appears to be pregnant.

The subject of the goldweigher seems to have been a relatively popular one in Dutch art at about this time. Pieter de Hooch, for example, executed a marvelous painting of a goldweigher—obviously influenced by this Vermeer—in about 1664; it is now in Berlin. Significantly, de Hooch stresses the opulence of the room, with its rich, embossed gilt leather walls, an emphasis to be taken perhaps as a commentary on wordly goods. This theme was explored frequently by Dutch artists throughout the seventeenth century and before—pertinent perhaps in this prosperous middle-class society. Its text might have come from Matthew 6:19–20: "Lay not up for yourselves treasures upon earth, where moth and rust doth corrupt, and where thieves break through and steal: but lay up for yourselves treasures in heaven." And while de Hooch

underlines the "treasures," Vermeer, by including a sixteenth-century Northern painting of a Last Judgment framing the head of his goldweigher, warns the viewer that another sort of weighing awaits us all, the weighing of the soul at the final judgment. Indeed, the head of the woman seems to fill the space in the sixteenth-century composition where traditionally St. Michael would be seen going about precisely this activity.

Vermeer, although including the mirror, the gold, and the pearls, pulls the spectator beyond the more physical world of Pieter de Hooch toward the spiritual implications of all *vanitas* pictures. In this light one may wonder at the significance of the woman's apparent pregnancy. More prosaic interpretations of Vermeer merely note that Catherina Vermeer had at least 11 children, and perhaps more. Yet Vermeer was not casual about the incidentals in his pictures. Those among them which do not reflect the norm in seventeenth-century Dutch art may well have significance. In this case did Vermeer intend some comment on life and death? The question is raised not to turn Vermeer into a metaphysical philosopher but only to note that during the seventeenth century, when the realities of life and death were closer to both the individual and society than today, thinking in these terms was not uncommon. Thus, by rendering his model as pregnant, Vermeer may have been attempting to communicate something of this attitude.

On August 11, 1663, a French art collector, Balthazar de Monconys, visited Vermeer's studio in Delft. Not only was the artist not present, de Monconys complained, but there were no pictures to be seen. He was, however, taken to a nearby baker's shop where he was shown a painting of an interior with a single figure—perhaps even this one—which was valued at 300 guilders. De Monconys thought the price much too high. Nevertheless, it was not much out of line with that asked by other Dutch painters of the time. The popular Gerrit Dou, for example, offered de Monconys a picture for 300 guilders, while his Leyden compatriot, Frans van Mieris, demanded 600 for one of his. Vermeer clearly commanded a price comparable to that of the best-known painters of his day. De Monconys' story also adds credence to the belief that Vermeer painted relatively few works. In the years that he was head of the Delft artist's guild, Vermeer had not a single work available in his studio either to show or sell!

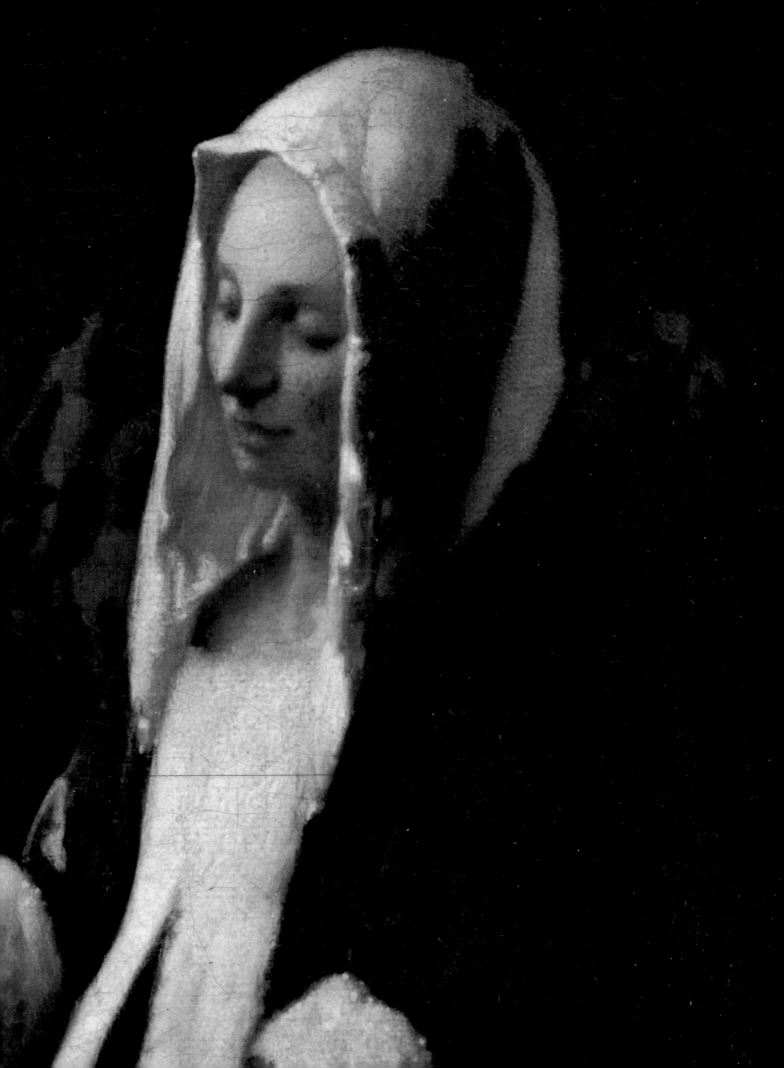

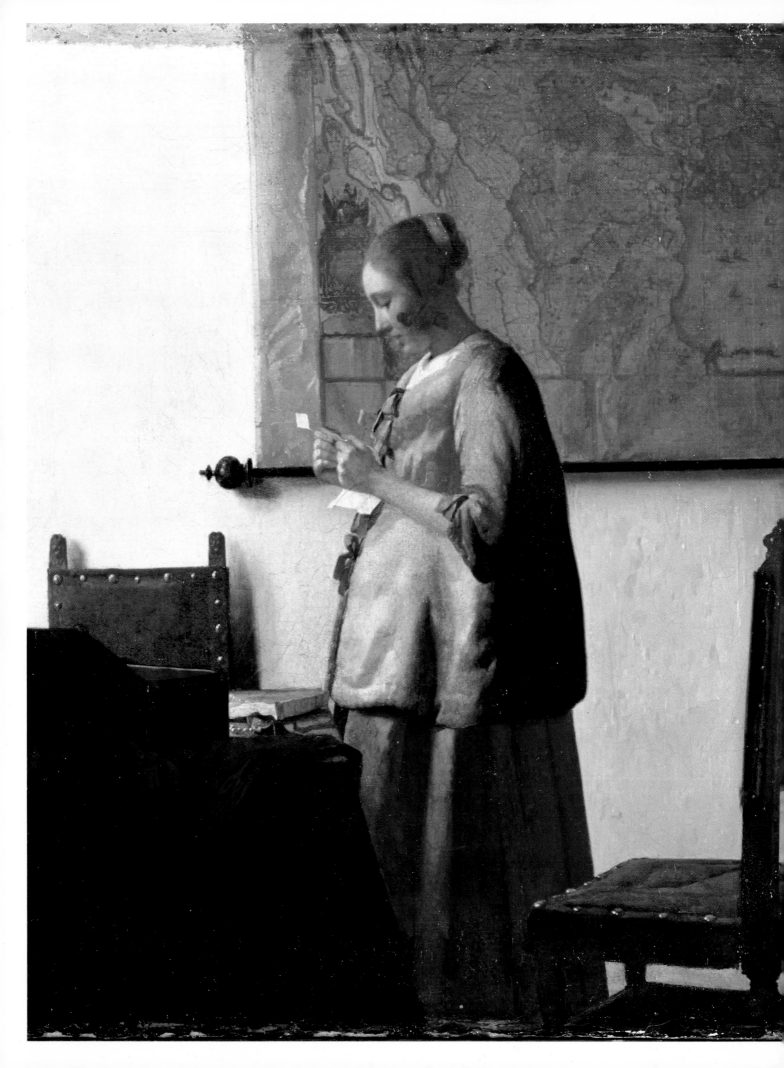

Canvas, 18¼ x 15⅛ in. (46.5 x 39 cm.)

Amsterdam, The Rijksmuseum

VERMEER
Woman Reading a Letter

c. 1662–64

The letter as focal point of a composition plays a greater role in Vermeer's art than in that of any other major artist of the seventeenth century. No less than six Vermeer pictures are involved with either reading, writing, or receiving letters. So great was the Dutch seventeenth-century interest in letters, and especially love letters, that one Leyden painter and writer, Philips Angel, went to great lengths to assert—in his 1642 book *In Praise of the Art of Painting*—that the Old Testament King David must have sent a love letter to Bathsheba! Not long afterwards, Rembrandt, in his thoughtful 1654 *Bathsheba*, depicted the beautiful woman reading David's letter with great concentration and emotion. Popular seventeenth-century emblem books, like those by Otto van Veen, often used letters as symbolic devices. Thus, works like the present one and Vermeer's earlier, closely related *Girl Reading a Letter* in Dresden, deal with letters—and most likely love letters. The worldly subject is emphasized here by the compositional device of placing the map so that it frames the head and hands of the woman.

Other compositional aspects may be linked with various innovations developed by Vermeer during the early 1660's. Both the Berlin *The Pearl Necklace* and the New York *Woman with a Water Pitcher* can be seen as contributing to the creation of this canvas. In addition, the presence of pearls on the table, as well as the cool tonality, links it with the other so-called pearl pictures. There appears, of course, a significant change in this painting, at least in terms of Vermeer's previous work. For the first time in his mature development, neither a window nor a window wall is included in the composition, which results in an even greater sense of classic control than usual. Though the marvelous light effects here seem to develop out of the *Woman with a Water Pitcher*, it is clear that Vermeer felt confident enough in rendering them to omit the source and depict only the light itself filtering into the room from a now unseen window.

Vincent van Gogh, who saw this picture shortly after it entered the Rijksmuseum in 1885, wrote about it to his friend the artist-writer Emile Bernard: "Do you know a painter called Jan van der Meer? He has painted a dignified and beautiful Dutch woman, who is pregnant. The palette of this strange artist comprises blue, lemon-yellow, pearl-grey, black and white . . . The Dutch had no imagination, but they had extraordinary taste and an infallible feeling for composition."

The fact that the woman here, as van Gogh noted, is apparently pregnant has prompted several scholars to suggest, as with *The Gold-weigher*, that it represents Vermeer's wife Catherina. Although pregnancy was a frequent condition for Catherina Bolnes Vermeer, it seems quite clear, whoever the model may have been, that no personal or family association was intended in this painting.

VERMEER
Girl Playing a Lute

c. 1662–65

The extremely poor condition of this painting has led some scholars to question its authenticity. However, since its public history can be traced to at least the year 1817, before the Vermeer revival led by Thoré-Bürger, and since it bears faint traces of a signature, there is no serious reason to remove this picture from the artist's list of authentic works. Indeed, compositionally it can be related to several other Vermeer pictures, as, for example, the Berlin *The Pearl Necklace* and the Washington *Woman Writing a Letter*. Additionally, the girl wears the same yellow, ermine-trimmed jacket found in several other authentic works, not to mention the pearl earrings and necklace. Even the same pattern of window mullions is found here as in a number of other unquestionable works of about the same time.

The recent identification of the map hanging on the wall supports the authenticity of this picture further. The map, inscribed EUROPAE, can be identified with one which first appeared about 1613 under the name of the famous Dutch cartographer Jodocus Hondius. A second version of this important map was again published in 1659 by another famous mapmaker in Holland, Joan Blaeu. Thus Vermeer could have used either for this composition since they are, except for the changes in the publisher's name in the cartouche, exactly the same. Here then, as in other paintings by the master, a real map serves as a symbol of the worldly qualities of the activity depicted.

In both subject matter and the extreme reticence of the model this canvas recalls the work of the most sensitive and subtle of the Utrecht followers of Caravaggio, Hendrick Terbrugghen. Terbrugghen, along with his Utrecht colleagues Baburen and Honthorst, developed and popularized the single-figured musical composition in Dutch art. As an art dealer as well as an artist with an active interest in "caravaggism," Vermeer would certainly have known paintings of this type; and there is even some evidence that his mother-in-law had owned two such musical pictures.

Despite the relationship of this work to earlier Utrecht types, the subject apparently derives its meaning from the writings of Jacob Cats. Indeed, Cats' 1618 book of moral and love emblems was one of the most popular works in seventeenth-century Holland. The condition of the present picture has made the viola da gamba on the floor difficult to see clearly, and, therefore, its close relationship to one of Cats' emblems has been overlooked. In addition, it is evident that the girl is tuning rather than actually playing the lute as the usual title implies. Thus, although Vermeer has depicted a woman rather than a man, the exact situation shown in the Cats emblem has been re-created in this work. Presumably, therefore, the same meaning also pertains. Cats' poem, under the motto "Who is insensible to Love?" reads: "Behold the wond'rous sympathy between/ The strings of yonder lute, and this I play!/ Is it not just as though some hand unseen/ Swept the same chords, and tun'd the self-same lay?/ So lov'd one—though untouch'd by thee, I feel,/ Sense of thy touch through all my being steal."

This theme of Cats and Vermeer is not totally new in the North. Lucas van Leyden, for example, early in the sixteenth century, engraved an old married couple making music on stringed instruments as a symbol of marital harmony. Actually van Leyden, like Vermeer, also used the concept of masculine and feminine instruments, and the same idea was taken up by the elegant Amsterdam genre painter Willem Duyster, who included a viola da gamba in his c. 1630 rendering of a man tuning a lute as a well-dressed young lady waits nearby. Vermeer's composition can thus be seen as a Delftian updating of a traditional symbolic and moral theme in the art of northern Europe.

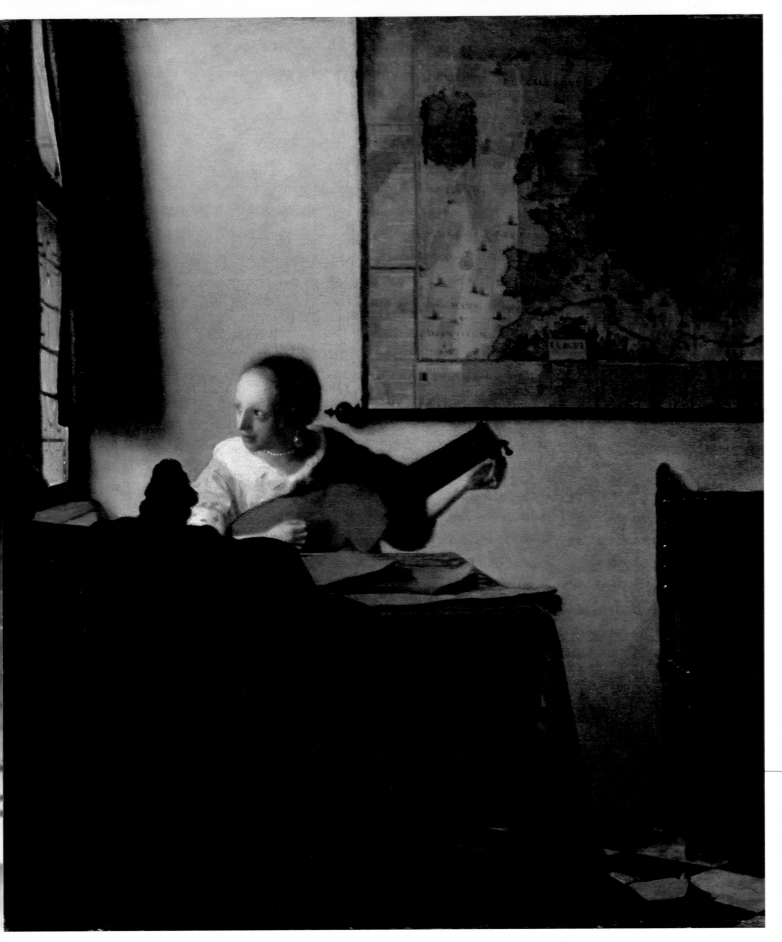

Canvas, 20½ x 18 in. (52 x 46 cm.) New York, The Metropolitan Museum of Art

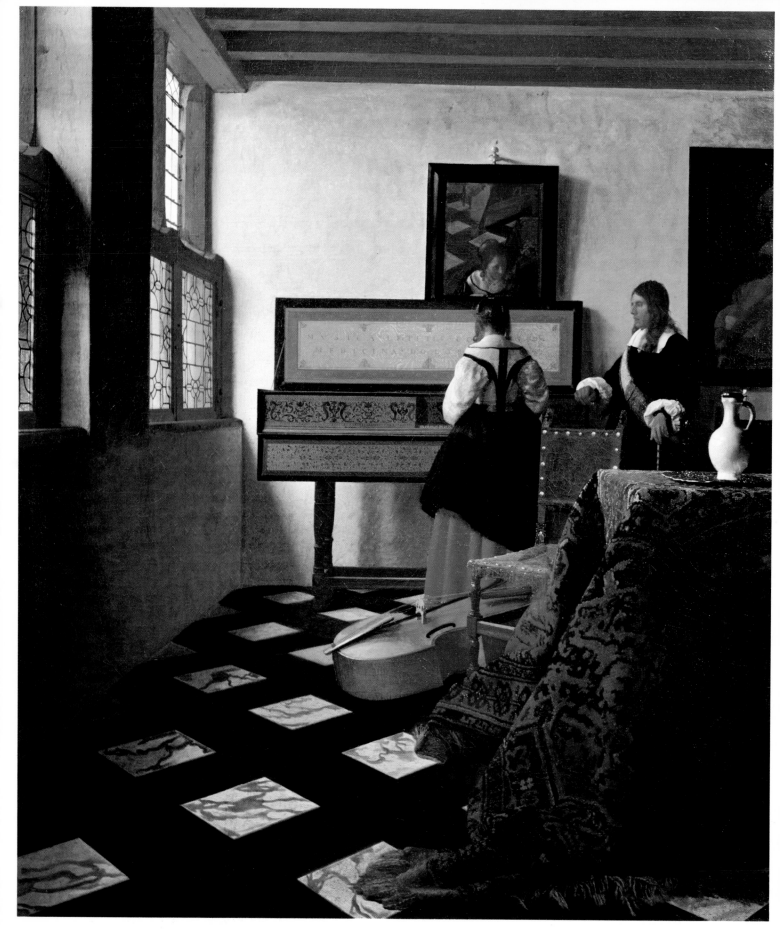

Canvas, 29 x 25¼ in. (73.6 x 64.1 cm.) London, Buckingham Palace

VERMEER

Lady and Gentleman
at the Virginals

c. 1664

The unusually subtle nature of this composition and the original and provocative handling of the theme may account for the interesting and varied provenance of this picture. It was also almost certainly number 6 in the 1696 sale of the Dissius collection, where it was described as "a young woman playing a virginal in a room with a man listening to her." Later the picture became the property of Joseph Smith, British Consul in Venice from 1740 to 1770 and a famous art collector who owned, among other things, more than fifty of the most important paintings by Canaletto.

Clearly, then, there is some specific and special relevance of taste involved here since both the Delft seventeenth-century artist and the Venetian eighteenth-century painter Canaletto utilized the *camera obscura* in their work. Indeed, the French critic Maxime du Camp, writing in 1857, referred to Vermeer's *View of Delft* as "an exaggerated Canaletto." It is presumed, since Smith acquired this work from the widow of the painter Giovanni Antonio Pellegrini, that Pellegrini must have bought the picture during his 1718 visit to

The Hague. Nevertheless, despite this impressive provenance and the fact that the canvas is signed, after Smith sold part of his collection to King George II, this work was catalogued in the royal collection as a Frans van Mieris, perhaps through either a misreading or a misunderstanding of Meer for Mieris. It was not returned to the Delft master until the Vermeer revival of the 1860's.

Stylistically and compositionally this picture, and a related one in Boston, can be seen as developing out of the spatial innovations found in the Berlin *Man and Woman with a Wine Glass* and the Brunswick *A Woman and Two Men*. Indeed, it shares with these two earlier works the same pattern of window mullions, although it excludes the significant Temperance figure. Spatially, by pushing the figures even further into the background than usual, Vermeer stresses here the volumetric qualities. Their remote positions and static poses allow for little speculation on their relationship, for they are animated neither by expression nor gesture. The face of the woman, who has her back to us, is only partially revealed through its reflection in the tilted mirror over the keyboard instrument. The viola da gamba—which also appears in a number of other Vermeer pictures—is rendered as eloquently and carefully as the two immobilized figures.

If Vermeer used the *camera obscura* for this picture, as has been suggested, clearly he must have shifted it backwards and forwards

as needed. This is partially confirmed by the apparent presence of the base of the artist's easel reflected (top left) in the tilted mirror. Perhaps the box also reflected behind this easel base is in some way connected with the *camera obscura*. If this is truly a reflection of how Vermeer worked, then he must have painted the figures from up close—the way he situated his allegorical artist in the Vienna *Allegory on the Art of Painting*—and then moved back to render, perhaps through several stages, the remainder of the composition. Additional support for this section-by-section procedure is to be found in the unfinished *A Woman Brought a Letter by a Maid* in the Frick Collection.

Despite his unique manner of working, Vermeer most certainly partakes of what might be termed the Delft style that began to develop during the late 1650's. Works like this one can, for example, be compared with the interior scenes of Pieter de Hooch, even though the artist had left Delft by the time Vermeer painted this work. In addition, Emanuel de Witte's *Interior with a Woman Playing the Virginals* (c. 1664–65) in Rotterdam can be seen as iconographically as well as stylistically dependent on both this Vermeer and the works of de Hooch.

Inscribed on the virginal—probably an instrument built in Antwerp by Andries Ruckers the Elder—is a Latin motto which translates as: "Music is the companion of joy, the medicine of grief." Although the same inscription

also appears on two surviving instruments by Ruckers, it is apparent that it was specifically selected by Vermeer to assist the viewer in understanding the meaning of this strangely silent musical scene. Hanging on the wall behind the man is a painting frustratingly cut by the edge of the canvas. Ever the "sphinx of Delft" Vermeer gives us just enough of this composition (as with the cut Cupid picture in the Metropolitan Museum's *Sleeping Girl*) for us to identify its subject but not its author. Even without the assistance of the inventory of Vermeer's mother-in-law in Delft, where a picture on this theme was listed, it is possible to determine that it represents a famous story from Valerius Maximus known as *The Roman Charity*. This strange tale, favored in the seventeenth century by the Utrecht followers of Caravaggio, was used by the classical author to show the superiority of painting over the other arts as a moral force. Clearly, Vermeer's inclusion of this picture is meant as an indication of the positive role played by the arts. Since the theme of *The Roman Charity* was specifically used to foster the concept of filial piety, and this picture indicates the healing role played by music in overcoming melancholy, the moral power of the arts is certainly indicated. The rather obvious placement of the viola da gamba may be taken, at least in this particular case, as an attribute of harmony in the spiritual as well as the musical sense.

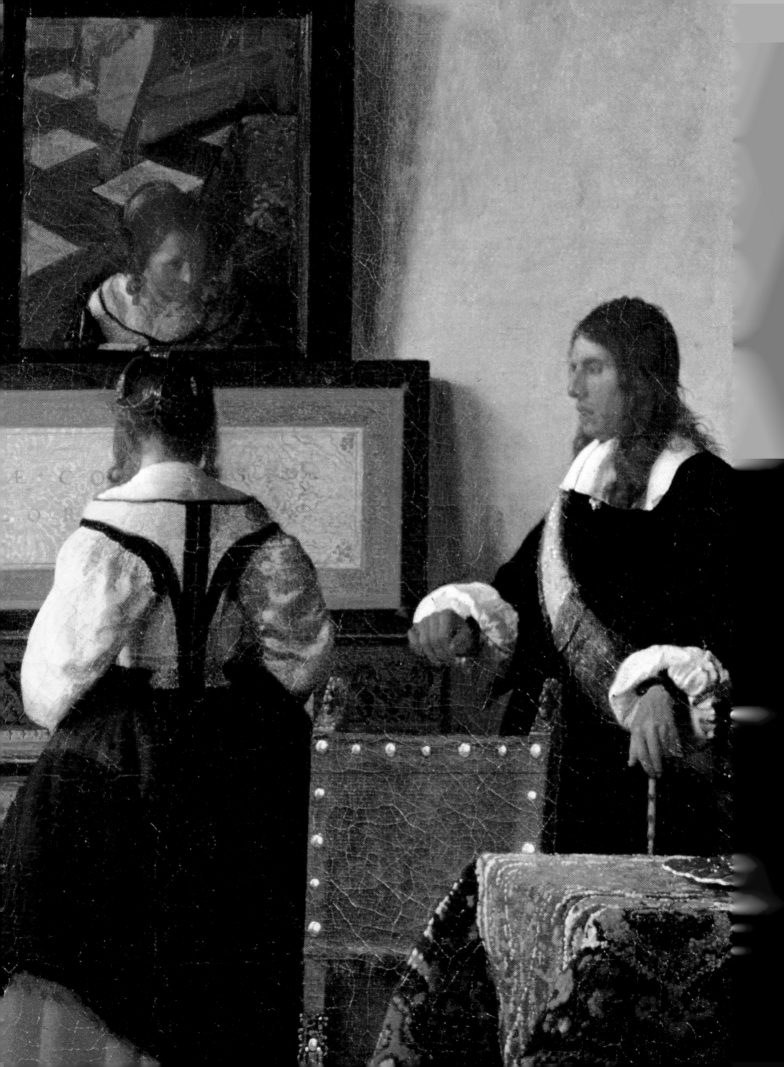

VERMEER
The Concert
c. 1664

Although this work is often considered to be a counterpart to the Buckingham Palace *Lady and Gentleman at the Virginals*, and the subject matter and composition of the canvases clearly complement one another, there is nothing in the past history of either work to indicate they were ever together as pendants. The Buckingham Palace picture, for example, figured in the important 1696 sale in Amsterdam and has an entirely different history from the present work. This canvas was first cited in 1780, and later was in the collection of the man who wrote the first important articles on Vermeer, Thoré-Bürger.

For only the second time in his mature career Vermeer includes three figures in a composition. Here, however, unlike the Brunswick *A Woman and Two Men*, all three are involved in one unified activity—making music. Despite this obvious social relationship, the mood of the picture, like most of Vermeer's work, is strangely quiet and the composition unusually reticent. Prominently placed in the foreground, as in the Buckingham Palace canvas, is a viola da gamba; while another stringed instrument, along with some music, is carefully placed on the table.

Aside from the activity of the individuals and the instruments directly portrayed, music is also featured in the figural composition hanging on the wall. Like the *Roman Charity* picture in the Buckingham Palace composition, this *Procuress* scene also appears in the inventory of Vermeer's mother-in-law, and can be further identified as a signed work, dated 1622, by the Utrecht artist Dirck van Baburen, now in the Museum of Fine Arts, Boston. Indeed, this boisterous caravaggesque composition is clearly one of the formal sources of Vermeer's own early *Procuress* picture in Dresden. Now, however, the mood is rather more staid than both Baburen's and his own earlier composition, although clearly the original cast of characters is continued, as also is the actual arrangement: a central male and two flanking females. The inclusion of the Baburen, which Vermeer used again in a later musical composition, is certainly meant as a guide to understanding the subject matter.

If the Buckingham Palace *Lady and Gentleman at the Virginals* represents the harmonious, positive attributes of music, then it is clear that this canvas depicts the other side of the coin: music as the symbol of venal love. Indeed, given the arrangement of figures, and the Baburen on the wall, one wonders if Vermeer did not have the same theme of the contemporary prodigal son in mind here that he appeared to have had in his earlier Dresden *Procuress*.

Since the sixteenth century, Northern artists had used half-length, three-figured compositions—like those still used by Baburen and other Utrecht followers of Caravaggio in the early part of the seventeenth century—for pictures with moralizing messages. Certainly Vermeer's activities as an art dealer would have made him particularly aware of these earlier tendencies. Thus, in this work, he seems to be providing us with a seventeenth-century updating of the earlier theme, now cast completely in the new Delft compositional mold. The significance of his treatment would not have been lost on Vermeer's Dutch contemporaries, who were used to multi-leveled symbolic representations. In this connection, Jacob Cats, the most popular of Vermeer's literary contemporaries, often published emblems with three distinct levels of meaning. By comparison, Vermeer's meaning—especially with the Baburen present—must have been relatively obvious to his Dutch compatriots.

66

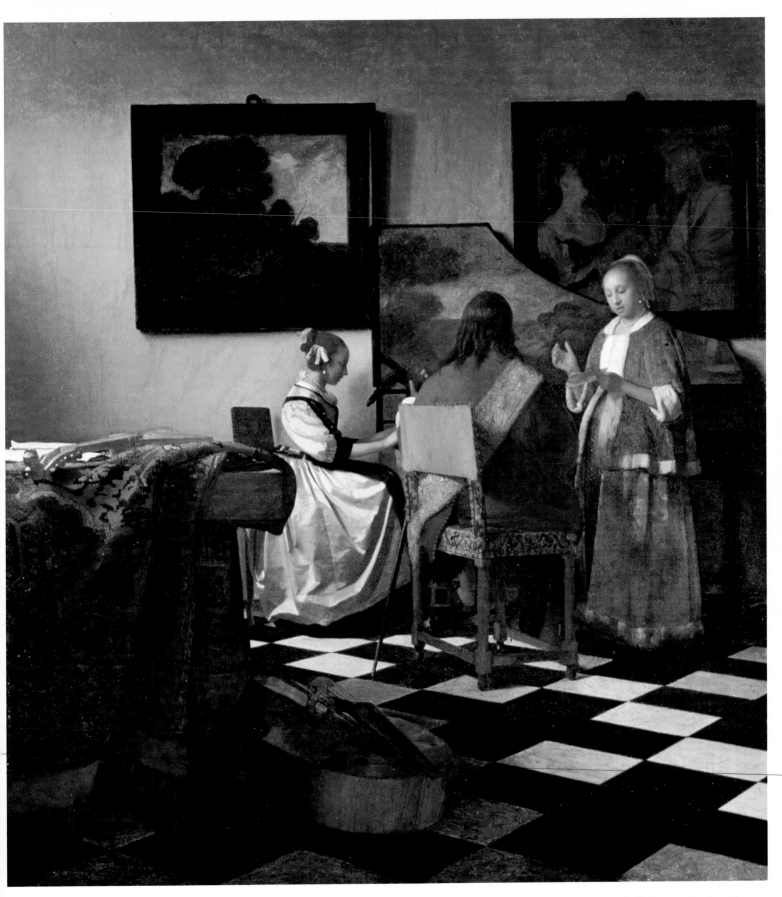

Canvas, 27¼ x 24¾ in. (69 x 63 cm.) Boston, Isabella Stewart Gardner Museum

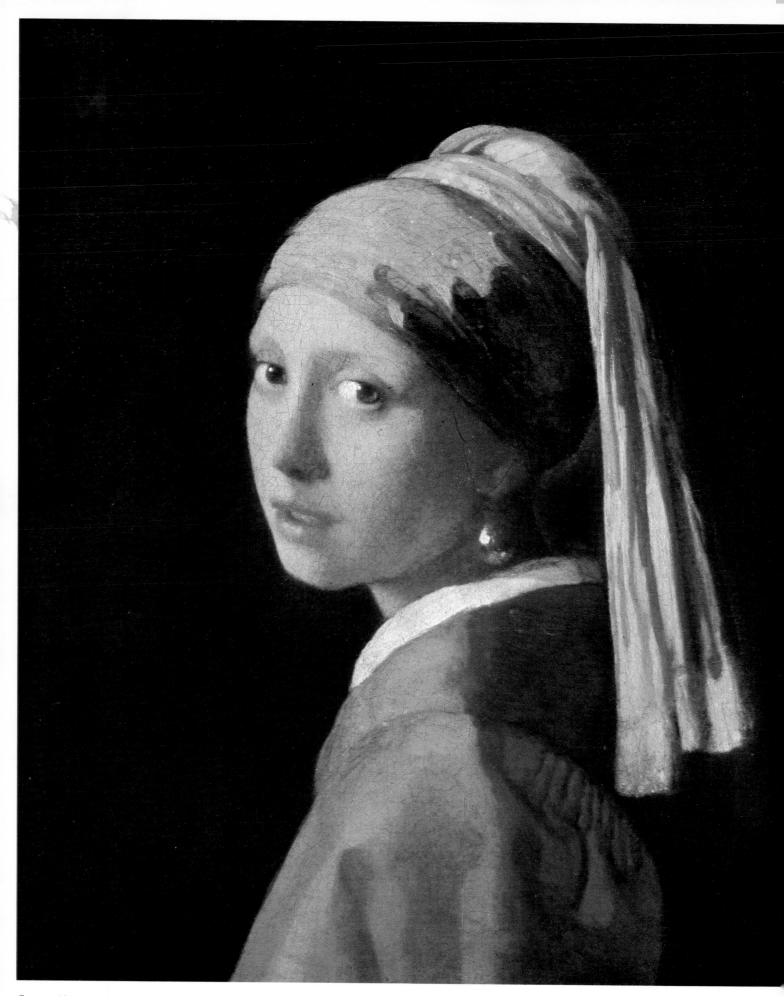

Canvas, 18¼ x 15¾ in. (45 x 40 cm.) *The Hague, Mauritshuis*

VERMEER
Head of a Girl
with a Turban

c. 1664

Two seventeenth-century references, one even during Vermeer's lifetime, have been linked with this simple but subtle painting. The earliest, however, from 1664, mentions only "a head by Vermeer," a description vague enough to fit four known pictures. The work which was described simply as "a head in antique costume" in the important Vermeer sale of 1696—and which brought 36 guilders—could only refer to two known works, especially given the relatively high price for a quite simple composition: this canvas and a similar one formerly in the Wrightsman collection and now in The Metropolitan Museum of Art, New York. The two tiny panels in the National Gallery, Washington, while also fitting the description, are much too small to have brought so high a price. Besides, they can be better identified with a pair of pictures sold in the same auction. The great reputation of this charming picture has certainly been enhanced by the immediate yet enigmatic quality of the expression Vermeer has managed to capture.

Unlike most of the other paintings by the Delft master, the subject here is only a simple head of a girl looking over her shoulder at the viewer. No hint of a setting is provided, other than its atmospherically dark tone. This too is unusual for the mature Vermeer. Only the turban-like headdress suggests that the artist had something other than a contemporary subject in mind, for even the large pearl earring appears in other Vermeer pictures with more contemporary setting and significance. The unusually direct contact between sitter and spectator, and the slightly parted position of the lips, presents a sense of immediacy so great as to imply strongly some specific act or identity—such as a sybil uttering her prophecy or some biblical personage. Nevertheless, it should be recalled that Vermeer's older contemporary, Rembrandt, painted single figures and heads in exotic costume all during his life, and that similar small heads with unusual headgear by Carel Fabritius indicate that he may have carried this tradition to Delft. The activities of the Dutch East India Company may also lurk somehow behind this picture as they do behind another Delft product: that marvelous and world-renowned blue-and-white pottery.

X-rays of this canvas have provided surprising information about Vermeer's working methods. In most seventeenth-century pictures the underpainting reveals adjustments and corrections of edges, shapes, and forms. Here, however, rather than the tentative building up of elements, we find a sharp pattern of light and dark, without evidence of a search for the artistic means necessary to give the work its manifestly perfect surface. This is all the more extraordinary since there is no sign of either line or drawing to guide the master to this perfection. Such an unusual—even astounding—procedure may once more provide evidence in support of Vermeer's use of the *camera obscura*. Indeed, one modern critic has suggested that the sharply contrasting patterns of light and dark may be Vermeer's direct transcription of the incidence of light as viewed through his *camera obscura*. If this is so, it would begin to account for the almost photographic directness apparent in this unusually naturalistic work.

69

VERMEER
Woman Writing
a Letter

c. 1665–66

Throughout his career Vermeer returned to the compositional pattern and iconographic theme of his Dresden *Girl Reading a Letter*. At least six pictures focus on actions involving letters—reading, writing, or receiving them —and it is possible that a seventh, the Frick *Girl Interrupted at Her Music*, may also involve a letter, although the physical condition of the canvas makes it impossible to be certain. Thus, while it is probable that this painting was the one described in the 1696 Vermeer sale as "a Young Woman writing, very good (selling for 63 guilders)," we cannot be completely certain. A number of Vermeer's contemporaries also executed pictures of single figures, both male and female, writing letters. Gerard Terborch's *Girl Writing a Letter* (c. 1655) in the Mauritshuis is of particular interest since we know that they met in 1653.

That the letters found in seventeenth-century Dutch genre paintings are concerned with love is supported, first, by a large body of popular enblematic literature. Then we find a proliferation of books, European and often Dutch, on the art of writing letters, including especially love letters. In addition, the popular book of love emblems written and illustrated by Otto van Veen contained, under the heading "Love is revyved by letters," the following caption to an illustration of Cupid reading a letter delivered by a man dressed as a pilgrim of love:

When love impatient growes through absence and delay,
And with his love to bee no remdie can fynd,
Love letters come to him and tell his lovers mynd,
Whereby his joy is kept from dying and decay.

Similar ideas appear in Jan Harmensz Krul's 1644 *Paper World*, which illustrates, under the heading "Love Letter" a woman, very much like Vermeer's, writing a letter.

Given the popular understanding of Vermeer's letter as specifically a love letter, other elements of the composition, although not firm symbols in their own right, can be taken as having supporting meaning. For example, the painting hanging on the wall is a still life with musical instruments; perhaps it is the same one which appeared in the inventory of Vermeer's widow as "a (painting) with a viola da gamba with a deathshead." Paintings of this sort were a specialty of seventeenth-century Holland and warned of the transience of human existence and the temptations of this world. Clearly then, Vermeer intended this picture to help provide another level of meaning in his painting; the rich dress of the woman, the pearls and jewel box, and even the luxurious writing set make it clear that the theme is worldly love and vanity. As it happens, the same rich trappings appear in the Frick *A Woman Brought a Letter by a Maid*, and the yellow ermine-trimmed jacket, which earlier appeared in the Berlin *The Pearl Necklace*, is later to be seen in another letter picture, the Amsterdam *The Love Letter*. The tight linking of these specific physical elements with the letter-writing theme indicates that for Vermeer, as well as for his contemporaries, the letters in these paintings meant profane love and worldly concerns.

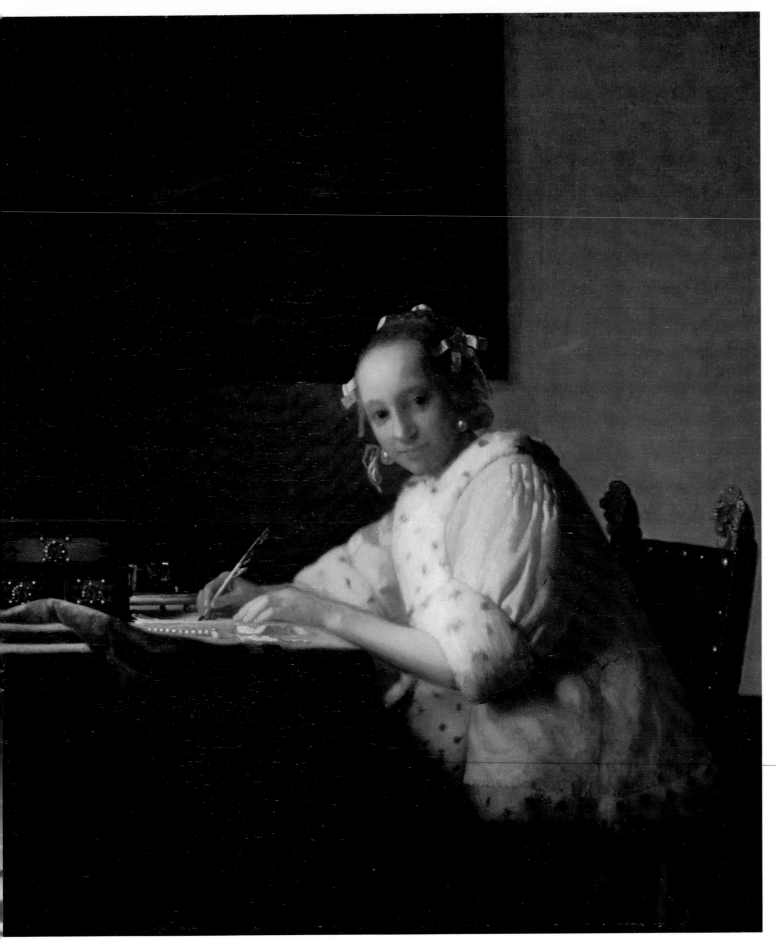

Canvas, 18½ x 14½ in. (47 x 36.8 cm.) Washington, D.C., The National Gallery of Art

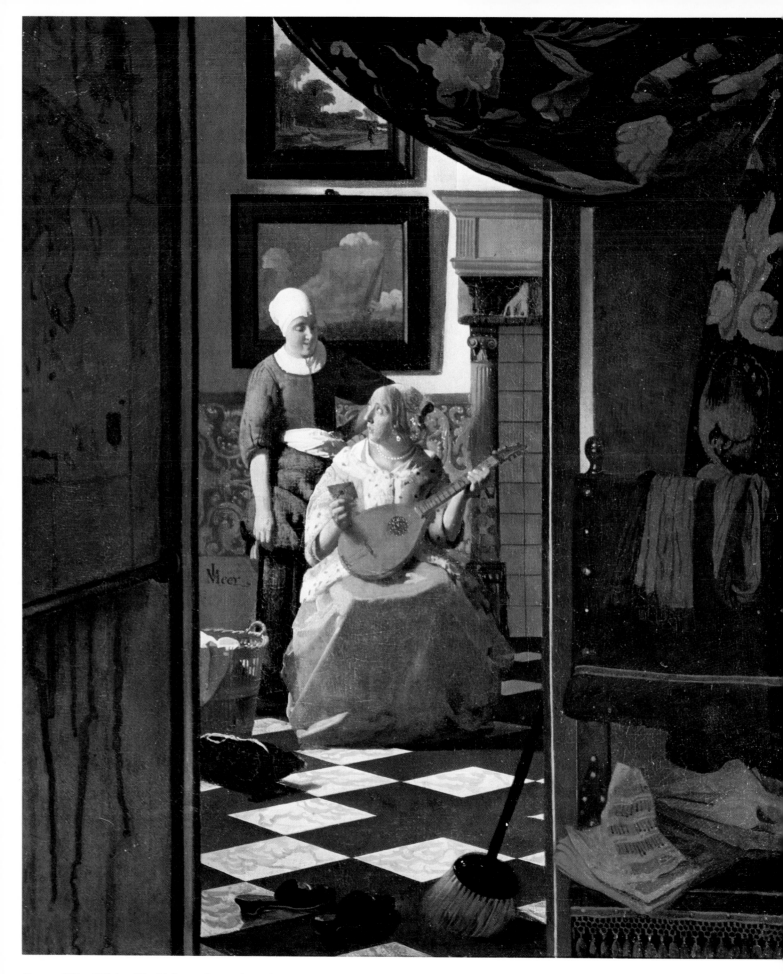

Canvas, 17¼ x 15¼ in. (44 x 38.5 cm.) Amsterdam, The Rijksmuseum

VERMEER
The Love Letter

c. 1666–67

Although the Frick *A Woman Brought a Letter by a Maid* also fits the description of number 7 in the 1696 Vermeer sale—"a young woman with her maid with a letter"—the unfinished state of the Frick work leaves this canvas a better candidate for identification as that item. Letters, as we have seen, were an important subject for Dutch art, and earlier in the seventeenth century painters such as Dirck Hals, brother of the famous Haarlem portrait painter, and Pieter Codde both executed works in which letters, and in particular love letters, play a central role. Similar secondary elements, the painting of the seascape, the empty chair, and, of course, the letter itself, appear in two Dirck Hals pictures from the 1630's.

Even closer to the Vermeer in time, style, and subject is Gabriel Metsu's *Woman Reading a Letter*. It has in fact long been recognized that the present Vermeer is the source of Metsu's inspiration. Unfortunately, neither the Vermeer nor the Metsu is securely dated, although the latter was completed by 1667, the year of Metsu's death. These two paint-

ings also remind us that homely and everyday elements—such as the sewing basket, the slippers, the empty chair, and the seascape painting which appear in both works—were relatively defined symbols for seventeenth-century viewers, and their meanings often had to do with love. Popular sayings, poems, plays, and emblem books clearly contributed to this situation.

Although Jan Harmensz Krul's 1640 book of love emblems did not originate the concept of a ship on the seas as a love symbol, it does appear to have popularized it. The poem beneath Krul's illustration of Cupid at the helm of a boat, with the lover standing on the prow, sailing towards a young woman on the distant shore, informs the reader: "Love is like the sea, a lover like a ship." Clearly the seascape in this work functions in just such a way. Nevertheless, to re-enforce the love theme Vermeer, unlike most other seventeenth-century Dutch artists, places a lute-like instrument in the woman's lap. The association between music and love is an old one, documented by numerous Dutch pictures, including several by Vermeer himself.

It is also significant that two earlier artists, both often discussed in relation to Vermeer's early development, Hendrick van den Burch and Samuel van Hoogstraten, executed extremely odd pictures which include elements similar to the present ones, but without any figures! Hoogstraten's Louvre composition,

known as *The Slippers*, is apparently the source of Vermeer's device of viewing the figures through a vestibule and framing doorway. Since both earlier artists focus only on the chair, broom, and slippers, these elements were obvious enough symbols to function independently of figures. Today we can only point to numerous Dutch seventeenth-century and earlier folk sayings, which utilize the shoe as an erotic symbol. Doors and threshholds also carry, then as now, similar levels of meaning sufficient during the seventeenth century to tell the entire story without human actors. Most Dutch painters, like Jan Steen in his 1663 *Morning Toilet* in Buckingham Palace and Vermeer in this painting, preferred to use these symbolic elements as compositional devices which underscore the human activities. Vermeer's solution must have pleased both his public and his artist contemporaries, for the exact structural format of this work was taken over by Pieter de Hooch only a few years later; the activities were different but related.

Some of the elements in this striking composition appear elsewhere in Vermeer's works, while others show up in the inventory of possessions made shortly after his death. The ermine-trimmed yellow jacket, for example, appears in a number of pictures beginning with the Berlin *The Pearl Necklace*. Interestingly enough, two other letter pictures utilize not only the same jacket but also the pearls, indicating that, at least in Vermeer's mind, these elements in combination had worldly connotations. The seascape, although not specifically identified, shows close stylistic affinities with Jacob van Ruisdael, and is very likely one of the two pictures of this type owned by Vermeer and listed in his inventory. The marvelously rendered embossed gilt leather behind the two women also appears in the same inventory of February 1676—"seven ells of gold leather on the wall"—as well as in the Metropolitan Museum's *Allegory of Faith*. Thus, Vermeer continued to utilize actual paintings as well as other properties that he owned to enhance his works.

Earlier historians of Vermeer have made much of the unusual compositional arrangement of this work and have offered complex theories as to how and why the artist arrived at it. Several critics have even suggested that mirrors were used to achieve the desired effect. Since Hoogstraten had used a similar structure earlier, it is clear that neither mirrors nor Vermeer's use of the *camera obscura* account for the work's structure, although the latter device certainly enhanced its remarkably candid visual effects. Content rather than form, however, seems to have been Vermeer's interest in adapting this unusual but not unique compositional device to his own ends.

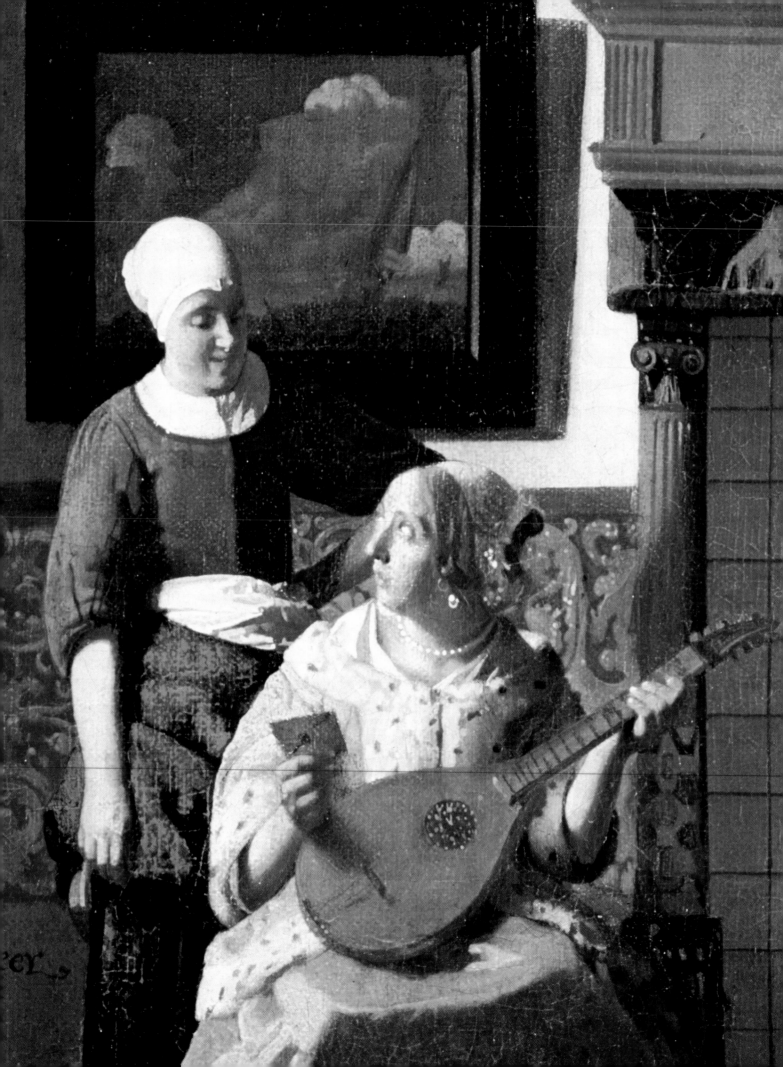

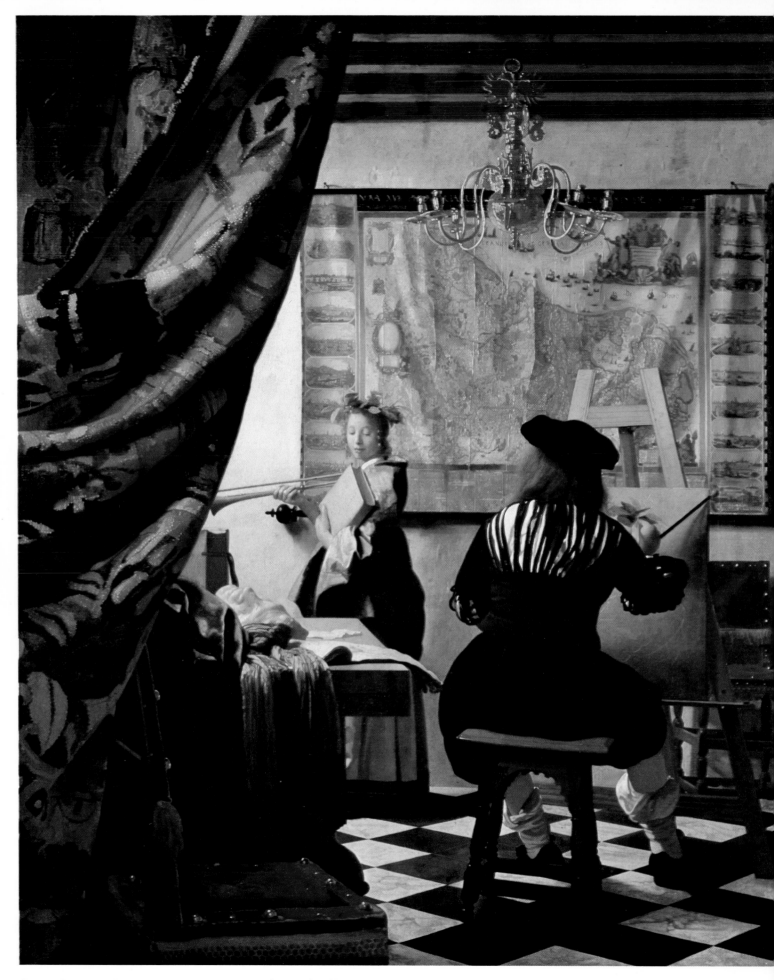

Canvas, 51¼ x 43¼ in. (130 x 110 cm.) Vienna, Kunsthistorisches Museum

VERMEER

Allegory on the Art of Painting

c. 1666–67

The history of this large allegorical painting is nearly as complex as the subject portrayed. Given Vermeer's small output, it must be considered significant that this picture was still in the artist's possession at the time of his death in 1675. Early in 1676 it was transferred by his widow to her mother as security for a 1,000-guilder loan that had been made to the artist in 1675. At that time the canvas was referred to as "the art of painting," and there is no reason to doubt this identification. The work was later sold at public auction in the chambers of the Delft artist's guild on March 15, 1677. Thus it is most unlikely that this picture was the same one sold at the 1696 Dissius sale as "the Portrait of Vermeer with various accessories, uncommonly well painted." Since this now lost work brought only 45 guilders, one would assume that it was a much smaller painting, possibly containing only one figure.

This complex composition is one of the two allegorical-literary works by the artist which have come down to us, and it would seem, given Vermeer's working methods, that it was the genre he was least suited to. Official art theory and criticism of the seventeenth century, and earlier, tended to see realism as an inappropriate means of rendering literary and allegorical subject matter. Yet Vermeer and numerous other Dutch artists of the period clearly showed the fallacy of this academic point of view. It is even possible that with this picture Vermeer was offering a subtle challenge to the growing classicism in Holland at just this moment. (Nevertheless, it must be remembered that numerous other seventeenth-century Dutch artists also produced studio scenes with various levels of symbolic and allegorical meaning.)

Although it embodies certain of Vermeer's ideas about the art of painting, this canvas hardly represents either the artist himself or his working methods. For one thing, the costume the painter wears here is distinctly old-fashioned and what might be termed "Burgundian." Vermeer actually seems to go to great lengths to stress this out-of-date character throughout his composition. The large map, for example, made by the famous Dutch mapmaker Nicolaes Visscher, is old enough to show the seventeen Northern and Southern provinces (essentially Belgium and Holland) as one united country. In addition, it has even been suggested that the method of working on the painting within the painting

is what might have been termed—had the phrase existed then—"old master-like." One might also note that the entire composition, while clearly related to Vermeer's spatial development of the middle 1660's, is archaistic to the extent that it is constructed like some secular version of St. Luke painting the Virgin.

It is obvious that Vermeer made use of several of the popular iconographic handbooks of his day in putting together this complex allegory. For example, the standing female figure the artist is painting can be identified as Clio, the Muse of History. She is rendered precisely as described by Cesare Ripa in one of the most popular books on artistic subject matter ever written, the *Iconologia*. The Dutch translation of this important Italian work, by Dirck Pietersz Pers, first appeared in 1644, and Vermeer, if he did not own a copy, must have known the book well. Both his allegories, this one and the *Allegory of Faith* in the Metropolitan Museum of Art, draw their basic symbolic inspiration, as well as specific details, from this widely used book. In it Ripa describes Clio as "a maiden with a laurel garland, who holds a trumpet in her right hand and with the left a book." Other elements, such as the composition of the still-life grouping on the table behind the seated painter, also appear to be dependent upon Ripa. Both the sculptured mask and the brushes are symbols of "imitation," and appear in this context in a 1661 rendering of Pictura—the personification

of painting—by Frans van Mieris. Van Mieris' allegorical figure carries as her attribute the tools of imitation: a palette and brushes, a mask, and a piece of sculpture. Vermeer, always more subtle and spare than his contemporaries, renders his symbolic mask as a plaster cast, taking the traditional elements of imitation one step further by blending the two and turning the result into an academic studio prop.

To complete his allegorical program, Vermeer includes not an ordinary curtain illusionistically pulled aside to reveal the painting, but a marvelously rendered tapestry. Given the subject of the composition, this device used earlier in his *Girl Reading a Letter* in Dresden, must be taken as a reference to the famous artistic competition of antiquity between Zeuxis and Parrhasios as related by Pliny the Elder. Although official art criticism of the time would probably have classified the works of Vermeer as lowly genre painting rather than have included them in that higher category of history painting, it seems likely that, as the subject of this picture indicates, Vermeer saw himself as a history painter in the purest sense of the word and may have painted this complex allegory to remind himself and his contemporaries of this fact. The personal association could explain why this extraordinary picture remained in his possession until his death.

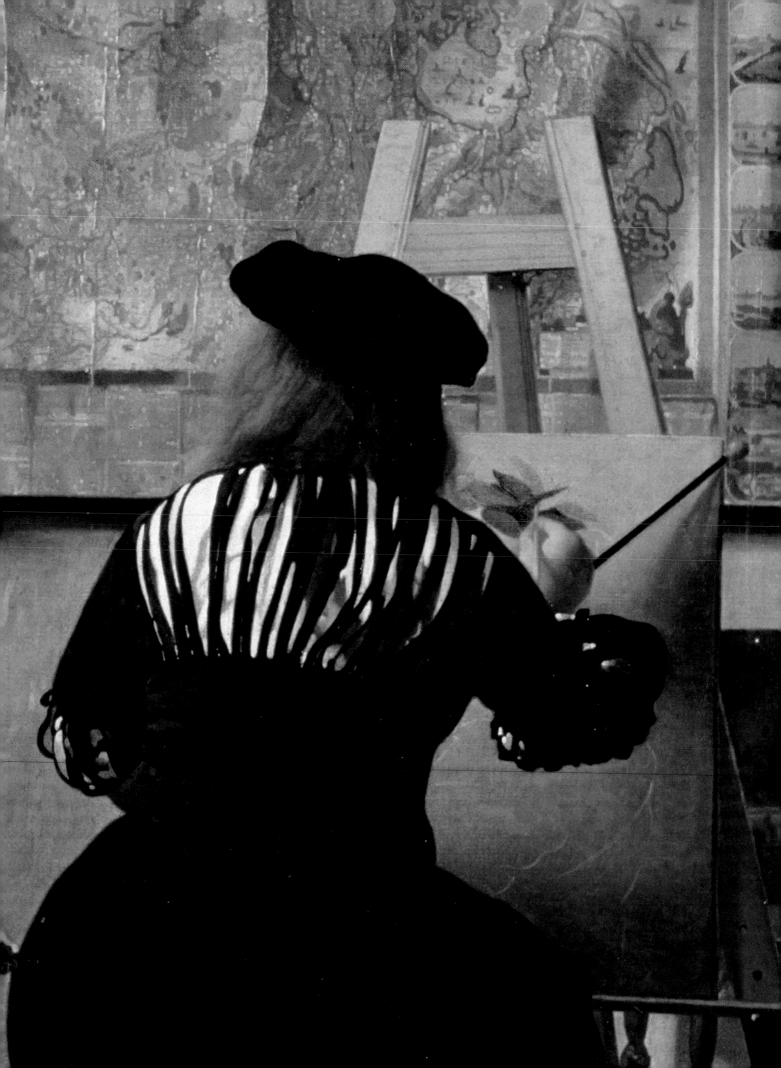

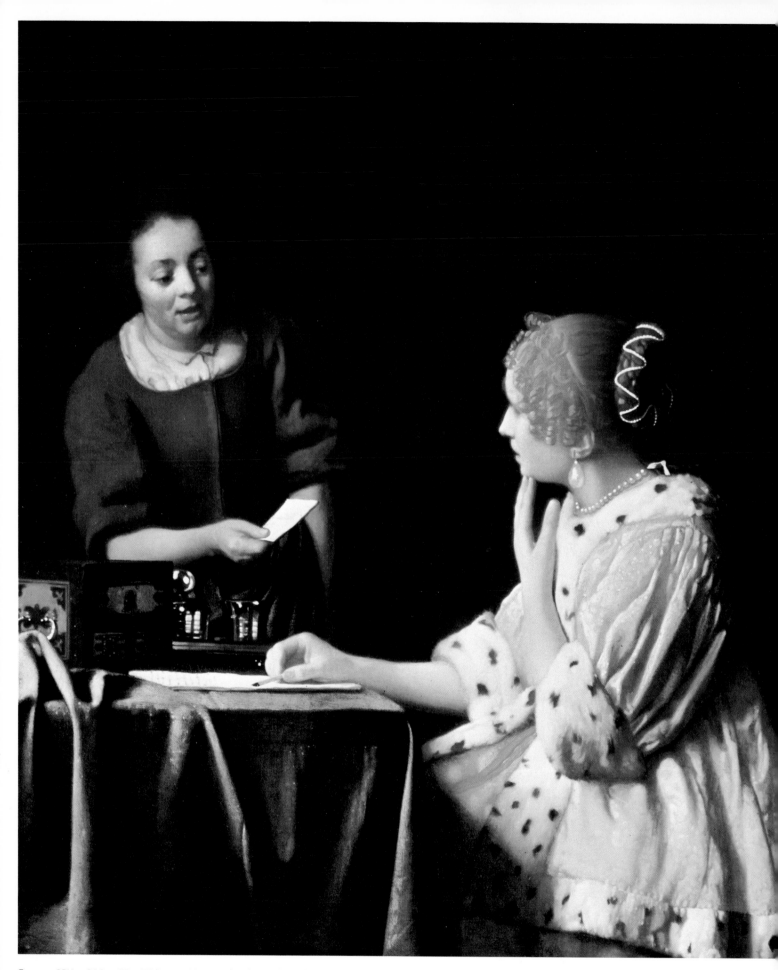

Canvas, 35½ x 31 in. (92 x 78.7 cm.) New York, The Frick Collection

VERMEER

A Woman Brought a Letter by a Maid

c. 1667

Although this work is often identified with lot number 7 in the 1696 Vermeer sale—"A young woman with her maid with a letter"—which brought 70 guilders, this description would fit the Amsterdam *Love Letter* equally well. Furthermore, there are significant facts concerning the physical state of the present work which would appear to support the candidacy of the Amsterdam work. Only two other Vermeer paintings are known to have what might be termed unarticulated backgrounds: the Mauritshuis *Head of a Girl with a Turban* and the Metropolitan *Head of a Girl*. The Louvre *Lacemaker*, although often included in this group, clearly has a wall with painted imperfections as setting. Both the Mauritshuis and the Metropolitan pictures are considerably smaller than the Frick canvas, and, even more importantly, have compositions which are limited to the head and shoulders of a single figure. Thus, the present painting is the only known work by the artist of this size and with more than one figure without some indication of a supporting interior setting.

It also seems probable that even the simple curtain which provides the only background for the composition today did not originate with Vermeer. An engraving of the picture, made in 1809 when it was in the collection of the French art dealer J. B. Lebrun (husband of the painter Elisabeth-Vigée-Lebrun) reproduces a completely bare setting for the figures. Thus, even the rather meaningless curtain seen today may be a nineteenth-century addition to what must have then been an unfinished Vermeer painting.

In its unfinished state this work would seem to supply evidence as to how Vermeer used the *camera obscura* in his painting procedure. The unusual fact that the objects on the table are brought closer to completion than the figures would seem to indicate that he had a greater opportunity to work on this section than on the figures. Even the fact that the two figures are at different stages of completion appears significant. Clearly he must have posed his models separately and used the table as the measuring and unifying factor. However, he apparently did little or no work on the figures unless the model was present. The limited depth of field obtainable with the *camera obscura* would have made it necessary either to refocus the device or physically move it, or both, to obtain a clearly articulated setting for his figures. This procedure has already been suggested for such works as the Buckingham Palace *Lady and Gentleman at the Virginals*, where double focusing of the optical device would be necessary in order to obtain a clear image in the mirror. In addition, the presence of the reflection of an easel leg in the mirror indicates that Vermeer painted the figures from close up and then moved back—along with his *camera obscura* —to execute the spatial setting. The specific nature of the levels of incompleteness found in the Frick canvas would seem to support this somewhat unusual working procedure. Nevertheless, we are still faced with the important question as to why Vermeer never completed this lovely composition. Since it is not a very late work by the master, the decision was apparently a conscious one. To what extent its state is a product of external factors —such as a lost commission—remains to be discovered.

VERMEER

The Astronomer

1668

It seems likely that this canvas and *The Geographer* in Frankfurt were originally intended as pendants. The two pictures were sold together on April 27, 1713, and they remained together through numerous eighteenth-century sales. They were not separated until sometime towards the end of the eighteenth century—perhaps when this painting appeared, alone, in an Amsterdam sale held on June 11, 1800. These two compositions provide us with the only relatively certain pair of pendants by Vermeer. Although both works bear signatures and dates, there is some question about the authenticity of these, since they do not appear on an engraving of *The Astronomer* made when it was in the collection of the French art dealer LeBrun in 1784. However, since the date seems in exact accord with our present understanding of Vermeer's artistic development, it seems likely that it was added to the picture—presumably from information on the original frame when LeBrun provided it with a new one. Its mate, interestingly enough, carries the date of 1669, which helps to confirm the accuracy of the 1668 date. Therefore, these two picures, along with the youthful *Procuress* in Dresden dated 1656, provide us with the only relatively secure dates with which to assess Vermeer's artistic development.

In this work Vermeer has gone to some lengths to provide his astronomer with exactly the proper scientific setting. The celestial globe he consults, for example, is identifiable with the one first published by Jodocus Hondius in 1600. On the table are actual and appropriate astronomical and astrological in-struments, such as an astrolabe and a pair of dividers. The chart on the cabinet also contributes to the technically oriented setting, and it has been suggested that the faint circular diagram on the open page of the book is an astrological diagram. As with most of his works, it seems that Vermeer here again left nothing to chance.

In Vermeer's day astronomy and astrology were still closely linked sciences, and both were associated with ancient occult learning from the East. It is against this specific background that he seems to have introduced the small painting hanging on the wall. The picture, a *Finding of Moses*, also appears in the Beit *Woman Writing a Letter with Her Maid*, although changed and much larger. Since Vermeer pictures within pictures usually carry some meaning, the inclusion of this theme in a depiction of an astronomer/astrologer may relate to the comment on the finding of Moses in the Acts of the Apostles, where we are told "and Moses was learned in all the Wisdom of the Egyptians."

This unusual picture-within-a-picture, however, is of great interest for another reason having nothing to do with its content. Art historians and critics have suggested various authors for the biblical composition. Untypically, it is one of the few paintings used by Vermeer which does not appear in any of the old inventories associated with him or his family. Jacob van Loo, Christiaen van Couwenberg, and Peter Lely have been suggested as possible creators. Yet it is also possible to suggest a fourth: Vermeer himself. The two versions of the *Finding of Moses* which appear in his paintings approach in several important ways the early Mauritshuis *Diana and Her Companions*. This *Moses* composition could thus be an early work by Vermeer himself and the only case where he set one of his own paintings to an iconographic task.

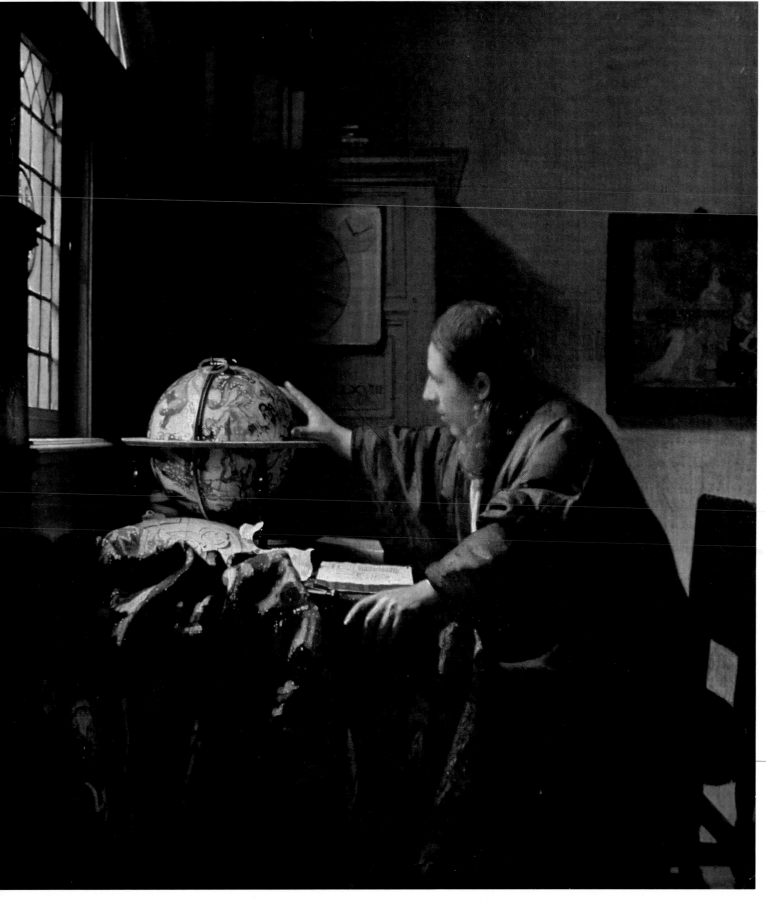

Canvas, 19¾ x 17¾ in. (50 x 45 cm.) Paris, Rothschild Collection

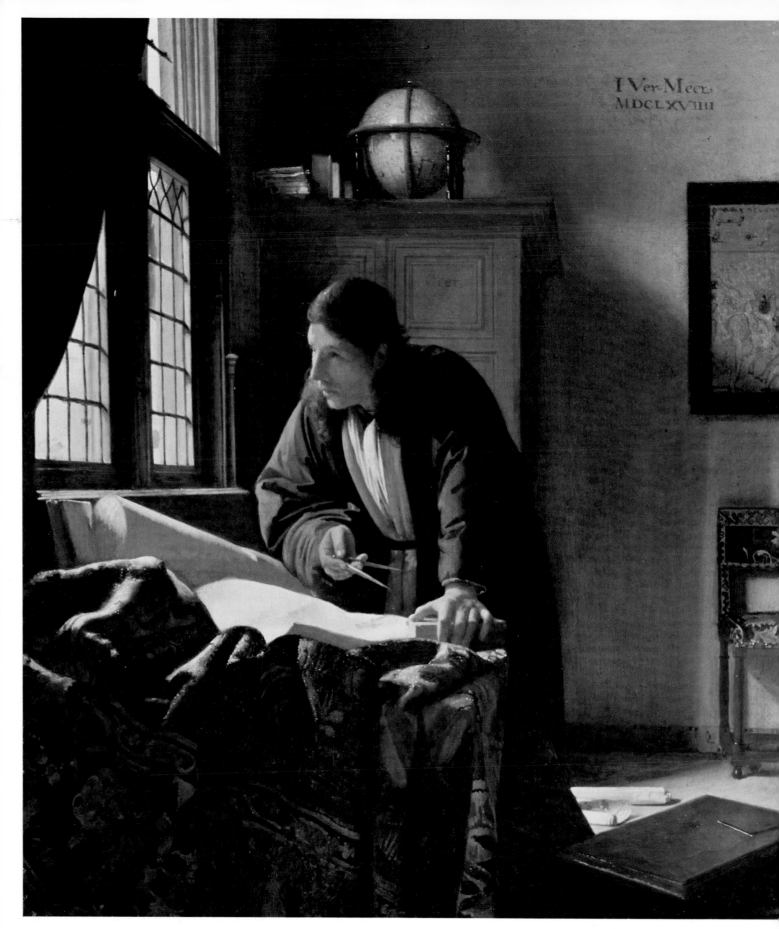

Canvas, 20⅞ x 18¼ in. (53 x 46.6 cm.) Frankfurt, Städelsches Kunstinstitut

VERMEER

The Geographer

c. 1669

The slight difference in size between this work and its 1668 pendant, *The Astronomer* in the Rothschild collection, is probably due to the different histories these two works have had since they were separated at the end of the eighteenth century, having been first mentioned together as early as 1713. Although the signature on this picture is probably not authentic, the date apparently records accurate information that may have been on the original frame. It seems unlikely that at a time when so little was known about Vermeer such precise dates could have been arrived at, unless it was provided by some trustworthy source. The point is an important one since, aside from this pair, only one other dated work by Vermeer is known. That a matched pair of relatively small pictures are dated a year apart may also be taken as some confirmation of the artist's working habits. Only some thirty-five pictures by Vermeer are known today and thus we must assume that he either worked considerably slower than most of his contemporaries or that he worked less consistently. Since all his works exhibit great care and deliberation the former would appear to be the case. Perhaps his use of devices such as the *camera obscura* required special procedures we are unaware of today.

Despite the difference in his working habits, it is clear that with regard to subject matter and other formal qualities Vermeer is typical of Dutch seventeenth-century artists. For example, it has been pointed out that the figure here takes a pose reminiscent of Rembrandt's famous etching of *Faust* (c. 1650). Did Vermeer intend this quotation as a special homage to his great Amsterdam contemporary in the year of Rembrandt's death, or is the borrowing merely a stylistic device? We shall probably never know.

As with his *Astronomer*, Vermeer has gone to great lengths to provide an authentic setting for the *Geographer*. For example, the terrestrial globe is, like the celestial one, a real globe designed by Jodocus Hondius, and the two were originally published and sold together. Thus even the central symbols of the activities of these two works demonstrate a pendant relationship which appears to affirm that they were indeed conceived of as a pair. Vermeer must have owned the globe used here (although it did not appear in his death inventory) for he utilized it again, turned to one side, in his later *Allegory of Faith* in the Metropolitan Museum of Art.

Other specific elements in this picture indicate the extreme care Vermeer took in as-

sembling the smallest detail before he began painting. For example, the framed map on the wall is Willem Jansz Blaeu's famous Sea Chart of Europe; and the sheet on the table, although difficult to read today, may also be a nautical map. Aside from the easily recognizable cartographic instruments—such as the square and dividers on the table—Vermeer also included a cross-staff hanging on the central window divider. Although this scientific device had a number of uses, there was no other known way in the seventeenth century to obtain the latitude measurements essential to accurate mapmaking. Clearly, in this area Vermeer knew exactly what he was doing. In addition it might be noted that devices such as the *camera obscura* were also utilized by cartographers during the sixteenth and seventeenth centuries. Thus this picture might be taken as another example of Vermeer's expertise in this scientific area. Although it is not possible to connect Vermeer with the Delft scientific community during his lifetime, it is certainly significant that Anthony van Leeuwenhoek, inventor of, among other things, the microscope, became executor of the artist's estate. Since there was no financial reason for this—Vermeer was virtually bankrupt due to the disastrous Franco-Dutch war—the two men must have known each other during Vermeer's lifetime.

It may be that through this relationship Vermeer learned about optics and lenses: Leeuwenhoek was certainly the one man in Delft capable of introducing the artist to the workings of the *camera obscura*. (And Vermeer's change in style happens to coincide with Leeuwenhoek's return to Delft from Amsterdam.) Interestingly enough the names of the two men, both famous in their respective areas of endeavor, appear together on a document having no references to Vermeer's estate. Born within a very few days of each other, both their names are inscribed on the same page of the baptismal records for the Nieuwe Kerk in Delft.

Despite the scientific and technical orientation of many of the elements of this composition, it is likely that it has a second level of meaning related to the popular emblematic literature of seventeenth-century Holland. An illustration in Adriaan Spinniker's emblem book, for example, depicted a geographer, very much like the one in Vermeer's painting, under the heading "So that one may travel safely." Spinniker's text, however, stresses travel not in the geographic sense, but in relation to the metaphorical way of the Bible. As an example Spinniker cites John 14:6: "Jesus said unto him: 'I am the way.'" Thus Vermeer's composition, in addition to its scientific accuracy, probably also functioned, at least to the seventeenth-century viewer, as a moral and religious reminder.

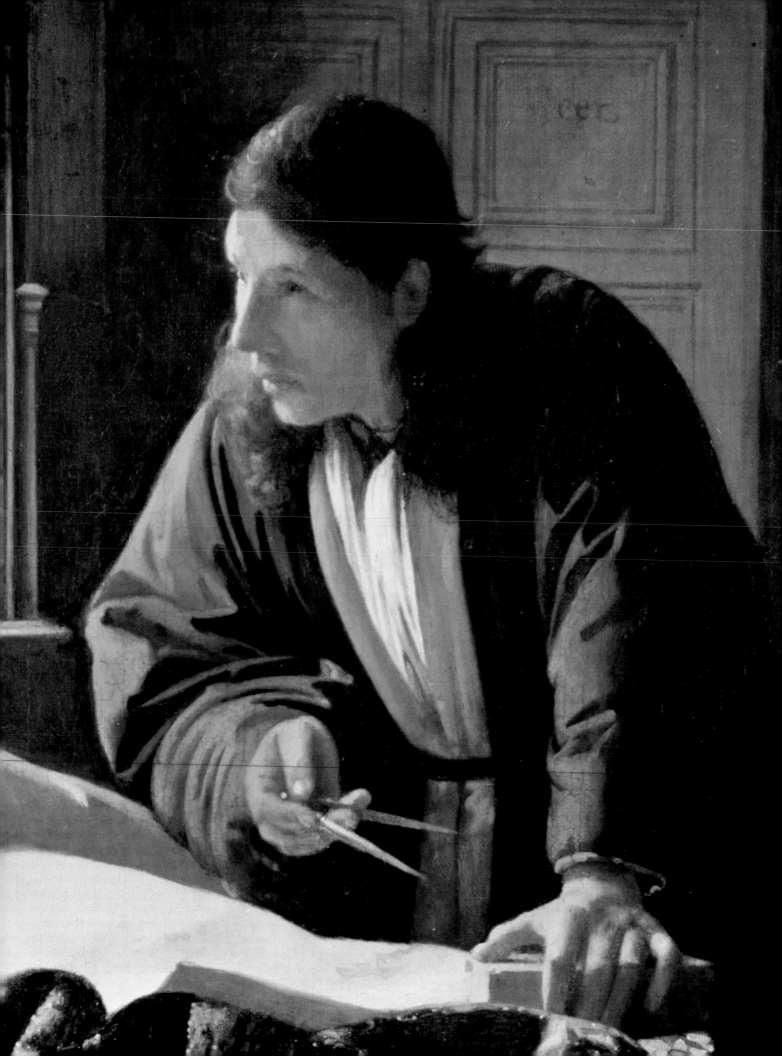

VERMEER
Lady Standing
at the Virginals

c. 1670–71

Although two other Vermeer pictures could also fit the description of a painting which appeared in the inventory of the Antwerp banker Diego Duarte in 1682—"A Lady playing the Virginals with accessories by Vermeer"—there are external as well as internal reasons for believing this to be the picture. It seems unlikely that, as is sometimes suggested, the Duarte description refers to the Buckingham Palace *Lady and Gentleman at the Virginals*. In the first place, seventeenth-century descriptions of Vermeer canvases are, for the most part, accurate. And second, it is unlikely that a figure essential to the meaning of the picture, as well as to the price, would have been overlooked or forgotten. However, both this canvas and its possible pendant, the *Lady Seated at the Virginals*, also in London, fulfill the 1682 description.

Given the subject matter, it is obviously significant that the Duarte family, both father and son, had more than a passing interest in music. Diego, for example, corresponded with Constantine Huygens, Jr., about music, and his father had a spinet made for Huygens. Thus the question arises, did Vermeer also have contact with Huygens? In 1672, Ver-meer was documented in The Hague, where Huygens lived. Aside from music, the entire Huygens family was interested in art and, indeed, the role Constantine the elder played in Rembrandt's early career is well documented. Unfortunately, no information has yet appeared either to confirm or deny such a meeting with Vermeer.

In 1696, at the Dissius auction in Amsterdam, another (or the same?) Vermeer of the same description was sold. Again, both of the London pictures fit the catalogue entry. This is indeed a frustrating situation, for the two surviving works seem to complement one another in every way—subject, composition, and size—better than any other presumed pair of Vermeer canvases. Even better, for example, than *The Geographer* and *The Astronomer*, which, although complementary in subject and size, are oddly mismatched in terms of a clear compositional relationship. Both these musical works prominently feature paintings hanging on the walls which also appear in Vermeer family inventories and, significantly, in other Vermeer compositions. The Cupid holding a piece of paper was used earlier in the Frick *Girl Interrupted at Her Music*, and can be associated with the style of Caesar van Everdingen. Since Dutch emblematic literature often illustrated the Latin motto "Only One" with such Cupid figures, it seems clear that Vermeer must have intended the same positive meaning here as for the Frick canvas, which may also stress the harmonious qualities of music. Symbolically, it is also certainly significant, given the positive role music plays in the two works, that both female figures are posed in an upright position.

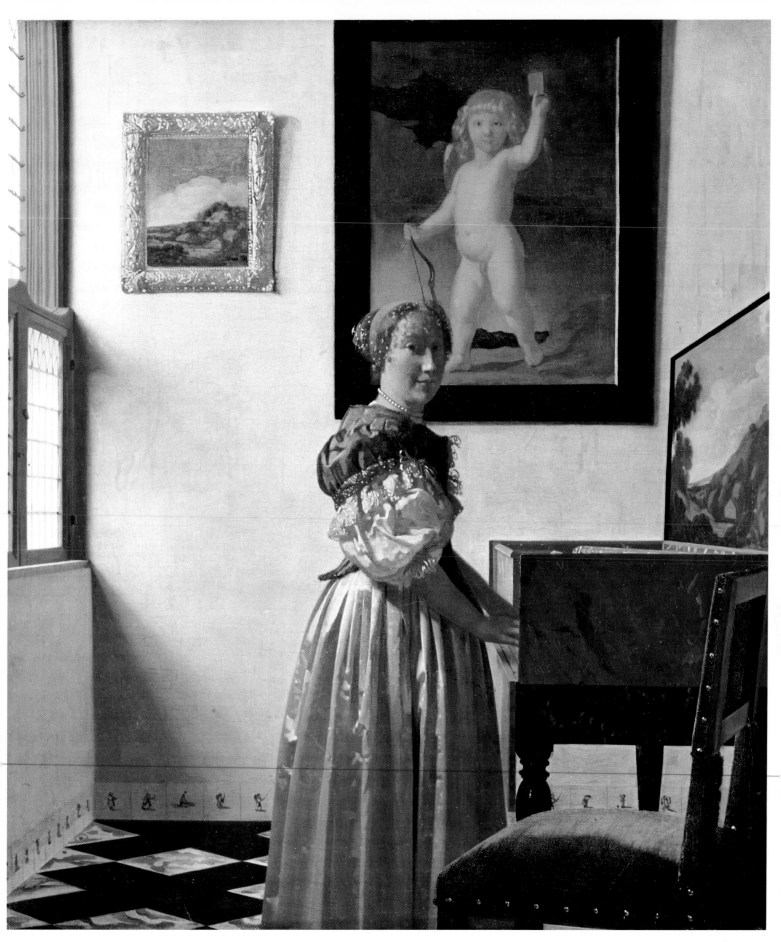

Canvas, 20 x 18 in. (51.7 x 45.2 cm.) London, National Gallery of Art

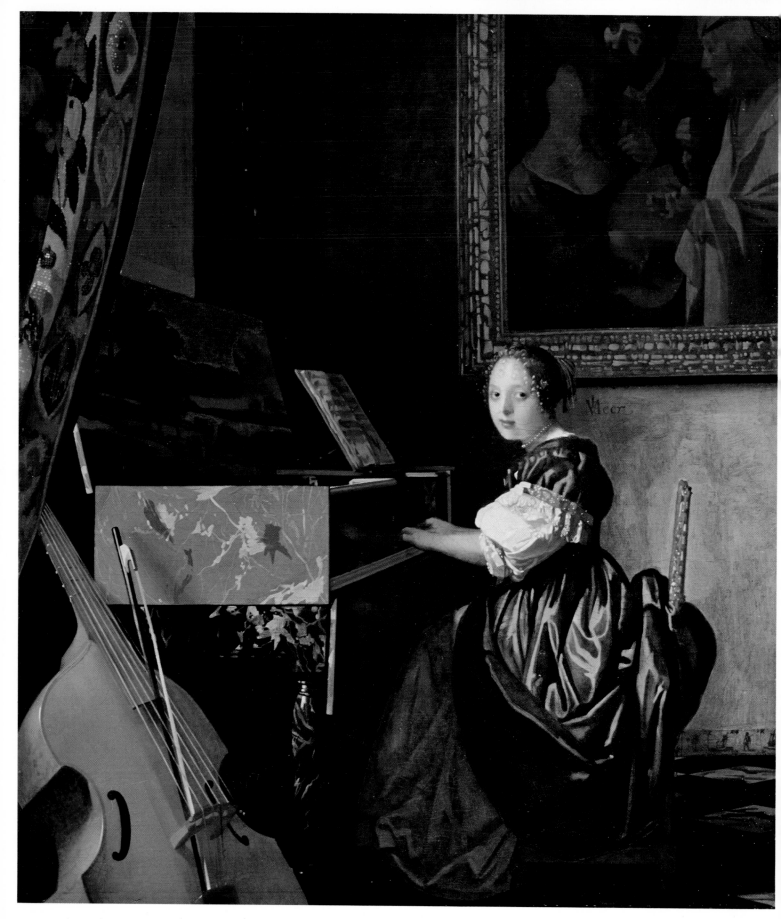

Canvas, 20¼ x 17¹⁵⁄₁₆ in. (51.5 x 45.5 cm.) London, National Gallery of Art

VERMEER
Lady Seated
at the Virginals
c. 1671–72

The early history of this canvas, like that of its presumed pendant, is difficult to sort out. It seems probable that one of the two pictures was owned by Diego Duarte in 1682, and the other by Jacob Dissius, whose collection contained twenty-one Vermeer paintings when it was auctioned off in 1696. It is, of course, also possible that Dissius acquired his painting from Duarte. Between 1682 and the Amsterdam sale Dissius is known to have added two Vermeers to the nineteen he had owned earlier.

Unlike the *Geographer* and the *Astronomer*, whose early history indicates they were together as pendants, only the physical and iconographic evidence of this canvas, and that of its presumed mate, the *Lady Standing at the Virginals*, also in London, support the relationship. Both canvases are very nearly the same size, and their compositions and subjects closely complement one another. In addition, paintings within the paintings add an important iconographic dimension to each work. Both secondary pictures, in fact, were apparently owned either by Vermeer or his

family, and both, interestingly enough, may be broadly described as caravaggesque. The picture utilized here, by the Utrecht artist Dirck van Baburen, appeared earlier in the background of Boston's *The Concert*. Additionally, the prominent placement of the viola da gamba in the foreground is also to be found in the Boston composition, once more linking their meaning.

It seems more than likely that the same complementary iconographic relationship between the earlier musical pair, the Buckingham Palace *Lady and Gentleman at the Virginals* and the Boston *Concert*, is to be found in this picture and its presumed mate. Not only does this canvas share specific stylistic and symbolic elements with the earlier related work, but the pair as a whole—as with the earlier pair—deals with the contrasting qualities of music: the harmonious and the bacchic. This is most clearly indicated here, and in its mate, by the paintings on the wall. The 1622 Baburen *Procuress*, with its lute-playing female and obviously erotic activity, clearly deals with music as an accompaniment, if not an incitement, to venal love. Its pendant, on the other hand, renders faithful love as its primary theme.

Vermeer attempts to make the divergent musical qualities clear through a number of artistic and formal devices. Here, for example, as in the Boston picture, the female virginal player is depicted seated. On the other hand, both the Buckingham Palace canvas and

the mate to the present work render the female in an upright position. Thus, among other things, the contrast of poses carries an essential part of the moral message for Vermeer and his contemporaries. Upright in Dutch, as in English, is a moral as well as a physical stance.

Musical iconography during the seventeenth century often stressed the concept of sympathetic vibrations in properly tuned stringed instruments. In the north the idea may go back to an early sixteenth-century engraving by Lucas van Leyden which rendered an old couple playing stringed instruments. Carel van Mander, the important chronicler of Dutch art, and a painter in his own right, explained this print as a depiction of harmonious love. Vermeer, on the other hand, has placed the viola de gamba in the foreground so that the viewer can plainly see that the bow has been placed through the strings in a way that will prevent the sympathetic vibrations from occurring. Since the instrument occupies a position parallel to the empty chair in its pendant, its symbolic role must be taken in a related sense. Vermeer, and many other seventeenth-century Dutch artists, often used the empty chair as a symbol of the absent lover whose place is reserved. The viola da gamba, with its ready bow, would apparently serve as an open invitation to the viewer to take up the instrument and join in the fun. To this end Baburen's *Procuress* depiction surely set the appropriate tone. The faithful Cupid, on the other canvas, assures the viewer that the empty chair will remain that way until the awaited lover returns to take his place.

Other contrasting pictorial qualities in the two works would support this unified musical program. The *Lady Standing at the Virginals* is flooded with clear, cool daylight recalling the earlier *Woman with a Water Pitcher* in The Metropolitan Museum of Art, while the present composition is unusually subdued, especially for Vermeer, in its light qualities. The window has been covered with a blue curtain here, while in its mate it is rendered as clear and unobstructed. In addition, the range of values and colors used for the two females also presents an obvious contrast. The standing virginals player is dressed predominantly in light, almost white hues, while the seated instrumentalist wears a darker blue overgarment. Thus the two works complement one another in almost every way in their suggestion of the musical iconography as well as in the other formal and physical elements. Given this enormous coincidence of elements, it seems quite likely that Vermeer meant the two works to be viewed together as pendants. Thus, although historians have often separated the two canvases by several years, it seems unlikely—even given Vermeer's slow working habits—that they were more than one, or at the very most, two years apart in execution.

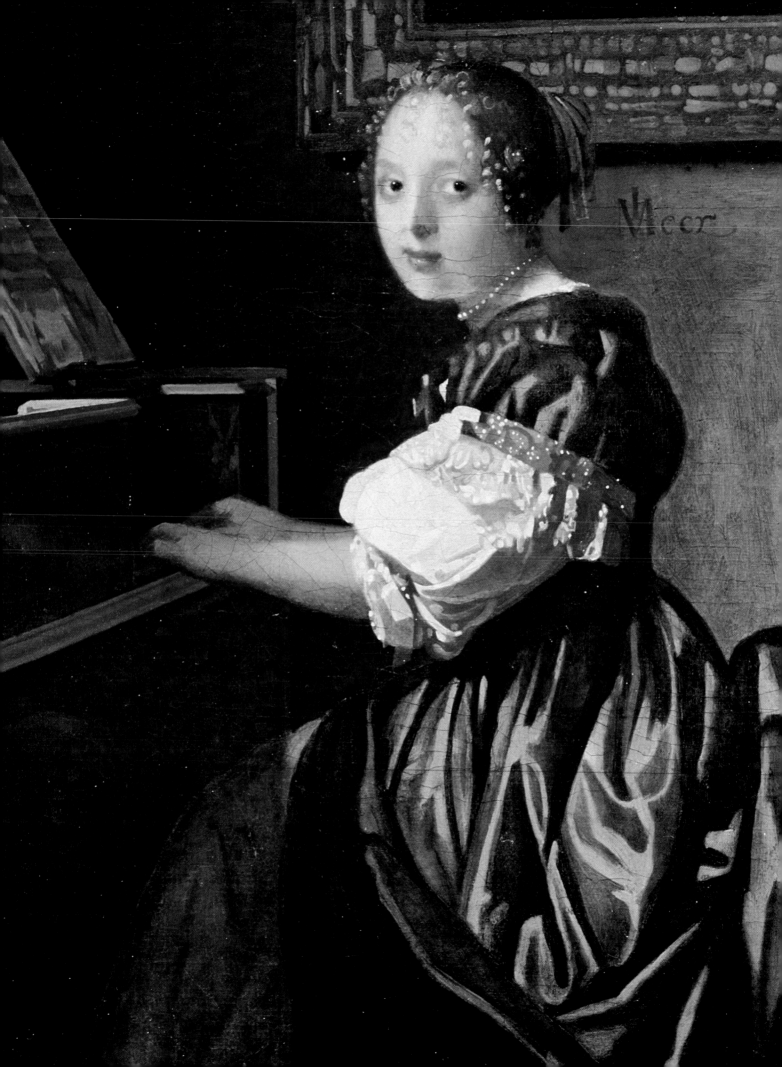

VERMEER
The Lacemaker
c. 1671–72

This tiny canvas, which first appeared in the 1696 sale, seems to have experienced an unusually early popularity for a Vermeer. The fact is attested to, not by the picture's history, which cannot be traced after the Dissius auction, but by two old copies: an eighteenth-century watercolor by the Dutch artist Jan Stolker and a panel painting which appeared in an 1810 sale. And closer to our own time, the great impressionist painter Renoir thought *The Lacemaker*, along with Watteau's *Embarcation for Cytheria*, the most beautiful pictures in the world!

Although the tapestry on the table is the same as the one found in the 1668 Rothschild *Astronomer*, the handling of the paint surface and the intensity of the woman's concentration are more closely related to qualities which appear in the Beit *Woman Writing a Letter, with Her Maid* (c. 1672). Parallel stylistic elements are also present in another late picture, the Kenwood *Guitar Player*, in the rendering of the figural planes, the elaborate coiffeur, and especially in the fact that the light enters the picture from the right side. There are only four works assigned to Vermeer in which the light enters from this direction; however, the other two are the recently contested little panels in the National Gallery, Washington.

It seems quite clear when one compares this picture with other late works, that the small format and close-up view of the figure best suited Vermeer's late pictorial vision. Perhaps this is due to the fact that Vermeer himself must have worked at his own craft with an intensity equal to that which he has captured here. Thus it is not beside the point to note that several seventeenth-century Dutch writers compared a woman's needle to a painter's brush. Certainly the richly colored threads which seem to pour from the pillow-shaped sewing box, and which are rendered with a thick but fluid paint, seem to confirm this literary conceit. Although such other seventeenth-century Dutch artists as Casper Netcher and Nicolas Maes painted the same subject, Vermeer's work appears to be the only one interested in fulfilling Jacob Cats' emblematic metaphor.

Spinning, weaving, and needlework of all kinds have, since biblical days, been seen as activities associated with feminine virtue. The book of Proverbs (31:10–13), for example, in a section which contains the lines "Who can find a virtuous woman? for her price is far above rubies," goes on to say: "She seeketh wool, and flax, and worketh willingly with her hands." In the *Odyssey*, to cite a classical example, Penelope puts off her anxious suitors, while awaiting Ulysses' return, by weaving by day and unraveling her work by night. Vermeer himself, in the Amsterdam *Love Letter*, depicts his woman as having put aside her sewing in favor of a lute. Thus this virtuous activity is often depicted in direct contrast to other more frivolous temptations. The intense concentration captured here makes it quite clear that virtue and industry are what Vermeer had in mind.

Some critics suggest that with his late works Vermeer becomes too facile and empty. Works like this one, however, clearly negate any such judgment. The visual innocence and the compositional sophistication with which this tiny corner of the world is captured suggests that Cézanne's knowing comment about Claude Monet, "he is only an eye, but my God, what an eye!" might be equally applied to the late works of Vermeer.

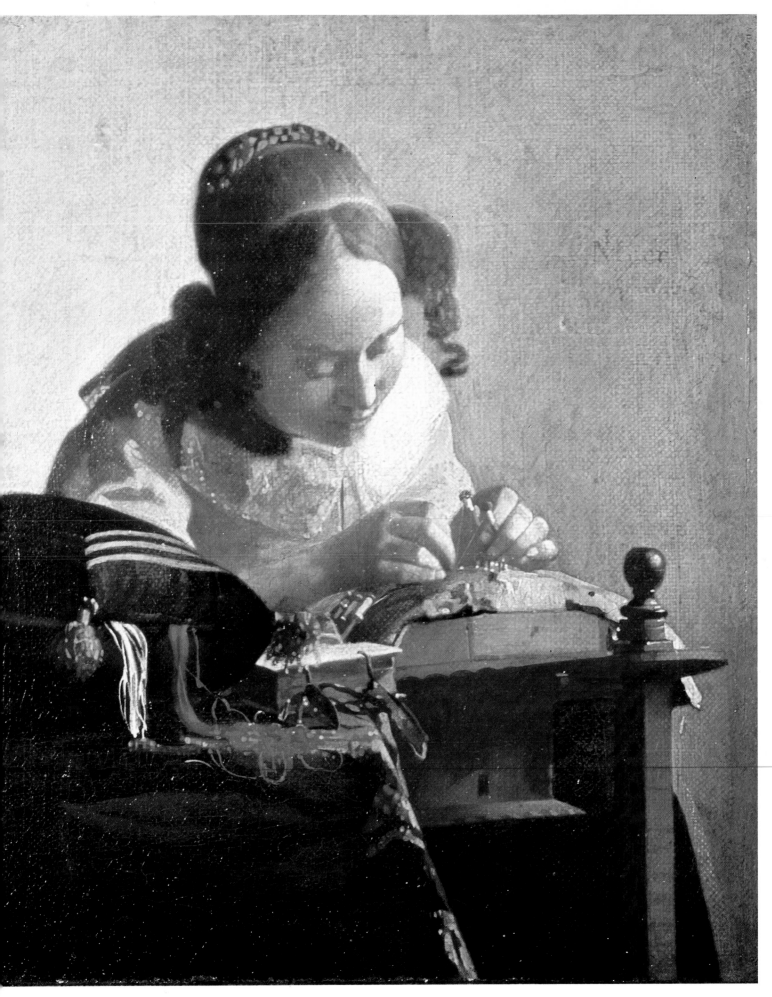

Canvas, 9½ x 8¼ in. (24.5 x 21 cm.) Paris, *The Louvre*

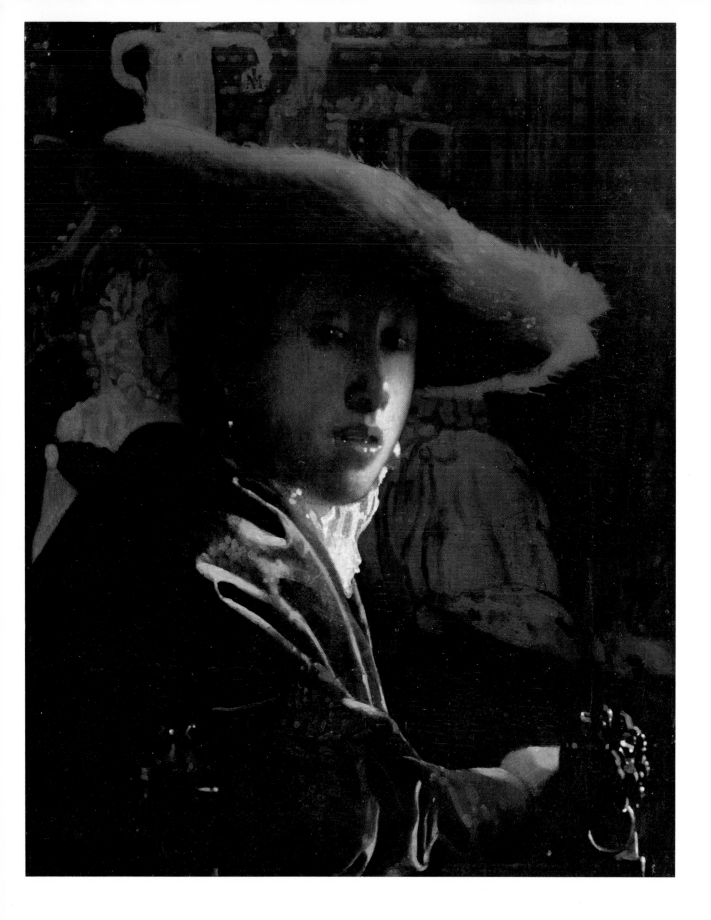

Panel, 9⅛ x 7⅛ in. (23 x 18 cm.)
Washington, D.C., The National Gallery of Art

VERMEER

Girl with a Red Hat

c. 1671–72

Although the earliest certain listing of this tiny picture is often said to be the Lafontaine sale, Paris, December 10, 1822, there is no real reason not to associate it with either number 39 or 40 in the 1696 Dissius auction. The sale catalogue described both of these works as representing "a head in antique costume." This identification is strengthened by the presence of another picture close to this one in the National Gallery, Washington. Additionally, since both these works brought only 17 guilders each, the lowest price of all the Vermeers in the sale, one must presume that they were quite small in size.

Unfortunately, contemporary scholarship on this painting and its presumed pendant has been notably uneven. Some writers have not been cognizant of the fact that this work is painted on panel; while others, more recently, have made too much of this same information. Then again, since this work and its presumed pendant are the only works reasonably assigned to Vermeer which are on panel, the fact has been used to reject this unusual head as an authentic work of the master. However, it is clear that Vermeer must have used panels as well as canvas in his work, at least towards the end of his life. The room-by-room inventory made of his house in 1676, shortly after the artist's death, listed six panels and ten canvases along with two easels and three palettes. The nature of the listing makes it absolutely clear that these were painting materials.

It is indeed unfortunate that it has been impossible to subject this panel to the same kind of dendrological analysis of the wood itself as has been done with its presumed pendant. Nevertheless, specialists have examined the rendering of the tapestry in the background and found that it compares favorably with known late sixteenth-century Flemish types. Thus, the only major problem concerning this picture which remains is the odd fact that the lion-head finials on the chair face in the wrong direction. As bothersome as this inconsistency is, it does not seem to justify the doubts cast by one recent critic over the work's authenticity. Actually the pose, if not the chair, can be compared with one used by Frans Hals in several of his portraits, including some during the 1660's.

The startling visual accuracy of this tiny painting has often been related to Vermeer's use of the *camera obscura*. However, the same photographic and momentary quality has also been used as grounds for rejecting this picture. Photographic reconstructions of parts of its composition, made to study Vermeer's utilization of the *camera obscura*, have produced patterns of blurred and merged highlights similar to those present in the work itself. And the only logical accounting for the presence of such a quality, found in a number of other Vermeer pictures, lies in the possible use of this optical device.

Scholarly opinion as to its date, like everything else regarding this work, has varied greatly over the years. The closest parallel in size, visual acumen, and direction of light source is the Louvre *Lacemaker*, and one would assume the present painting to have dated from about the same time. There is stylistic confirmation in the fact that both small works render the pattern of drapery folds with similar fluid brushstrokes.

VERMEER (?)
Girl with a Flute

c. 1671–72

The present picture is the most controversial work tentatively assigned to Vermeer—or at least to his circle. Like its presumed pendant, also in Washington, some modern scholars have seen fit not only to question its authenticity but even to suggest a relatively modern origin. This last theory has been laid to rest by a recent analysis of the evidence. A new scientific technique has determined that the wood used for the panel dates from the middle of the seventeenth century. Thus, given time for the proper curing, the panel would have been ready to paint on towards the end of the 1660's or early in the 1670's. Since stylistic analysis of the presumed mate to this work provides about the same information—and the two works may have been together in the 1696 Dissius sale—approximately the same date would seem to be appropriate here.

Despite such new technical evidence establishing the panel's date, this painting does not appear to be completely by the hand of the master himself. Nevertheless, there are compelling stylistic reasons to place it close to Vermeer and probably within the master's own studio. The overall conception is extremely close to its presumed pendant and the compositions of the two are also similar and unusually striking, especially for an artist who frequently ignored such conventions.

If this work is from Vermeer's workshop, but not from his own hand, who did paint it? The question is especially intriguing since there is no record that the master ever had a student. Indeed, Vermeer's idiosyncratic working methods almost seem to preclude the proper training of students. However, a remote possibility does exist: one of his children was being trained first to assist and then to follow his father in his profession. Since members' children were exempt from tuition payments to the guild, their names do not always appear in the guild records. At his death in 1675 Vermeer left eight minor children and three who had reached their majority. It is possible that the creator of this picture came from the former group since we have no record of another Vermeer completing his training and entering the Delft artist's guild.

Once again, given the optical qualities of this tiny picture, it appears to have been painted like its presumed mate, with the aid of a *camera obscura*. Indeed, the highlight distortions in the lionhead finials are so very similar in both panels that it seems unlikely they were produced either physically or temporally apart from each other. In addition, both figures wear unusual and exotic costumes and are placed against rich tapestry backgrounds.

Because of the small size and photographic impact of both this panel and its presumed pendant, it has been suggested that they are direct one-to-one records of a *camera obscura* image. In that case, the image would have been projected directly onto the panel and the artist—difficult as it may seem—would have painted over the projection. Some support for this is to be found in the similarity of the patterns of light around the chin and nose of the present work and those revealed in x-rays of the Mauritshuis *Head of a Girl with a Turban*. Since these brash patterns were then covered by Vermeer's typically subtle brushwork in the Mauritshuis picture, it may be an indication that the present picture, like the Frick *Woman Brought a Letter by a Maid*, was never completely finished.

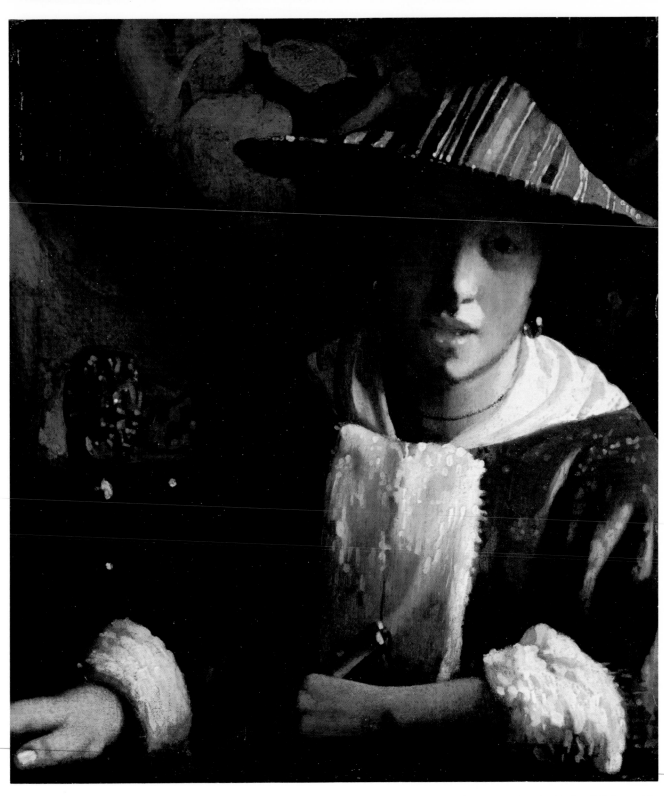

Panel, 7⅞ x 7 in. (20 x 18 cm.) Washington, D.C., The National Gallery of Art

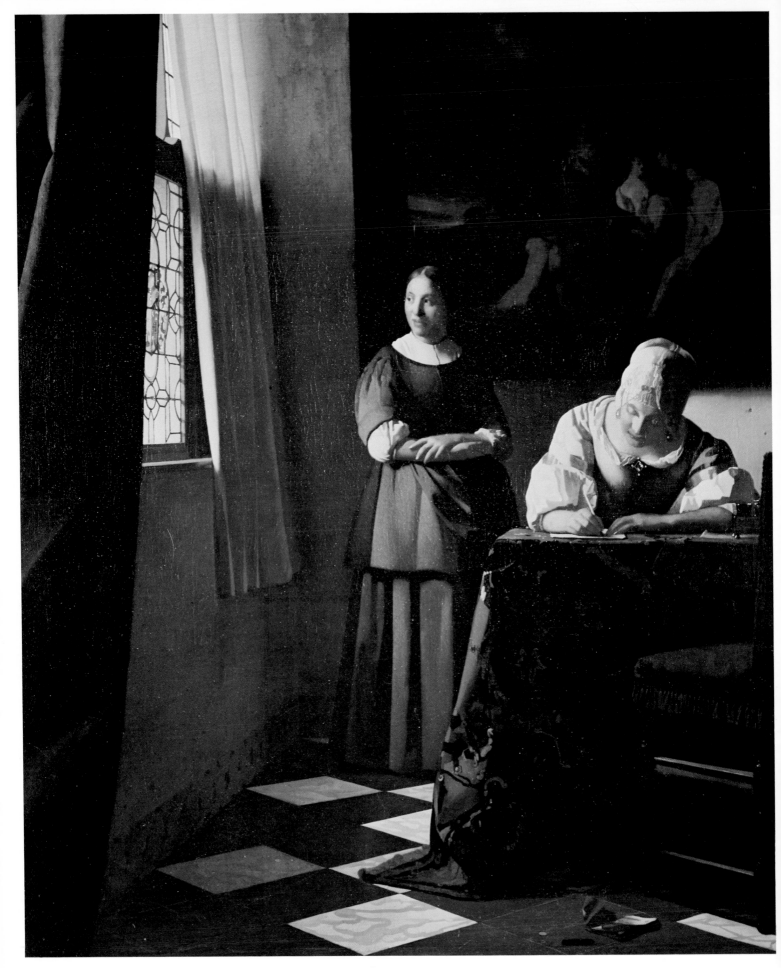

Canvas, 28 x 23¼ in. (71 x 59 cm.) Blessington, Ireland, Sir Alfred Beit Collection

VERMEER

Woman Writing a Letter, with a Maid

c. 1672

Shortly after the artist's death Vermeer's widow gave what was almost certainly this picture, "depicting two persons, one of whom sits and writes a letter," and the Kenwood *Guitar Player* to the Delft baker van Buyten as security against a debt of 617 guilders. This transaction, and others, have been seen as indications of the artist's financial difficulties in his last years. Although it is certainly true that Vermeer died deeply in debt, it must be remembered that external political events— Louis XIV of France invaded Holland in 1672— were the apparent cause of his poverty rather than any particular disfavor towards the artist or his style. In addition, since his debt to the baker was an extremely large one, it is highly unlikely that it was for anything so mundane as bread to feed his family. Significantly, when the French collector de Monconys visited Delft in 1663, he was directed to a local baker in order to see the only available Vermeer painting. This may only have been a coincidence; yet it does seem possible that the two men may have been involved together in some such business venture as art dealing.

Recently it has been hinted that de Monconys might not have been welcome in Vermeer's studio for personal reasons. Nevertheless, the early evidence of the artist's small production is supported today by the existence of only about thirty-five pictures, making it seem reasonable that in 1663 he had no works available in his studio. At his death, however, his widow was left with three works, two of which date from about 1672 or later. The third, the *Allegory on the Art of Painting* in Vienna, was produced earlier, but the artist may have wished to keep this unusual picture for himself. His production appears to have picked up—if one may use that term for an artist such as Vermeer—during the last three years of his life. Since this period (including the present painting) coincides exactly with poor wartime economic conditions in Holland, Vermeer's increased productivity may represent an attempt to paint his way out of financial troubles.

In its subject matter this canvas is Vermeer's final and in many ways most obscure exploration of the letter theme he had experimented with since the Dresden *Girl Reading a Letter*. Anecdotally, the present work is closely related to pictures such as the Frick *Woman Brought a Letter by a Maid* and the Amsterdam *Love Letter*. It also shares the elegant silver writing set with the Frick canvas and the Washington *Woman Writing a Letter*. However, the other telling elements are either missing or changed. The woman, for example, no longer wears the elegant yellow jacket trimmed in ermine, and the jewelry box is also gone.

How are we to read this exceptionally reticent, silent composition? Despite the crumpled-up letter on the floor and the large *Finding of Moses* on the wall, all hints of meaning and drama seem to have been siphoned away. Neither woman acknowledges the other—nor, for that matter, the viewer. The fact that the painting on the wall— perhaps a youthful work by Vermeer himself —also appears in the Rothschild *Astronomer* does not help at all. As one critic noted about this difficult work, "it is Vermeer's final evasion of the requirements of conventional genre painting."

VERMEER

Guitar Player

c. 1672–73

This was the second painting ceded by Vermeer's widow to a Delft baker, on January 27, 1676, against payment of a 617-guilder debt. The baker apparently sold the work, for twenty years later it appeared in the sale of Jacob Dissius' collection, along with twenty other Vermeer pictures. At that time the sale catalogue listed it as a "very good" work of the master.

These various transactions, as we have seen, raise important and interesting questions about Vermeer's finances, business, and patronage. After the artist's death, his widow testified that Vermeer had not earned very much money since 1672 due to the war with France. Could the baker, to whom these two paintings were given in 1676, be the same one resorted to in 1663 by de Monconys, in search of a Vermeer for sale? And what had been the business relationship between the artist and the baker—or bakers—to whom he obviously went for more than bread. Was the tavern that Vermeer had owned before 1672 involved, or was there some other business?

There are also important but equally unanswerable questions about Vermeer's relationship to the Delft book publisher and seller Jacob Dissius. Since Dissius owned no less than twenty-one works by Vermeer, it has been assumed by some scholars that he must have been the Delft painter's patron. However, there is not a shred of evidence to support such a relationship. And, although we may presume that Dissius acquired at least some of his Vermeers during the artist's lifetime, there is, again, no evidence to support this attractive presumption. One can only surmise that since he owned more than half the works now in existence, it is highly improbable that he purchased all of them after 1675. The record shows, as well, that he bought them in stages: in 1682, he only owned nineteen of the twenty-one that were his by 1696.

Were they friends? It would be odd for a collector with such a passion for Vermeer's works not to have had some contact with the artist. A Dissius-Vermeer relationship would also provide the artist with a source for the emblematic material frequently found in his canvases. Nevertheless, this question too must remain open, at least for the present.

Modern critics have not always looked sympathetically at the late works of Vermeer, and some have even seen in them a diminishing of his creative powers. This work, produced when he was forty, would seem to refute any such idea. Far from being diminished, his powers are at their height and he is in full control of his medium. The sureness and visual accuracy of this rendering indicate that some kind of *camera obscura* was still being utilized, but in new ways. In several works—the Louvre *Lacemaker* and this one, for example—he oddly shifts the direction of his light source so that it now enters the picture from the right. Various details, such as the yellow ermine-trimmed jacket, the pearls, and the stringed instrument, indicate that his subject matter remains essentially the same: a beautiful but subtle warning against the seductive pleasures of this world.

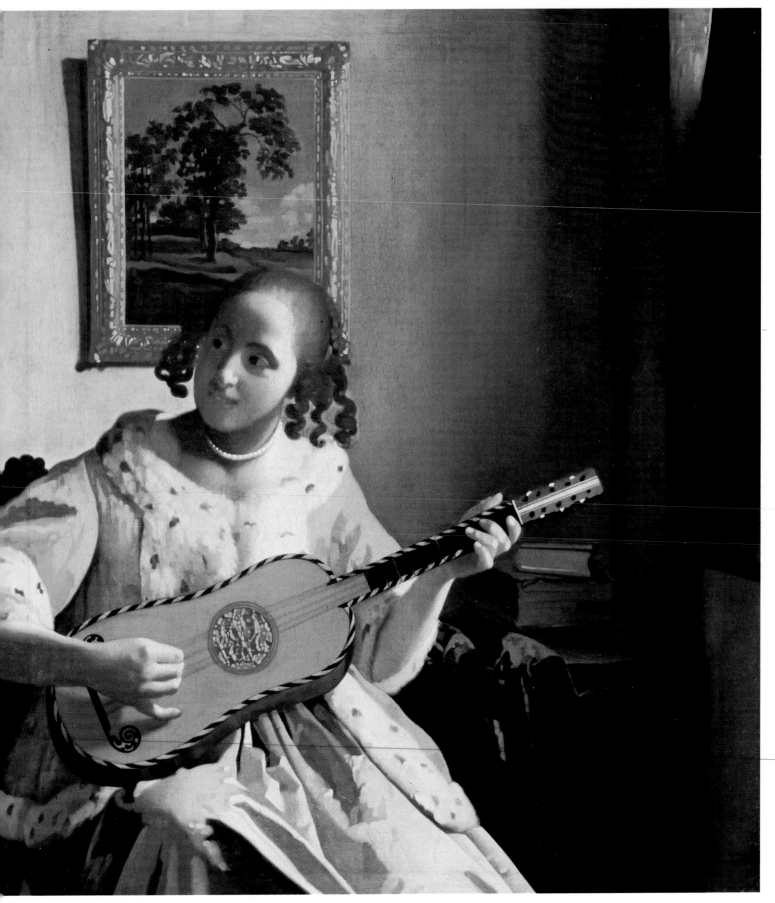

Canvas, 20⅞ x 18¼ in. (53 x 46.3 cm.) London, Kenwood House, The Iveagh Bequest

VERMEER
Head of a Girl

c. 1672–74

Since both the subject and the size of this picture are close to those of the painting in the Mauritshuis, it is possible that its provenance has been confused with that of the earlier work. Thus it may well be this one which was described in the 1696 auction as "a head in antique costume." The Wrightsmans acquired the picture in 1955 from the Arenberg collection, where it had been since at least 1829.

Given the unusual costume used here, it seems unlikely that Vermeer intended this as a formal portrait. Nevertheless, it should be recalled that Rembrandt and other Dutch artists did render what are known as portrait histories, works in which the sitter posed as either a historical or a literary personage. The 1696 sale did, however, distinguish between formal portraits (as, for example, the lost self-portrait) and heads such as this one. The close formal and thematic relationship here with the Mauritshuis picture might indicate that Vermeer intended this as a sibyl or perhaps some biblical character. Since both Rembrandt and Carel Fabritius painted similar heads in unusual costumes, and works of this type frequently appeared in seventeenth-century auctions, there apparently was a ready market for such paintings, even though they puzzle us today.

In 1672, just before the springtime invasion of Holland by France, Vermeer rented his house on the Delft market square and moved into a smaller one—no doubt because business was bad. However, we are not entirely certain which business supplied him with a living. In 1672, probably the very year he painted this head, we find Vermeer and another Delft artist were called to The Hague to testify on the value of some apparently inferior Italian paintings. The surviving document describes him as an expert in Italian art, indicating that he had still not left art dealing behind him. Besides that, since his artistic production appears to have picked up somewhat around 1672, the year of his move, the tavern he had been running may also have kept him occupied and so have limited the amount of time spent painting. Thus the varied events of 1672, together with his worsening financial situation, may have prompted him to return to a simple and presumably salable work like this one. There are, of course, other reasons to date this work late in Vermeer's development. The somewhat schematic handling of the facial planes is more typical of his later works, and the pose is close to that which also occurs in such other late works as the London *Lady Seated at the Virginals*. The handling of the drapery folds also recalls the late works in their simplified character, but also, in certain ways, harks back to those found on the goddess in the youthful Mauritshuis *Diana and Her Companions*. Perhaps the relationship is only an accidental one, but in an artist as purposeful and self-controlled as Vermeer, one can only wonder.

Thoré-Bürger, who saw this picture during his political exile in Brussels, wrote of it in exceptionally glowing terms. "Her face," he said, "has a melancholy finesse which forces one to look at this woman with a mysterious sympathy. It makes one think of the silent images evoked by Rembrandt and, curiously enough, of certain of Correggio's faces, and even, with the exception of the difference of the beauty of the type, of the prestigious Mona Lisa of Leonardo."

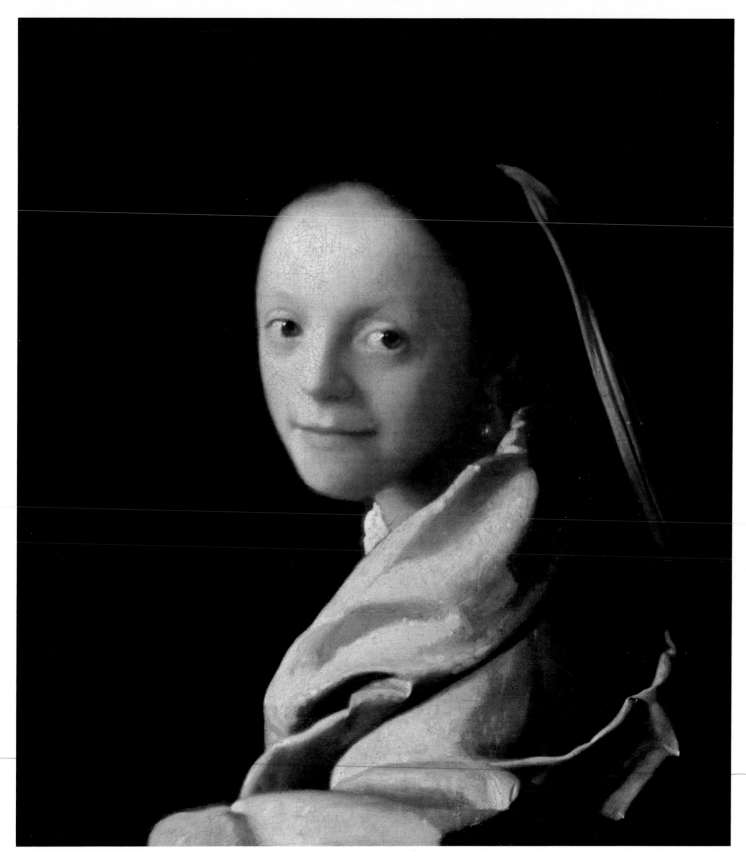

Canvas, 17¾ x 15¾ in. (45 x 40 cm.) New York, The Metropolitan Museum of Art

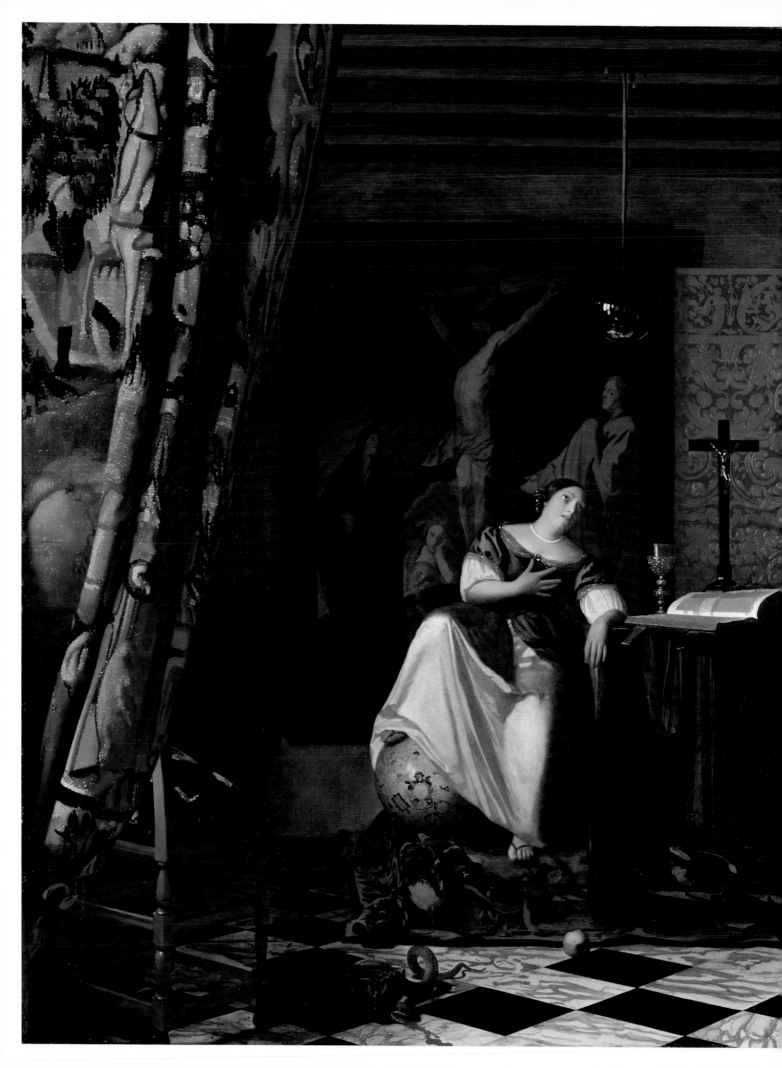

Canvas, 44½ x 34½ in. (113 x 88 cm.)
New York, The Metropolitan Museum of Art

VERMEER
Allegory of Faith

c. 1673–74

Although highly esteemed in the seventeenth century, the second of Vermeer's allegories has not fared as well with art historians as the first, the *Allegory on the Art of Painting* in Vienna. When the present canvas was sold in Amsterdam on April 22, 1699, however, it was described as "a seated woman, with more than one meaning, representing the New Testament, by Vermeer of Delft, powerfully and luminously painted," and it brought the quite high price of 400 guilders. By comparison, the still greatly admired *View of Delft* was sold for 200 guilders only three years earlier. Despite the fact that the *Allegory of Faith* appeared in numerous eighteenth-century sales properly identified, it was eventually bought by a Berlin art dealer as the work of Eglon van der Neer. Apparently, somewhere along the line, the name Vermeer was garbled. Soon afterwards it acquired a false Caspar Netscher "signature," and a new owner, the distinguished Dutch art historian, Abraham Bredius. But it was to be another famous art scholar, Max J. Friedländer, who first rediscovered this unusual work as a Vermeer. Bredius loaned the canvas to the Mauritshuis for a number of years, but neither he nor his colleague Hofstede de Groot had any real sympathy for either the subject or the style of this late Vermeer and it was eventually sold to Col. Friedsam in 1928; Friedsam bequeathed it to the Metropolitan Museum of Art in 1931.

The checkered career of this Vermeer, especially in this century, is typical of the reception of the late works of the Delft master in modern art history. Clearly baroque religious allegories—and especially Catholic ones—have not fitted the conception of Dutch art held by some recent authorities. The response of their seventeenth-century counterparts, on the other hand, is indicated by the glowing description and the high price.

As with his other allegorical canvas, Vermeer turned to Dirck Pers' 1644 translation of that popular Italian book, Cesare Ripa's *Iconologia*, for assistance. The elements which he selected, as well as the way they are utilized, reflect Vermeer's specific wish to portray Catholic faith: he himself was a convert to Catholicism, the religion of his wife. Thus many of the basic symbols—the chalice, the book, the cornerstone, serpent, crown of thorns, and apple—which support this intention have been borrowed from Ripa's ubiquitous handbook.

Recently some unusual elements of this complex allegory have been convincingly explained. The beautifully rendered glass ball suspended above the ecstatic personification of Faith and the ebony crucifix do not appear in Ripa and have long puzzled art scholars. Several Jesuit emblems, however, do use a similar combination of elements. The meaning of the magnificently rendered sphere in which the entire room is reflected is convincingly explained by Willem Hesius' 1636 *Sacred Emblems*: "A small globe encompasses endless skies/ And captures what it cannot hold. Our mind is large enough/ Though people think it small/ If only it believe in God, nothing broader than that mind; never can he who believes/ Appreciate the greatness of this mind./ The mind is larger than the largest sphere because it is human."

From 1672 the Delft Jesuits had their residence and church house practically next door to where Vermeer and his family had moved; and we know that the artist himself worshiped there. Thus he was in close contact with those who could provide him with specific iconographic sources for this work. It seems likely also, considering its size and subject, that the painting was done on direct commission—perhaps from a member of this religious group—rather than merely on speculation. It is a theme that might well reflect personal as opposed to group taste. The delay of some twenty-five years between the completion of the canvas and its next sale also seems to suggest a private commission. Perhaps it was prompted by the religious character of the 1672 war with France. Dutch Catholics may well have found their faith tested by these events, and the present picture could be the result.

As elsewhere in Vermeer's works a number of elements appear either in other paintings by the master or in his death inventory, or both. The magnificent gold leather behind the table, for example, appears in both the Amsterdam *Love Letter* and in the inventory as "seven ells of gilt leather on the wall." The large painting of a crucifixion was also listed and has been identified as an early work of the Flemish artist Jacob Jordaens. In addition, both the foreground tapestry and the terrestrial globe appear in other compositions: the globe, by Hondius, in the Frankfurt *Geographer* and the tapestry in the London *Lady Seated at the Virginals*.

The tapestry that appears here is typical of a number of late Vermeer canvases. The device appears to function not symbolically but as a visual introduction to the pictorial space. It has been convincingly compared to the rhetorical device of the prologue, which is common in seventeenth-century literature. Apparently the demands of the *camera obscura*, still used by Vermeer at this point, encouraged him to adopt a typically literary device to his own special visual requisites.

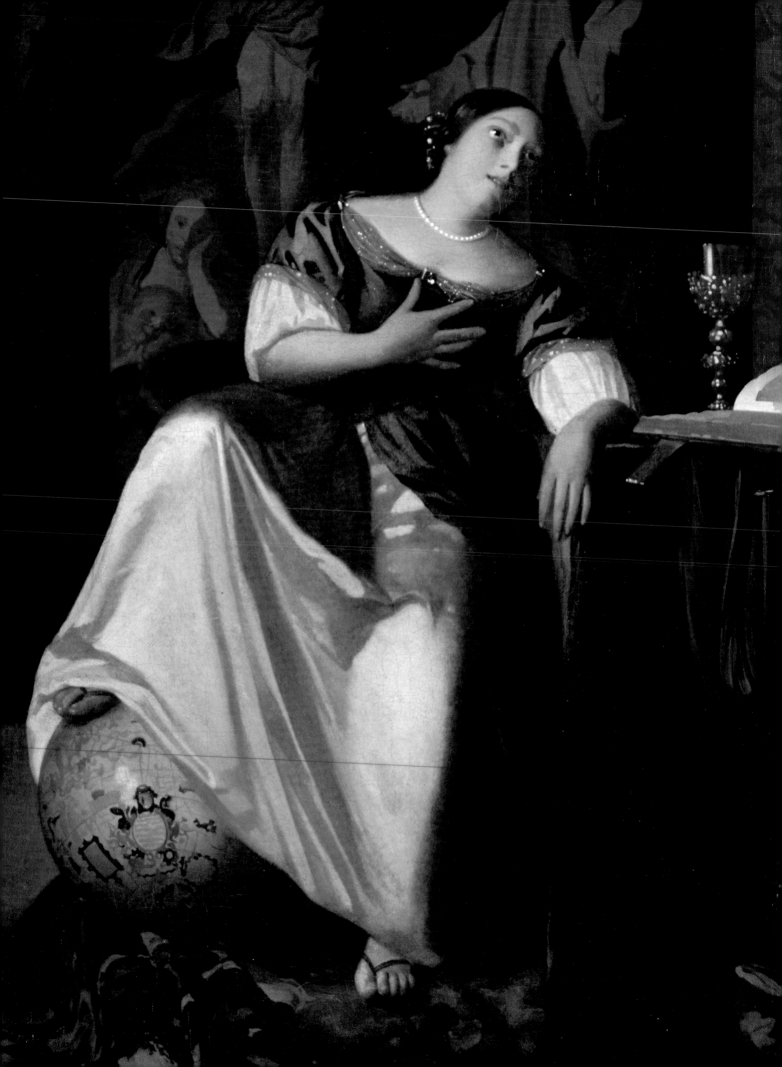

Panel, 15⅜ x 11⅝ in. (39 x 29.5 cm.)

The Hague, Mauritshuis

GERARD TERBORCH
Woman Writing
a Letter

c. 1655

For nineteenth-century art critics like Thoré-Bürger, Gerard Terborch was, after Rembrandt, the outstanding seventeenth-century Dutch artist. Modern historians of art, while praising Terborch's miniaturistic technique and charming style, would hardly rate him so high. Nevertheless, this delightful artist is one of the important innovators of Dutch genre painting during the late 1640's and into the 1650's, and his recently revealed contact with the young Vermeer in 1653 indicates that he may have played a direct and hitherto unsuspected role in the Delft artist's early development. This influence, interestingly enough, was not a one-way affair. Some late Terborch works are clearly influenced by the younger master's style.

Terborch's earliest painting is dated 1635, the year he entered the Haarlem artist's guild. During the same year the 18-year-old master traveled to England to work with his uncle Robert van Voerst. Thereby, at an important moment in his development, he was exposed to the achievement of Anthony van Dyck, the Flemish court painter active in England. Van Dyck's rendering of shimmering surface textures seems to have inspired the younger artist to attempt similar effects in his own, more careful style. His English voyage, unfortunately, was cut short by the sudden death of his uncle, and by the spring of 1636 Terborch was back in Zwolle.

Terborch's most famous work, *The Swearing of the Oath of Ratification of the Treaty of Münster, 15 May 1648*, in London, documents the two previous years he spent doing miniature portraits of delegates to the conference which officially ended the war between Spain and Holland.

In 1648, after a short stay in Antwerp, Terborch's presence was recorded in Amsterdam, where he seems to have begun to develop his new genre style. The following year he was working first in The Hague and then in Kampen, near his hometown; in 1653, his name appears in Delft, where he met Vermeer. In 1655, he was married in Deventer; and although he continued to travel, that town became his home base. He died there in 1681.

In the present picture, probably executed in Deventer, Terborch explores the letter theme which became so popular with Dutch painters, and especially with Vermeer. Two aspects suggest that this beautifully rendered and introspective composition deals with a love letter. As in Vermeer's later depictions of the theme, the woman is richly and elegantly dressed, introducing a worldly note. Furthermore, she is framed by a closed canopy bed.

Although essentially a miniature painter, it is clear that Terborch has absorbed the example of Van Dyck in his rendering of surface details and textures—an influence which at this moment, at least, he seems to have experienced in common with the early Vermeer. And the intense concentration captured by Terborch in the present work anticipates similar qualities of Vermeer.

111

Panel, 13⅝ x 10⅞ in. (34.5 x 27.5 cm.)

Rotterdam, Museum Boymans-van Beuningen,

Willem van der Vorm Foundation

GERARD TERBORCH
The Spinner

c. 1652–53

This charming and interesting little picture most probably originated as the right half of a pendant pair which included the so-called *Maternal Care* in the Mauritshuis. The two together form a multileveled depiction which, as in several other works by Terborch, seem to anticipate features of both style and subject later found in Vermeer's work. Since the two artists are known to have met in Delft in 1653, the year in which Terborch probably completed this work, the possibility of a direct influence now seems extremely likely.

Terborch is known to have used his second stepmother, Wiesken Matthys, as the model for both pictures in this pair. Thus, at the first and most obvious level, he presents us with what might be termed a portrait genre, as distinct from the better-known portrait history type. Rather than having the individual portrayed in the guise of a historical or literary character, we are now given a portrait of someone engaged in a common task. Although not invented by Terborch, the portrait genre is here imbued with a symbolic significance which enhances the moral character of the sitter.

The activity represented, spinning, has strong ties with the essential feminine virtues. Emblems by such popular writers as Roemer Visscher and Jacob Cats indicate that seventeenth-century Holland also saw spinning as the ideal symbol of modesty and virtue. Since the mate to this picture represents the same woman combing a child's hair, it is clear that together the two works represent Wiesken Matthys as combining motherhood with her other virtues.

Spinning and the combing of hair took on, in addition to these broader associations, an additional meaning during the seventeenth century: the implication of training or education. Terborch's introduction of a device for snuffing out candles as part of his spinning composition points clearly to this meaning, as does his other compositions. Several seventeenth-century writers saw in the candle snuffer a symbol of the old concept, "by taking away, obtaining," or, as one emblematic motto put it, "one must shear sheep in order to get wool." This popular saying may have prompted Terborch to link the two normally independent themes.

It happens that Jacob Cats applied the same general interpretation of education and training to his representations of a candlesnuffer and of a woman combing her hair. The latter, like the pendant to this work, *Maternal Care*, illustrated the motto "If you want fine hair, then some pain you must bear." The candlesnuffer, of course, was also an excellent educational image, for as Jan Luiken's heading to the picture indicates, one must put out the candle to preserve its usefulness. The English proverbial equivalent makes the meaning especially clear: "spare the rod and spoil the child." Thus complex moral programs, with their literature, underlay such simple scenes of everyday life as this Terborch and its pendant. In so doing they looked towards—and probably directly influenced—Vermeer's often emblematic approach to themes drawn from everyday life.

113

GERARD TERBORCH
Woman Peeling an Apple

c. 1661–62

Although the influence of Vermeer is exceptionally strong in this work, few would mistake it, as Thoré-Bürger did in the mid-nineteenth century, as a creation of the great Delft artist. Nevertheless, it is apparent that Terborch's early influence on Vermeer is now being repaid. Indeed, the Delft influence is one of the reasons, but not the only one, for dating this picture somewhat later than the usual c. 1660 often suggested. Clearly the development of Vermeer's so-called pearl pictures provided the impetus for the silvery tones Terborch utilizes here.

Interestingly enough, the basic theme of a figure occupied with peeling fruit was popularized by the innovative Italian painter Caravaggio. Although the influential Italian could not be considered directly responsible for this composition, his Northern followers did have a strong impact through Vermeer. The self-contained nature of the activity, captured by Caravaggio in his early *Boy Peeling Fruit*, was one feature transported to the North by Utrecht artists like Terbrugghen. Therefore, works such as this Terborch can be seen as descendants of the early attempts at internally generated and self-involved themes pioneered by Caravaggio and spread by his Utrecht followers.

Although the primal source of this theme comes out of late sixteenth-century Italian art, it is clear that Terborch's picture, in architectonic structure as well as tonality, derives from Vermeer and Delft. It is equally apparent that the theme of peeling fruit, so popular in Dutch seventeenth-century painting, had various moral applications—and was equally popular with writers of the period. Basically, the teaching of these emblems is that things easily obtained are held in contempt. Jacob Cats, for example, in his moralizing poem for an illusration similar to this picture writes: "Don't give a woman everything her brain requests, a child, a friend; and don't give yourself everything your abundant heart asks for."

Since Terborch has provided his woman with a mourning veil, and a snuffed-out candle stands on the table as a traditional symbol of *vanitas*, the moral of this picture may also be applied to the acquisition of worldly goods. The map on the wall, as in the works of Vermeer, clearly supports this application. It also may be that the marvelously rendered bowl of fruit on the table contributes something to the symbolic program. Roemer Visscher, another popular emblem writer of the period, accompanied his illustration of a rich bowl of fruit with the reminder that fruit which "ripened early, rotted first." Terborch has included a watching child, suggesting that the instructive thrust of Visscher's motto might well bear on this work. Thus, like many other seventeenth-century Dutch painters—certainly including Vermeer—Terborch provides us with a complex moral lesson disguised as a simple scene from everyday life.

Canvas on panel, 14⁵/₁₆ x 12¹/₁₆ in. (36.3 x 30.7 cm.) Vienna, Kunsthistorisches Museum

CAREL FABRITIUS
View of Delft
1652

Carel Fabritius, son of a schoolmaster and amateur painter, was born in Midden-Beemster in 1622. The name Fabritius, which he had assumed by 1641, could derive from his early training as a carpenter (farber) in his youth. His first artistic training may have been with his father, but his obviously superior talents quickly led him to Rembrandt's studio in Amsterdam. Between 1641 and 1643 both he and the painter-writer Samuel van Hoogstraten must have worked side by side under the great Amsterdam artist.

By 1650, and perhaps even earlier, Fabritius was recorded as living in Delft. However, he did not become a member of the painter's guild there until 1652. The belief that Vermeer was a pupil of Fabritius has come mainly from contemporary comments written vaguely and poetically after Fabritius' death in "the Delft thunderclap," the terrible explosion of the municipal arsenal on October 12, 1654. Even in the absence of firm support for that assumption, it seems possible that Vermeer may have spent some few months "finishing" with Fabritius after he completed his formal training under some still unknown lesser master. There can be no doubt, in any case, that the young Vermeer knew Fabritius' work. Such paintings as this View of Delft were of critical importance for both Vermeer and the development of the new Delft style during the 1650's.

Fabritius' tragically short life, ended by the explosion which also destroyed his studio, has made his certain works even rarer than those by Vermeer. Accordingly, his precise influence on the younger artist is difficult to assess. Works like his large Beheading of St. John the Baptist in Amsterdam may, even so, be seen as a possible stylistic source, along with the Utrecht school, of early Vermeer works like the Dresden Procuress. A Fabritius St. John, perhaps even the Amsterdam picture, was in the 1696 Dissius sale; and the presence there of the twenty-one Vermeer paintings indicates that the Fabritius had probably been in Delft earlier, and thus had been available to the young Vermeer.

Perhaps Fabritius' most important contribution to Delft art, and thus to Vermeer, was in the area of illusionistic perspective such as in this picture. Contemporary sources mention other similar works, but only this one survives to show his interest in optics and townscape. Like Vermeer's stunning treatment of the same subject, in The Hague, this tiny picture is topographically accurate. In the center is

DETAIL

the Nieuwe Kerk and just to the left of it, in the distance, can be seen the Delft Town Hall. On the right are several of the houses on the street known as the Vrouwenrecht. It may be that the foreground lute and viola de gamba, as well as the activities of the man, are symbols contrasting worldly values with the prominently depicted Delft church. Even the swan on the signboard, as it happens, is an old symbol of worldly pleasures.

The small size, unusual perspective, and cut-off viola da gamba in the foreground have invited the speculation that this canvas was once affixed to the hemicylindrical rear surface of a small perspective box. Photographic reconstructions of this painting as part of one of these unusual Dutch seventeenth-century contrivances seem to bear this out, for when the picture is viewed on a curved surface, its spatial distortions show an illusionistic, three-dimensional effect. Fabritius is known to have constructed a number of such devices, and through them he apparently fostered in Delft an interest in perspective, in optics, and in architectural subject matter—resulting in interior as well as exterior views of buildings and in realistic townscapes. Although it would be a mistake to credit the entire creation of the Delft style to Fabritius alone, works like the present one do show him as a prime catalytic factor.

119

Panel, 27⁹/₁₆ x 21 in. (70 x 53.3 cm.)
London, National Gallery of Art

NICOLAS MAES
The Sleeping Kitchen Maid
1655

This charming painting, also known by the title "The Idyle Servant," anticipates Vermeer's Metropolitan Museum of Art *Sleeping Girl* in elements of the subject matter as well as the style. Indeed, this Maes appears to be the earliest securely dated genre picture of this type, and it is clearly related to—although not directly dependent upon—developments in Delft. Since a visit to Delft by Maes is not documented, it is likely that he came to this important artistic stage along parallel paths.

Maes was born in Dordrecht in 1634, only two years after Vermeer, and Dutch sources tell us that he first studied drawing with "a mediocre Master." He must have shown early promise, for about 1650 he was sent to Amsterdam to study with Rembrandt. Three years later he returned to his hometown, moving back to Amsterdam in 1673. Unlike Vermeer, who rarely ventured far from Delft, Maes traveled to Antwerp to study the works of the great Flemish masters, Peter Paul Rubens and Anthony van Dyck. At that time he also visited the old Jacob Jordaens, among other painters. He died in Amsterdam at the age of 59.

It is difficult to isolate the critical factors resonsible for the precociousness of style in this work. The architectonically structured composition contains a perspective view into another room, a device later favored by Delft painters. It could have resulted from Maes' contact with Samuel van Hoogstraten, an artist who had worked in Rembrandt's studio at the same time as Carel Fabritius, and who was living in Dordrecht by 1654. It seems likely that the shared experience of Rembrandt's workshop would have brought Maes and Hoogstraten together. Like Fabritius, Hoogstraten was interested in perspective and illusionism and is similarly known to have constructed several perspective boxes. By 1654, Hoogstraten had, furthermore, begun producing completely illusionistic *trompe-l'oeil* pictures. It remained for Maes, however, to take these perspective and optical developments, and utilize them, for the first time, for genre painting. Hoogstraten thus appears to function as the catalytic factor for Maes in Dordrecht as Fabritius did for Vermeer in Delft.

In theme this moralizing genre picture seems to carry, at least at one level, a warning similar to that found in Vermeer's *Sleeping Girl* of just a few years later. Indeed, the servant's pose is one traditionally linked with the vice of Sloth, and seventeenth-century viewers would have quickly recognized the association. As in Vermeer's work, what at first appears to be merely charming narrative detail to enliven the composition, turns out to be a key to the picture's moral context. Thus, the hungry cat making off with the bird can be related to the explanatory poem for a popular emblem: "For, though the Mice a harmfull vermine bee, And, Cat the remedie; yet oft wee see, That, by the Mice, far lesse, some house-wives leese. Then when they set the Catt to keep the cheese, A ravenous Cat, will punish in the Mouse The very same offences, in the house, which hee himselfe commits." This moral, roughly a variation of the adage "while the cat's away the mice will play," may then be extended to include the second woman.

NICOLAS MAES
The Eavesdropper
1657

This unusual theme was apparently an appealing one to Maes and his patrons, for from 1655 on he executed a number of variations on it. The present work can be seen as an elaboration, formally as well as iconographically, of a 1656 picture in the Wallace collection, London. Here, departing from his earlier treatments, Maes has given free rein to his interest in complex spatial vistas as well as to an expanded symbolic exploration of the theme itself. The present version is clearly his most subtle investigation of both aspects.

Once more Samuel van Hoogstraten's influence appears as a critical factor. Pictures like Hoogstraten's unusual composition, *The Slippers*, in the Louvre, although completely without figures, can be seen to provide the impetus both for Maes' present explorations of architectural spaces and for Vermeer's Amsterdam *Love Letter*. Maes, however, goes considerably further in his depiction of a multi-leveled architectural interior: Hoogstraten's perpective boxes already appear to be influential. Nevertheless, the present picture is not merely the virtuoso whim of a young artist but a construction which communicates meaning through its various symbols. In this way it takes on added importance as an anticipation of both Pieter de Hooch and Vermeer.

As though it were some seventeenth-century Dutch "Upstairs, Downstairs," the various social classes are provided with their own territories. Central to the composition, and giving the canvas its name, is the mistress of the house, who, as she eavesdrops on the maid and her lover, hushes the viewer with a familiar gesture. An empty chair at the upstairs table tells us where she comes from and her fur-trimmed jacket, who she is. Downstairs, the object of her interest—the pair of lovers—is the focal point of a diagonal construction formed by the hanging map of the world, a chair draped casually with the outer garments of the male, and his sword. These motifs, frequently found in Dutch seventeenth-century genre painting, can be linked with profane love. Through the open kitchen doorway between the couple and the worldly symbols can be seen the same odd detail as in the 1655 *Sleeping Kitchen Maid* in London: a ravenous cat stealing a fowl. Here again this action must be understood in terms of the emblematic literature of the period.

Contemporary Dutch writers saw the hungry cat as a multi-leveled symbol—like the space of this picture—hinting at the theme, "while the cat's away the mice will play." Clearly it points to the relationship of mistress and maid in this work—a relationship also explored in Pieter de Hooch's 1658 *Maid and Child in a Delft Courtyard* in London. Here, however, the pertinent emblem underlines the responsibility of servants, public as well as private, to their duties. Maes includes, carved between the arches, a sculptured head inscribed Juno, who in Roman mythology was the goddess who protected heads of households as well as heads of state. Maes evidently wished this painting to take on the broader implication of the emblem, and so to encourage good public servants as well as private ones. Obviously, both were as difficult to find then as now.

Canvas, 36³/₁₆ x 47⅝ in. (92 x 121 cm.) Dordrecht, Dordrechts Museum

PIETER DE HOOCH

Maid and Child in a Delft Courtyard

1658

One could never guess from this work that Pieter de Hooch studied with the Italianate landscape painter Nicolaes Berchem. The facts of his early career are scarce; the present work carries the earliest date on a de Hooch picture—1658. A previous phase is indicated, however, by several genre paintings in the style of Pieter Codde from Haarlem and Willem Duyster from Amsterdam. These works seem not to have been terribly successful, for in 1652 he is recorded as a servant and painter working for the cloth merchant Justus de la Grange in Delft. The exact nature of this arrangement is uncertain, but like Emanuel de Witte, de Hooch may have been earning his keep as a contract painter. De la Grange, it appears, owned eleven of his paintings in 1655.

Whatever the arrangement with de la Grange, de Hooch did not become a member of the Delft artist's guild until 1655. It is clear from works like the present one that the Delft experience completely transformed his style— a change which probably came about through contact with Fabritius and with the enigmatic but seemingly important Delft artist Hendrick van der Burch. The architectonic Delft approach remained the basis of his work until his death in 1684 in an Amsterdam madhouse, when he was 55. De Hooch's settings became more opulent and rich after his move to Amsterdam in about 1660, and there is a considerable decline in the quality of his late work, possibly due to his mental condition.

Three de Hooch paintings besides the present one are dated 1658, and it is clear from all of them that he, along with Vermeer, had brought the Delft style to a high point. Behind this achievement is also the impetus of Fabritius and Nicolas Maes.

It is safe to presume that Vermeer and de Hooch knew each other's work, and very possibly each other since they were contemporary fellow guild members. Significantly, the influences seem to have moved in both directions. In structure the present picture anticipates works such as Vermeer's *The Little Street* in Amsterdam, and it is possible that the expansion of Vermeer's interior space during the early 1660's is a result of de Hooch's success with this compositional device.

As with Vermeer, and the works of many other Dutch genre painters of the period, the key to the meaning of this beautifully structured composition lies in a secondary feature. The inscription on the stone tablet, originally over the entrance of the Hieronymusdale Cloister in Delft (and still surviving, set into a Delft wall) reads: "This is St. Jerome's valley, should you wish to resort to patience and meekness. For we must first descend if we wish to be raised. 1614." Since many of de Hooch's works are concerned with the relationship between servant and mistress or master, the epigram is appropriate not only to this but to many of his other pictures as well. It may even apply to his own early relationship with Justus de la Grange. Interestingly, the play on words in the Dutch inscription echoes the spatial movements in and out of the architectural framework that de Hooch has here created. A final point of comparison: de Hooch often focused his compositions on children. Vermeer, although he painted pregnant women and was at least eleven times a father, never included a child in his work.

Canvas, 28¹⁵/₁₆ x 23⅝ in. (73.5 x 60 cm.) London, National Gallery of Art

PIETER DE HOOCH
The Linen Cupboard
1663

Although de Hooch seems to have moved to Amsterdam as early as May 1660, the first date to appear on one of his paintings after he left Delft happens to be the 1663 found on the present work. It is usually presumed that this picture was executed in Amsterdam. However, he was also recorded as being in Delft during this same year. The visit was of artistic importance for both de Hooch and Vermeer, who seem to have kept in touch with each other. De Hooch certainly saw Vermeer's *Goldweigher* (c. 1662–63), now in Washington, and one direct result was his own *Goldweigher* (c. 1664) in Berlin.

For Vermeer, the encounter was less obvious. Nevertheless, his expanded use of interior space in such a work as the Buckingham Palace *Lady and Gentleman at the Virginals* (1664) was probably due to this renewed exposure to de Hooch's interior compositions. The present work is typical of the type of expanded genre interior which de Hooch and Vermeer brought to its highest level during the mid-1660's and into the 1670's. Since Vermeer-inspired elements appear in de Hooch

as late as 1675 the two men must have stayed in contact.

As in many of his pictures, de Hooch presents the viewer with a contrast of activities, social positions, and ages. His treatment of the two women here again explores the relationship between servant and master (or mistress). The serious activity of the adults is in turn opposed to that of the child with the "kolf" club, who views the scene from the doorway.

An unusual aspect of this marvelous Dutch interior is the inclusion of a small statue of Mercury above the doorway, closely related to a bronze by Hendrick de Keyser in Amsterdam. De Hooch equips the god with a bag of what is presumably money in place of the usual cornucopia symbolizing abundance. The richness of the back room, the classical details of the architecture, and the activity of the women all seem to confirm this implication in the statue. As the god of industry and commerce, Mercury was frequently invoked on behalf of the rich mercantile city of Amsterdam, and de Hooch undoubtedly felt him to be quite at home in his scene. Later emblem writers like Jan Luyken, however, became more critical of such behavior as avaricious and of value only to moths! Except for his introduction of Mercury, de Hooch eschews any overt moral statement at all, and so avoids making his interior scene into a condemnation of the actions he so lovingly depicts.

126

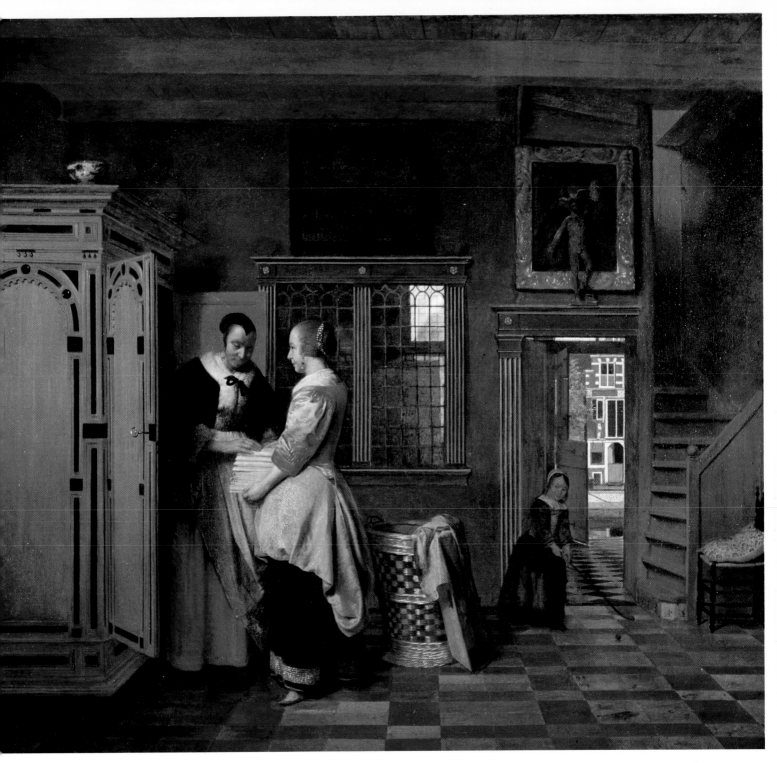

Canvas, 20³/₈ x 30½ in. (72 x 77.5 cm.) Amsterdam, The Rijkmuseum

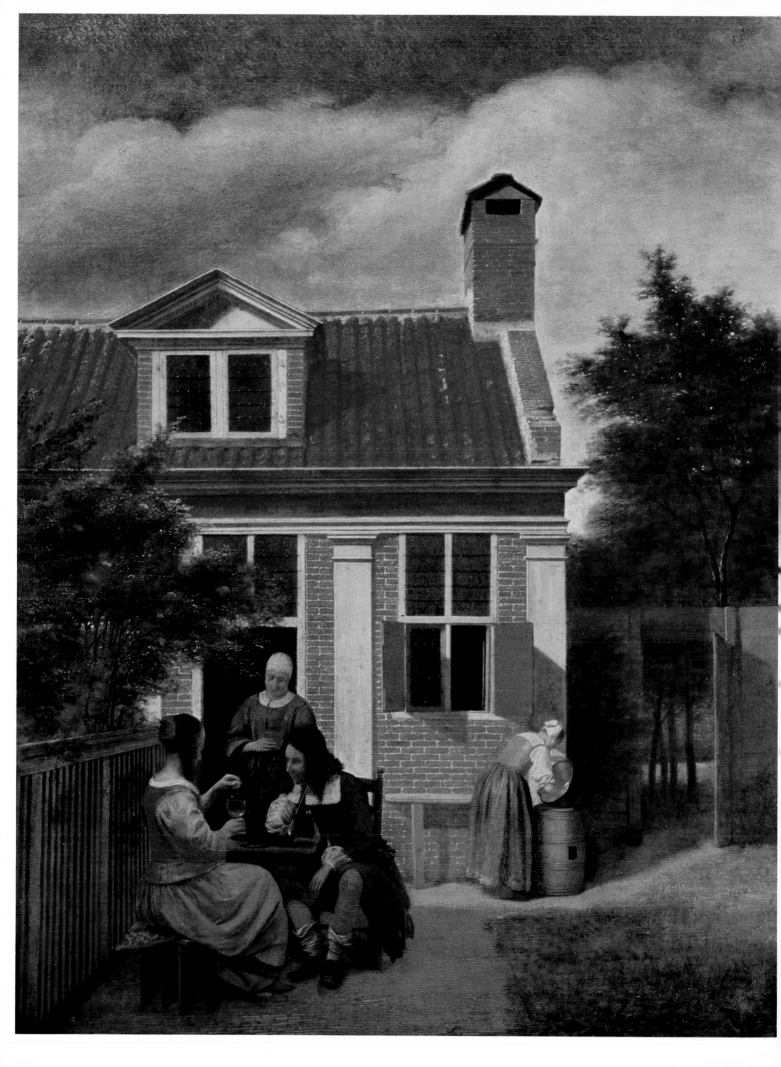

Canvas, 24 x 18½ in. (61 x 47 cm.)

Amsterdam, The Rijksmuseum

PIETER DE HOOCH
A Country Cottage

c. 1663–65

Although landscape painting was one of the important Dutch artistic specialties, and de Hooch had studied with the famous Italianate landscape artist Nicolaes Berchem, most of his outdoor scenes are hardly deserving of the name. Like Vermeer, who provided a landscape setting for only one early work, *Diana and Her Companions* in the Mauritshuis, de Hooch seems only marginally aware of the significant contributions his Dutch colleagues and his teacher were still making in this area. Indeed, de Hooch was apparently most at home with settings sympathetic to the architectonic structure so typical of Delft genre painting and so congenial to its exponents. Thus, when a Delft artist turned his vision to the world outside his carefully composed interiors, townscape replaced landscape.

As in de Hooch's earlier London *Maid and Child in a Delft Courtyard*, the present picture is entirely composed of architectural elements and is handled exactly like one of his interior works. Even the carefully controlled light, a significant aspect of the Delft artistic contribution, is closely related to his and Vermeer's earlier genre interiors.

Since this canvas was most probably executed shortly after de Hooch's 1663 visit to Delft, Vermeer's renewed influence is apparent in the oblique relationship between the seated figures, and in the woman's lost profile—the latter recalling Vermeer's *Soldier and the Laughing Girl* in the Frick Collection, with a repositioning of figures.

Here we are once again presented with de Hooch's clear distinguishing of activities. The servant girl busy scrubbing a pot at the water barrel in the background opposes the elegant "merry company" in the foreground. In some ways the latter grouping also recalls the three-figured procuress scenes favored by Dirck van Baburen and other earlier Utrecht painters. It is in fact quite probable that de Hooch knew Baburen's Boston *Procuress*, which Vermeer's family owned. The fashionable dress and the drinking, however, are updatings of the earlier moralizing composition, and the inclusion of a long clay pipe is another new addition. Literary comments to the effect that "smoke is the food of love" seem to underline the immoral character of the group. Yet de Hooch introduces a contrasting note in the activity of the servant girl. In many contemporary emblems and related pictures physical cleanliness was associated with moral purity. Biblical references to Mary as a "vessel most clean" would also have reenforced the moral reading of this simple, everyday action. As if to lend further emphasis to the moral contrast, de Hooch places the table grouping in the shade while the "virtuous" activity of the servant girl is caught in a patch of bright garden sunlight. Once more it becomes clear that Pieter de Hooch is at his best when the impact of Delft is strongest.

PIETER DE HOOCH
The Goldweigher

c. 1664

After his departure from Delft in 1660 de Hooch settled in Amsterdam. Nevertheless, it is obvious from this work that the Delft style remained a key feature of his Amsterdam production. Some have found him changing styles to reflect the wishes of his new, richer Amsterdam patrons. However, Dutch art as a whole was being similarly transformed during the 1660's, primarily under French influence, so that this view may be somewhat simplistic. Late Vermeer pictures such as the Metropolitan Museum *Allegory of Faith*, for example, have been similarly criticized as a diminishing of the painter's powers, simply because the more severe architectonic works are more to the taste of modern critics and historians.

It seems likely, given the subject of the present canvas, that the opulent setting provided by de Hooch is a result of a deliberate and meaningful decision rather than the whim, or taste, of some unknown patron. Even so, there is clearly an outside influence present in this work. Despite the visual impact of the rich gilt leather walls, the picture is obviously based on Vermeer's *Goldweigher* (c. 1662–63) in Washington. Compositional focus on a single figure, although quite nor-mal for Vermeer, is rarely found in de Hooch's art. Thus it is apparent that he must have maintained continuing contact with both Vermeer and Delft after his move to Amsterdam—and he could have seen Vermeer's painting during his known visit to Delft in 1663. There are differences, however, in the way the two artists interpreted the same basic theme.

Earlier seventeenth-century renderings of goldweighers—for example, Willem de Poorter's picture in Raleigh—show a handling of figures and settings that work primarily as a comment on the vice of avarice. Usually the personage depicted was either an old man or an old woman, in keeping with the belief that this vice was a product of old age.

Then, during the middle of the 1650's, painters like Gabriel Metsu began to stress only the broader concept of *vanitas*, as a warning on the corrupting power of worldly possessions—thus anticipating the present canvas. Since Vermeer, as well, included an old-fashioned Last Judgment picture in his *Gold-weigher*, he was connecting his weighing with the weighing of souls on the Day of Judgment. De Hooch, on the other hand, makes no specific allusion to this idea, but does stress the extreme richness of the interior setting in which the action takes place. Thus he calls attention only to the vanities of this world. The appropriate biblical text, Matthew 6: 19–20, ends with the phrase "but lay up for yourself treasures in heaven," an admonition implied by de Hooch, rather than stressed as by Vermeer.

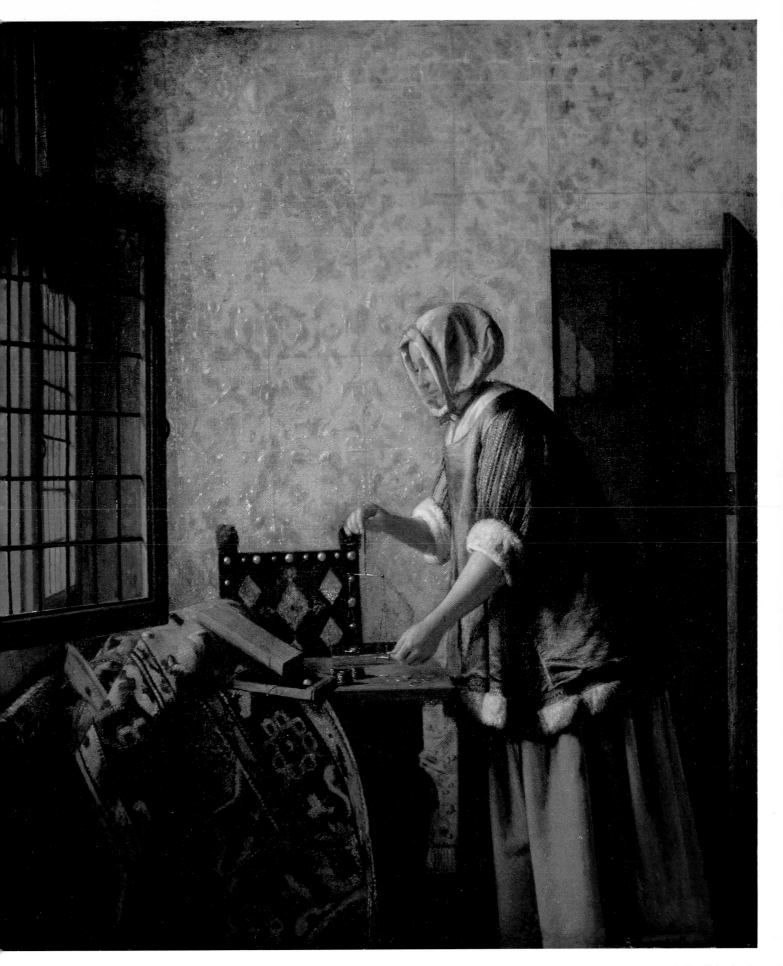

Canvas, 24 x 20⅞ in. (61 x 53 cm.) Berlin, Staatliche Museum Preussischer Kulturbesitz

JACOB VAN LOO

Wooing

c. 1650

Although little known today, Jacob van Loo enjoyed a considerable reputation in both Holland and France during the seventeenth century: a 1654 poem by Jan Vos praises him along with a roster of important Dutch painters that includes Rembrandt! Though few modern critics would put him in such illustrious company, he seems to have exerted a strong influence on the young Vermeer and, even more importantly, on the development of Dutch genre painting as a whole during the critical period of the late 1640's and early 1650's. Unfortunately, too little is known of van Loo's activity and we are unsure of the nature of his contact with Vermeer and Delft. Yet the composition, if not the color, of Vermeer's early *Diana and Her Companions*, in The Hague, is clearly dependent on van Loo's 1648 rendering of the same theme in East Berlin. How Vermeer came to know the work is still a puzzle.

Jacob van Loo was born about 1614 in Sluis in the Dutch province of Zeeland, the son of a minor genre painter who specialized in brothel scenes. His first artistic training apparently took place in his father's workshop. During the 1640's the influence of Anthony van Dyck and other elegant Flemish artists becomes apparent in his work (as in this example), suggesting that he may have traveled to nearby Antwerp. It is this Flemish quality which very possibly attracted the young Vermeer, and which shows also in his own early canvases. During the decade of the 1650's various influences from Terborch and Maes are also discernible in both van Loo's and Vermeer's work, indicating that van Loo was part of the stylistic mainstream of Dutch genre

painting outside of Delft. He seems to have lived in Amsterdam from 1642 until 1660 when he was involved in a murder and was forced to move to Paris. There he found quick acceptance, and soon became a member of the Royal Academy of Art.

In style, the present work is quite close to that of the 1648 *Diana* which influenced Vermeer. Other works of 1649 indicate that van Loo was also exploring musical themes related to those painted by Terborch about the same date. Thus, although undated, *Wooing* fits comfortably into his stylistic development about 1650.

The young servant closing the door behind him and the partly open canopy bed framing the couple indicate that van Loo has given us no ordinary domestic interior. Notwithstanding the elegant dress worn by the participants, numerous elements support the theme of seduction: the evidently intimate relationship between the man and woman; the presence of a large glass on the table; as well as the large shell in the pediment above the door, a traditional symbol of Venus. The woman, although having put aside her sewing basket, a traditional virtue symbol, has not yet abandoned her footwarmer. Roemer Visscher, the popular emblem author, mentioned the latter as a reliable replacement for a man, and one much beloved by Dutch women. In this case it makes the cajoling posture of the man quite understandable.

In some ways this elegant interior scene represents an updating of the type of brothel scene painted by van Loo's father, Johannes —a step toward gentility from those brash early Amsterdam and Haarlem bawdy-house depictions comparable to Vermeer's *Soldier and the Laughing Girl* at the Frick. At the same time, both the architectonic structure and the stylistic elegance of the present work anticipate qualities developed later and even more successfully in the canvases of Terborch, de Hooch, and Vermeer.

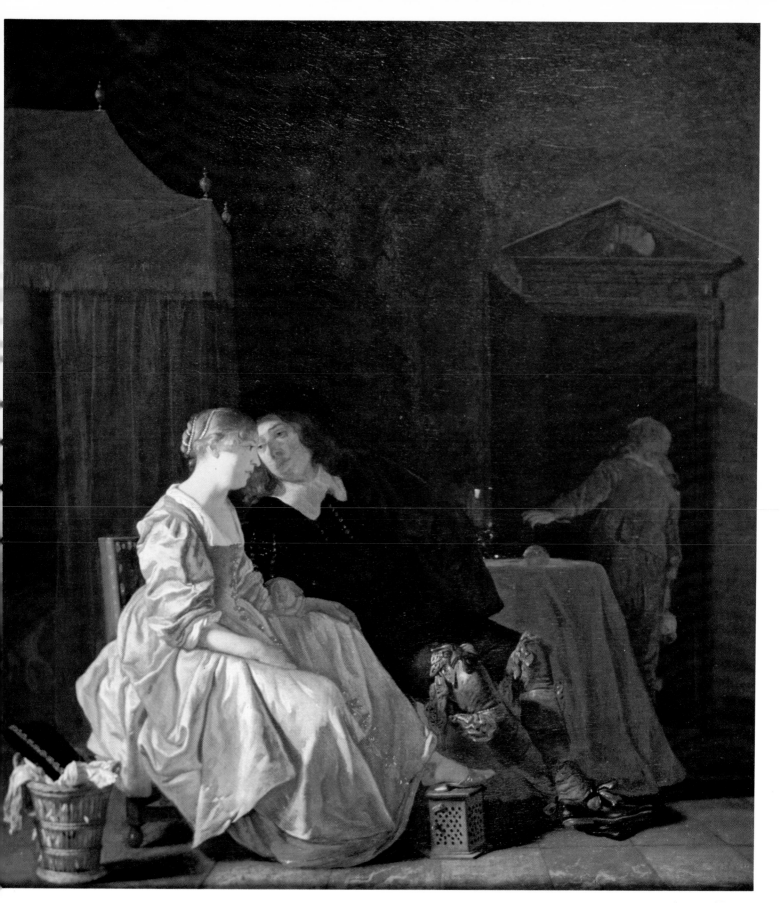

Canvas, 28⅞ x 26⁵⁄₁₆ in. (73.3 x 66.8 cm.) The Hague, Mauritshuis

PIETER JANSZ SAENREDAM
The Old Town Hall of Amsterdam

1657

Psychohistorians might make much of the fact that Pieter Saenredam, who became the first and foremost specialist in paintings of realistic architectural subjects in The Netherlands, was a hunchback and something of a recluse. Yet his choice of both subject and style derived quite predictably from his family background and his early artistic contacts. Born in Assendelft near Haarlem in 1597, Pieter was the son of a noted graphic artist, Jan Saenredam. While he was still a child, after the death of his father, his mother took him to Haarlem where he spent ten years, 1612–22, in the studio of Frans de Grebber. There he worked with one famous architect-painter, Pieter Post, and was probably influenced by the drawings of another: Jacob van Campen. By the time he entered the Haarlem artist's guild in 1623, his area of specialization seems to have been decided and steadily deepened. A 1662 biography, written three years before his death, notes that Saenredam by "about 1628 devoted himself entirely to painting perspectives, churches, halls, galleries, and other things from the outside as well as the inside, in such a way, after life, that their essence and nature could not be shown to a greater perfection." His earliest dated work, a 1628 *Interior of the Church of St. Bavo, Haarlem*, in the Heldring collection, Oosterbeck, confirms that Saenredam was already an accomplished architectural painter.

Despite his disability, Saenredam traveled frequently in order to make the numerous drawings of Dutch public buildings and churches which became the basis of his paintings. His methodical working habits, recorded in many of the drawings that survive, show three main stages. First, he made careful sketches and ground plans, and took measurements at the building site. Back in his Haarlem studio these were then used in the creation of a large finished drawing. Finally, when Saenredam was ready to paint, the drawing was transferred to his invariable painting material, a panel. Often, however, a long period elapsed between drawing and finished painting—in the present case, sixteen years!

Such methodical working habits made for excellent documentation. The study for this magnificent portrait of the Old Town Hall of Amsterdam in the Teyler Foundation, Haarlem, is inscribed as follows: "I made this sketched drawing from a big and neat drawing, which I had drawn from life as perfectly as possible . . . in the year 1641 on the 15th, 16th, 17th, 18th, 19th and 20th of July working on it assiduously from morning till night." Years later, after the Gothic structure had been destroyed by fire, Saenredam salvaged his drawings and made the present painting.

In 1648 Jacob van Campen began the construction of a new town hall for Amsterdam, on a different site from the old one. He designed it in the classical style and had it decorated with sculptures and paintings which symbolized the virtues of municipal government. It replaced a gothic structure which had come to seem old-fashioned and out of keeping with the economically flourishing city. Nevertheless, after the old building burned in 1652, the city seems to have experienced a

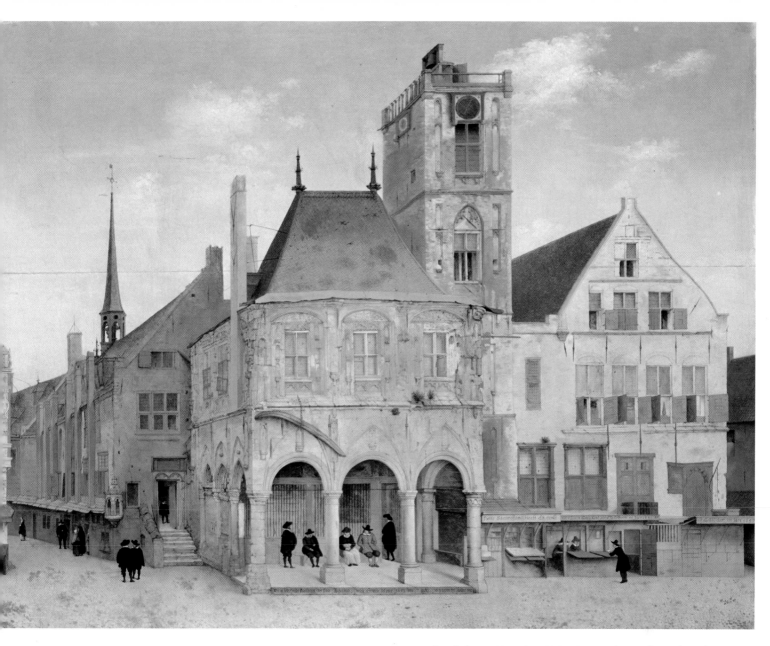

Panel, 25⅛ x 32¹¹/₁₆ in. (64.5 x 83 cm.) Amsterdam, The Rijksmuseum

deep feeling of loss. When Saenredam fin-
ished his painting, the burgomasters hung it
in their new town hall chambers, as a tangi-
ble and significant image of Amsterdam's
progress from Gothic past to classical present.
In common with other realistic architectural
paintings, this one seems thereby to hint at a
kind of civic virtue. Although Saenredam him-
self seems to have had no contact with Delft,
his example as the foremost architectural spe-
cialist in Holland must have served to inspire
other painters at this time, both in Delft and
elsewhere.

Panel, 22¹/₁₆ x 14¹⁵/₁₆ in. (56 x 38 cm.)
The Hague, Mauritshuis

GERARD HOUCKGEEST
The Tomb of Willem the Silent in the Nieuwe Kerk in Delft

1651

Though Gerard Houckgeest was once thought to be a follower of Emanuel de Witte, critical opinion has recently switched roles: Houckgeest, it is suggested, was the true innovator and de Witte, the follower. Since both men lived in Delft at the same time, and the crucial pictures in this scholarly argument have no dates, the question of precedence will probably remain open, at least for now.

Houckgeest was born in The Hague about 1600 and joined the guild there in 1625. By March 1635, however, he was living in Delft, and four years later became a member of the guild of that town. In 1649, he again pulled up stakes, sold his house in Delft, and three years later was recorded in Steenbergen. Shortly thereafter we find him in Bergen op Zoom, where he died in 1661.

Although Houckgeest specialized in architectural pictures, until 1650 his work consisted mainly of fantasy buildings of the type favored in the Southern Netherlands. His first realistic church interior, in Hamburg, dates only from the year 1650, just after he left Delft. But the artistic development of that town had already begun, and was no doubt critical to this new realistic aspect of his style. Houckgeest, being already an architectural specialist, was particularly affected by the phenomena that eventually produced the new Delft style—one of which could well have been Fabritius' arrival in Delft sometime before 1650. Some unrecorded contact between Houckgeest and the innovative Fabritius very likely sparked the former's sudden shift to realistic architectural subjects. (Before 1650, Pieter Saenredam in Haarlem was the only Dutch artist to specialize completely in this type of painting.) Not only the Delft subject of the present picture, but also the qualities of light in it and the handling of color suggest the contact with Fabritius—as may also the earliest architectural pictures of Delft churches by Emanuel de Witte. Since he too left Delft shortly after Houckgeest, it is clear that the important developments there—and possibly the arrival of Fabritius—took place before 1649.

Houckgeest painted several interior views of the New Church in Delft in which the tomb of Willem the Silent (1533–1584), father of the Dutch republic, is featured. The present picture, painted from the southeast, focuses on one of the many allegorical figures on the tomb, the one which personifies freedom. In 1648, the signing of the Treaty of Münster had finally granted the Northern Netherlands legal and official independence from Spain (though the northern provinces had, in reality, been free from Spanish rule since 1609): thus, both the compositional and symbolic importance here of the allegorical figure of Freedom. Perhaps the comment extends also to the recent and unpopular political moves of Willem II just before his death in 1650, in this unusual blending of architectural realism, national history, and political symbolism.

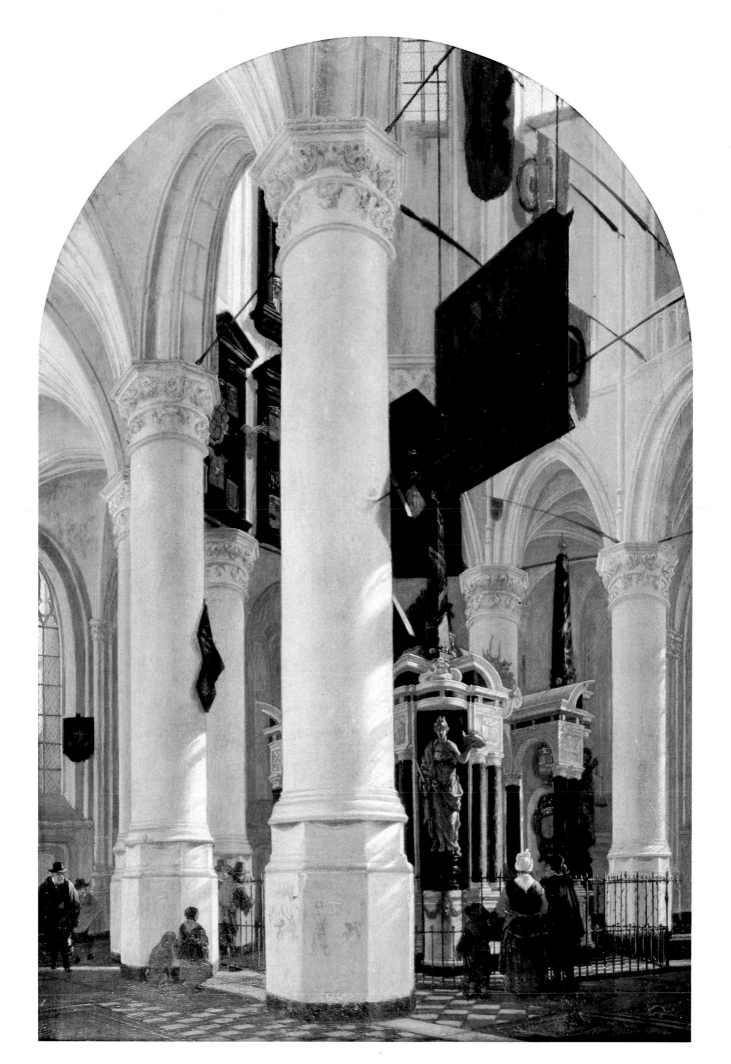

JAN STEEN
The Theater of the World

c. 1665–67

Earlier romantic and realist critics who believed that seventeenth-century Dutch artists painted only their own physical surroundings naturally identified this work with the tavern Jan Steen ran, and entitled it "Jan Steen's Tavern." Vermeer, as it happens, also seems to have run a Delft tavern, "The Mechelen," during much of his adult life. However, since Vermeer's quiet interior scenes do not suggest, as Steen's do, the boisterousness of seventeenth-century tavern life, the association was never pointed up.

Steen, like his fellow Leydener, Rembrandt, appears to have had an exceptional education for an artist. The two artists also shared a middle-class background: Steen's father was a brewer, Rembrandt's a miller. The former seems to have had a classical education, for in 1646 he enrolled at Leyden University. As he was about twenty at the time, Steen must have been born about 1625 or 1626.

Like his academic education, Steen's artistic training was also extensive. He first studied with Nicolaus Knupfer at Utrecht, then continued with Adriaen van Ostade at Haarlem. Finally, he seems to have "finished" with the landscape painter Jan van Goyen in The Hague; and he married van Goyen's daughter in that city in 1649.

Steen then appears to have spent several critical years painting and running his tavern, "The Snakes," leased for him by his father. Thus he was on hand at the inception of the Delft artistic blossoming. His temperament and training, however, were such that the architectonic elements favored by the leading Delft innovators had only an occasional influence upon his style. The present interesting and beautifully executed work seems to be such an occasion, especially in the cool light, the clearly defined interior space, and the use of an illusionistic curtain. The latter element was popular in Delft, though it could also have derived from the work of Gerritt Dou, who began using it in Leyden as early as 1646.

Steen seems to have moved about a great deal, and was known to have been active in Haarlem in 1661. By 1670 he was living back in Leyden, where he continued to paint and run a tavern until his death in 1679. This secondary profession does not seem to have diminished his artistic production. Unlike his fellow tavern owner, Vermeer, he was extremely prolific, executing some eight hundred works.

The present picture apparently deals with the popular seventeenth-century concept, which appeared, among other places, carved over the entrance to the new Amsterdam theater, built in 1637: "The World is a Play, each plays his role and receives his share." Like his great sixteenth-century predecessor, Pieter Breugel the Elder, Steen may be seen as cataloging human folly. Where Breugel painted *Children's Games*, Steen presents us with a variety of activities which might be termed "Adult Games." Each group seems to depict some facet of human foolishness as the painted curtain is drawn aside. That these activities are condemned as worldly vanities is

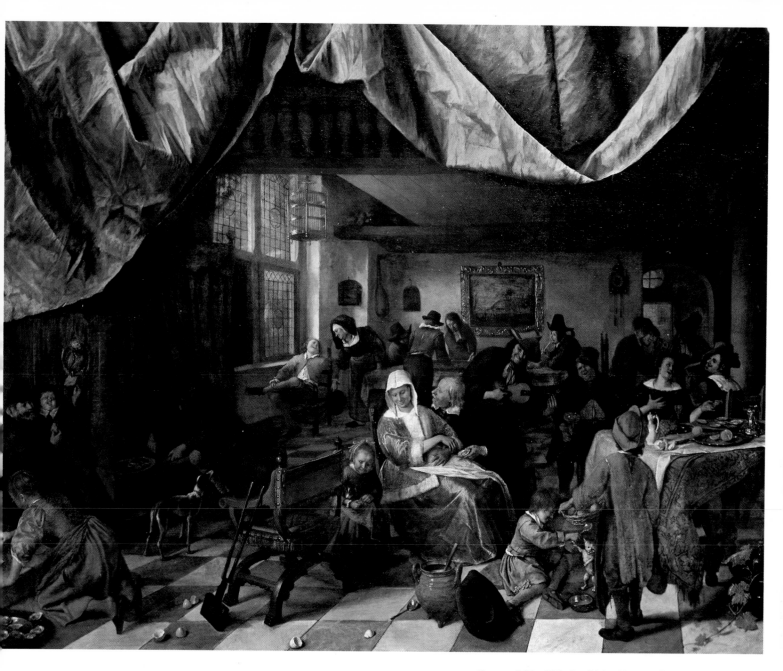

Canvas, 26⅞ x 32⁵⁄₁₆ in. (68.2 x 82 cm.) The Hague, Mauritshuis

revealed by the presence of a small figure blowing soap bubbles in the rafters next to the birdcage, a death's head at his side. Both these images—the bubbles and the skull—were traditional metaphors for the transience of human existence; and so they provide the moral framework through which all the actions in this picture must be viewed. Thoré-Bürger, the nineteenth-century discoverer of Vermeer, recognizing the satirical and moral aspects of Steen's art, called him, appropriately, "the Molière of Dutch painting."

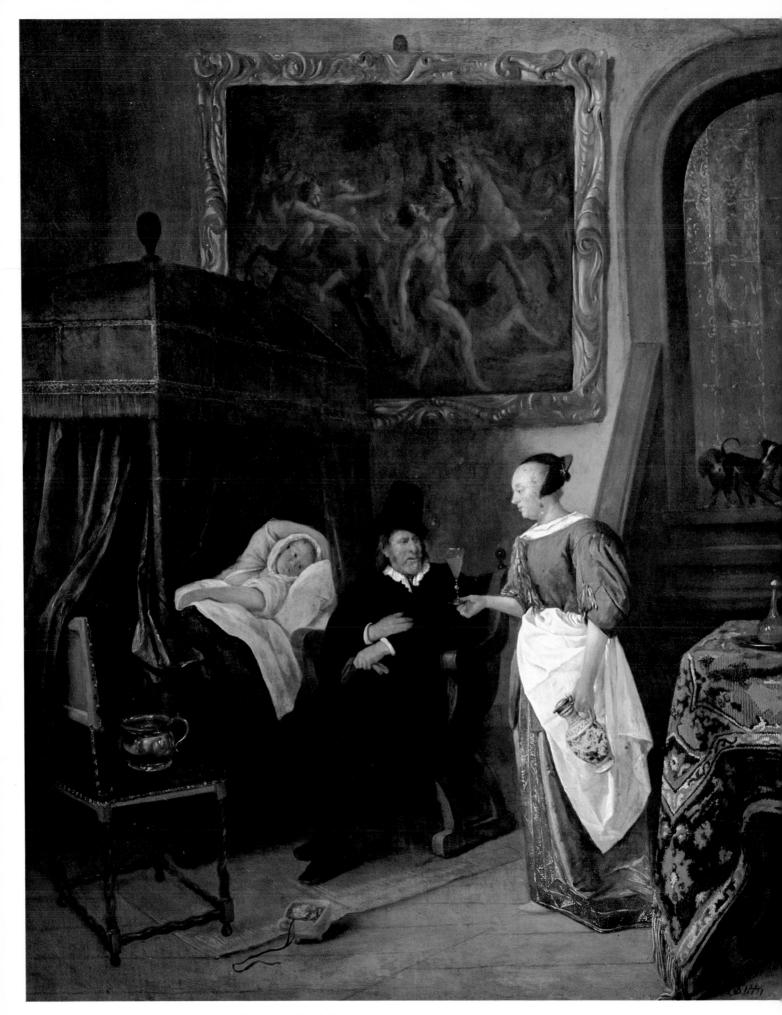

Panel, 23¹³/₁₆ x 19¹/₁₆ inches (60.5 x 48.5 cm.) The Hague, Mauritshuis

JAN STEEN
The Lovesick Maiden

c. 1660–61

Although this painting was probably executed after Steen had already left Delft, traces of the influence of the Delft style are still apparent in the structure of the interior space and the placement of the table, covered with an oriental carpet, in the foreground. It is also apparent from the small size of the figures in relation to the space that Pieter de Hooch as well as Vermeer may be seen as having an influence on this work. The overtly satirical nature of the theme, of which Steen painted a number of variations, is rather foreign to the normally serious Delft approach, and must be seen as part of his special contribution to the moralizing genre subjects that were popular at the time.

Having had a classical education and even, for a short time, having attended Leyden University, Steen often uses references to antique events and stories to make his moralizing points clear. The large painting on the wall in this picture, for example, represents the abduction of Hippodamia and depicts the battle between the Lapiths and Centaurs which broke out at the wedding celebration. Steen, in composing his picture within a picture, combines two elements which support the moral reading of the entire composition. On the left, a drunken centaur is shown abducting the bride, while on the right, the motif of the man and horse is clearly recognizable as the famous sculptured group known as *The Horse Tamer*, on the Quirinal Hill in Rome. Thus the former group is a reference to animal passions and lust and the latter one, the controlling of these passions. Confirmations for this interpretation comes from the Dutch writer-painter Carel van Mander.

Other comic references, although obscure for the modern viewer, were immediately recognizable in Steen's day. For example, the "physician" is obviously depicted as a charlatan, costumed like a quack doctor in the popular theater of the day, the Dutch version of the Commedia dell'Arte. Given the nature of the illness, he is clearly the only one who would treat the patient in Steen's picture.

Secondary elements also seem to comment on the cause and nature of the woman's sickness: for example, the two sniffing dogs at the top of the stairs. Seventeenth-century viewers would have quickly connected their actions with Jacob Cats' popular dictum that a lady's dog mirrored the actions of its mistress, a belief which here makes a comment on her problems.

Other small details in this charming satire may also have carried contemporary meaning. The unusually prominent placement of a chamber pot on the chair may allude to the seventeenth-century test for pregnancy— examining the clarity of the urine. Indeed, exactly the same motif appears in another Steen rendering of the subject, in the Wellington Museum, London, as well as in the work of other seventeenth-century Dutch artists dealing with this popular theme.

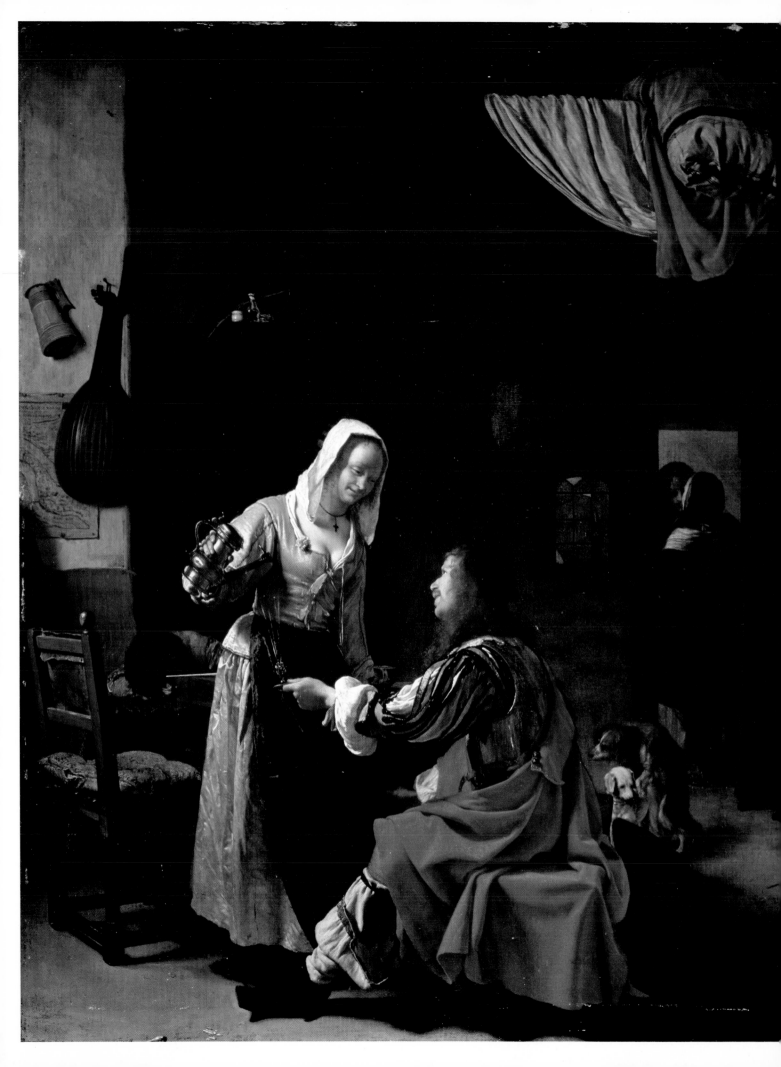

Panel, 16⅞ x 12⅞ in. (43 x 33 cm.)
The Hague, Mauritshuis

FRANS VAN MIERIS
An Inn Scene
1659

Although not particularly well known today, van Mieris was one of the most popular seventeenth-century painters in Holland and, along with his teacher Gerrit Dou, one of the acknowledged leaders of the Leyden "fine painters" school. This meticulous style, much admired at first by seventeenth-century and later critics, gradually lost favor after the rediscovery of Vermeer during the nineteenth century. Nevertheless van Mieris was, along with Vermeer, one of the artists sought out by the French collector Balthazar de Moncony, in 1663; evidently his fame had already spread beyond the boundaries of The Netherlands.

Van Mieris' first training took place under the glass painter Abraham Toorenvliet. He must have shown promise, for he was soon sent to Dou, Rembrandt's first Leyden pupil and the leading artist there. Later he was in the studio of the elegant portrait and history painter Abraham van den Temple. Quite unusual is the fact that he then returned to Dou's studio, apparently to finish his studies there. The relationship between Dou and van Mieris seems to have been a close one, and Dutch sources tell us that Dou referred to him as "the Prince of my pupils." His earliest dated work is from 1657, and the following year he entered the Leyden painter's guild.

Despite the rather unsubtle handling of the theme, this early van Mieris picture reveals some unexplained links with Delft in its com-positional structure. Since Jan Steen had close links with both Delft and Leyden, he could have transmitted these architectonic elements to van Mieris. This possibility is supported by the fact that Steen, too, occasionally used similarly paired dogs to underscore the moral of his pictures. Indeed, his *Lovesick Maiden* in the Metropolitan Museum, one of Steen's many variations on this theme, includes this somewhat crude motif to indicate the causes of the maiden's complaint. Even without Jacob Cats' comment that a woman's dog mirrors the actions of its mistress, the meaning is obvious in Steen's picture as it is here.

Unlike some of his more delicate contemporaries, van Mieris makes obvious what other Dutch painters of the period only hint at. Thus, in addition to the copulating dogs—painted out during the nineteenth century and only revealed when the picture was cleaned—all the other symbols of erotic and worldly love are also present. Certainly the loose bodice of the female, and the gesture of the pouring of the wine, would alone have indicated the venal character of the encounter to seventeenth-century viewers. Additionally, the couple in the doorway and the drunken man asleep at the table contribute to the bawdy nature of the setting. Even the wine pouring seems to parody the traditional gesture found in personifications of Temperance. On the back wall the more subtle symbols of love still appear: the map, lute, and drinking mug. And, as if these were still not enough, bedding is casually draped over the balcony. Thus, like his more delicate counterparts in Delft and elsewhere, van Mieris provides us with a moral comment. Indeed, his popularity may have been partially due to the overt way he handled traditional themes.

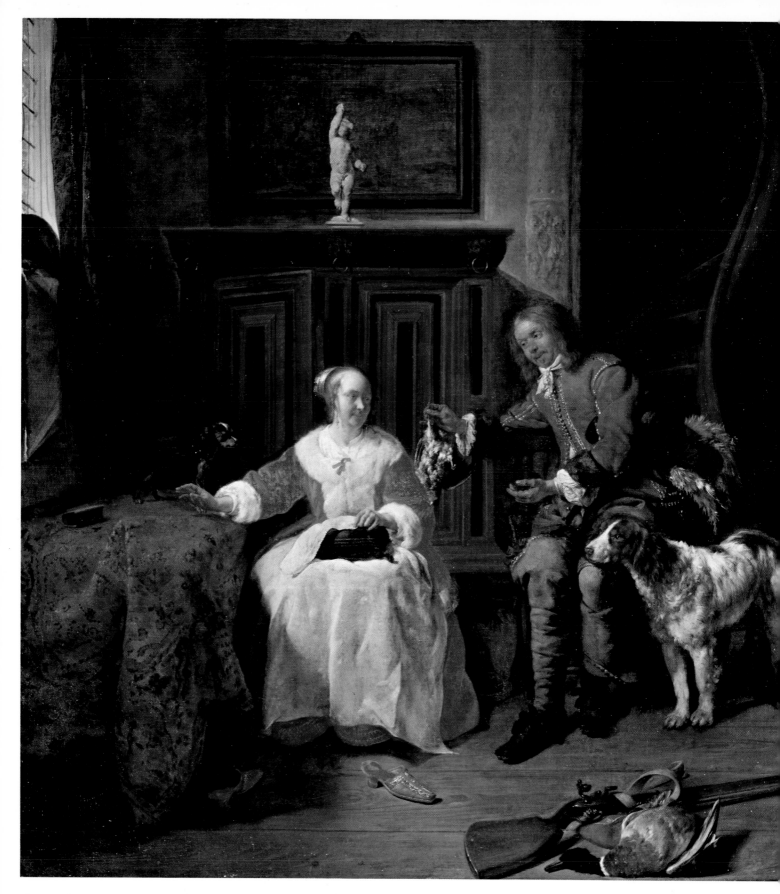

Canvas, 20¹⁄₁₆ x 18⁷⁄₈ in. (51 x 48 cm.) Amsterdam, The Rijksmuseum

GABRIEL METSU
The Hunter's Present

c. 1658–59

Of the same generation as Vermeer, Metsu was born in Leyden in 1629. His earliest work, *A Young Woman Spooling Thread*, in Leningrad, bears the date of 1645, indicating an exceptionally precocious painter. He did not, in fact, enter the Leyden guild until three years later. And even with the existence of this early work we cannot be sure who his teacher was. The Leningrad picture shows him, at least at 16, to be a follower of the Leyden "fine painter" school and of Gerrit Dou, though with no way of determining the exact nature of the relationship. The situation is complicated by the very different character of Metsu's next dated work, a 1653 *Christ and the Adulterous Woman* in the Louvre—no longer reflecting Dou or the "fine painter" school but executed in a style somewhat reminiscent of the more elegant followers of Rembrandt. Since Metsu seems not to have gone to Amsterdam until about 1657, his early development and training remain an open question. His total production is uneven, including elegant religious paintings along with his genre works. He died in Amsterdam in 1667.

In paintings like the present one, executed shortly after his move to Amsterdam, Metsu shows himself to be a prime exponent of the sort of multi-leveled genre painting practiced by Dutch artists of Vermeer's generation. Today these works are often difficult to interpret since their meaning frequently depends on visual puns and the popular literature of the day. In this picture, however, the erotic overtones are unmistakably represented by a small statue of Cupid over the woman, with one arm raised as if he were about to fling an arrow at the "hunter" below. Exactly the same Cupid appears in a work by Jan Steen, *The Lovesick Woman*, in Munich, confirming it as a familiar key to meaning. For added assurance, above the man are two prancing Eros figures, carved on the column.

Yet here, as in Delft, the scene carries various meanings beyond the apparent one. For example, the bird the hunter offers, a partridge, has old and traditional links with Venus, goddess of love. In the Dutch translation of Ripa's important handbook of symbolism, the personification of Lust is depicted, as is the hunter in this picture, holding a partridge. Clearly, given this association, and the various Eros figures, the offer being made is an erotic one. Indeed, in seventeenth-century Dutch literature the verb "to bird" was a euphemism for sexual activity.

Additionally, early Dutch and Flemish artists often symbolized the temptations of the flesh literally, with both meat and fowl. Given this framework, almost any everyday activity may contribute secondary meanings. The presence of sewing materials, normally associated with female virtue and modesty, and the woman's gesture towards the (prayer?) book on the table, transform this scene into a potential conflict between good and evil. Other details, the shoe, gun, and birds, all carry opposing sexual associations which perhaps qualify this painting as a genre parallel to the old classical theme of Hercules at the crossroads, in which a choice must be made, as here, between virtue and vice.

Canvas, 13 x 10¼ in. (33.2 x 27.2 cm.)

Amsterdam, The Rijksmuseum

GABRIEL METSU
The Sick Child

c. 1663–64

During the 1660's several stylistic features begin to appear in some of Metsu's genre pictures which make it clear that he must have had some contact with Delft, or at least Delft art. Sometimes, such as in this small painting, the influence is general enough to have been arrived at through a number of channels. In other cases, such as his *Woman Reading a Letter* in the Beit collection, the stylistic relationship to Delft, and specifically to Vermeer, leaves no doubt that he knew specific works by the great Delft master. The situation is quite puzzling. Since most of Vermeer's very few works appear to have remained in Delft, at least during his lifetime, how was his style, or influence, propagated? In the case of Metsu, who had no documented contact with Delft, the question has as yet no certain answer.

Certain elements of the Delft style—and notably those apparent in the present work—could have been arrived at by Metsu through contact with such other artists as Pieter de Hooch, who had participated in the development of the style at its inception and on through the 1650's. In addition he is known to have visited Delft in 1663. Since Metsu's interest in those Delft-like qualities only begin to manifest themselves in works which can be dated into the 1660's, after his move to Amsterdam, de Hooch may well have been the transmitter of stylistic information. Certainly the subject of this sentimental little canvas is more closely related to de Hooch's work—where children are often the focal point—than that of Vermeer, where they never appear. In fact, the quality of pathos, so obvious in this work, is completely foreign to Vermeer, who for the most part eschewed such overt emotional elements in his art. Even so, it seems clear that a picture of this type could not have been painted without the example of Delft. The light-colored background and the quality of light must both—despite their transformation—depend on the precedent of Vermeer's so-called pearl pictures.

Though the present instance is the most interesting of several in which sick people are depicted by Metsu, modern critics often find it a bit too sentimental despite masterful handling. Compositionally, *The Sick Child* appears self-consciously to parallel the *Pietà*, the traditional depiction of Mary with the dead Christ in her lap. This symbolic device, common in Italian Madonna and Child pictures as a prefiguration of Christ's death, is rare in the art of Protestant Holland. Since Metsu carefully places a small crucifixion painting over the child's head, the symbolic connection seems to be a conscious one. Still, it is not completely certain how one must understand this canvas. Is the *Pietà* reference merely a prefiguration of the child's death, or are we also to see it as a multi-leveled work of art with religious content? Concepts of this sort would not have been foreign to Metsu, since he continued to execute pictures with biblical themes all during his life. For the contemporary viewer, unfortunately, sentimentality of this type makes it difficult to universalize the meaning. Metsu's inclusion of a map opposite the crucifixion may indicate that, like other Dutch seventeenth-century genre painters, he wished to suggest profane as well as religious concepts. By placing his figures between these two contrasting elements, he also holds the mother and child between this world and the next.

146

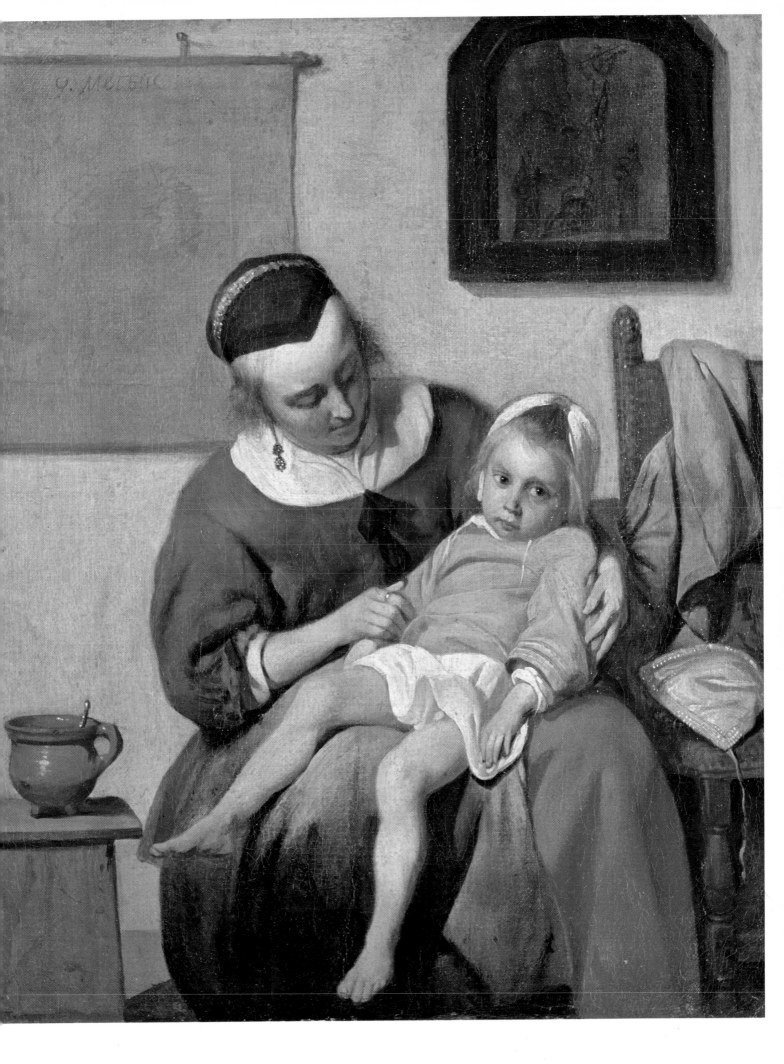

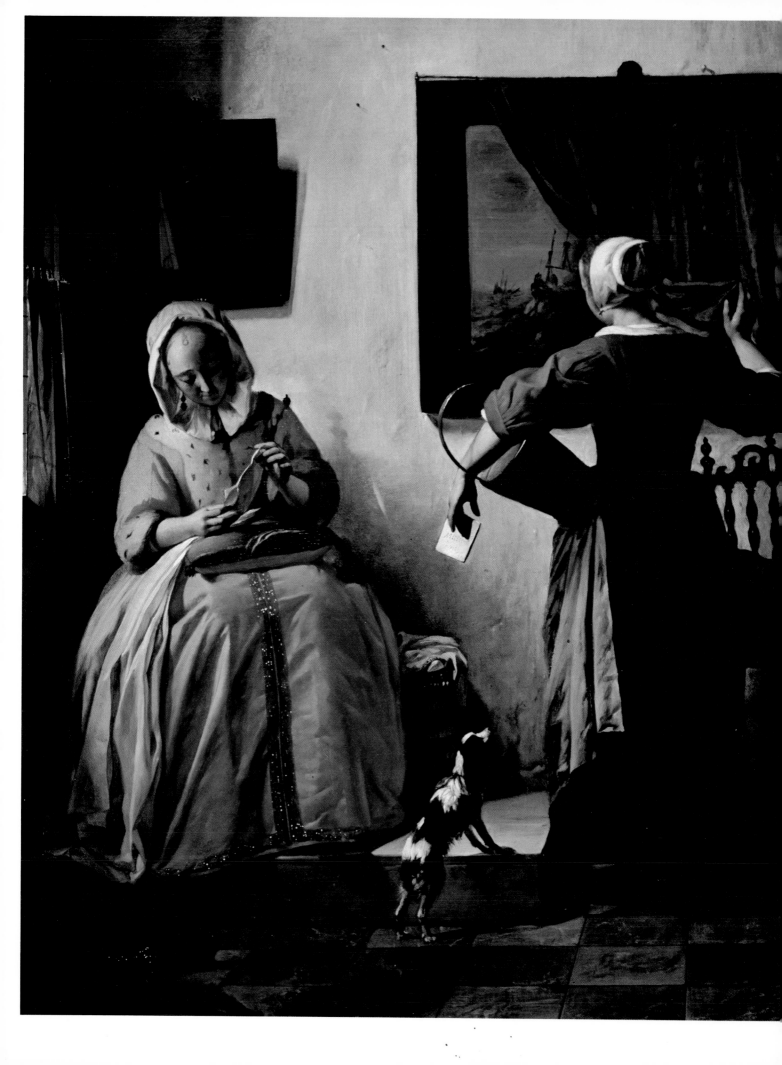

Panel, 20³/₁₆ x 15¼ in. (51.3 x 40 cm.)
Blessington, Ireland, Sir Alfred Beit Collection

GABRIEL METSU
Woman Reading a Letter

c. 1667

It is unfortunate that neither this picture by Metsu nor Vermeer's Amsterdam *Love Letter* is securely dated since an extremely close relationship obviously exists between the two works. The exact nature of that relationship remains obscure, although the influence of the Delft style is to be observed in other Metsu works during the 1660's. Since the qualities apparent in this picture, and its pendant in the same collection, are so close to the works of Vermeer and Delft in general, and are somewhat unusual for Metsu, we can assume that Vermeer and not Metsu is the innovator. Accordingly, this panel and its mate should be dated from the last year of Metsu's life. The Vermeer, on the other hand, would have to have been executed not later than 1666–67.

Some scholars are unhappy with this early dating, and even speculate that the influence may have moved in the other direction, from Metsu to Vermeer. But although Metsu is an accomplished master, his overall development does not indicate any great amount of inventiveness. The major question that does persist is one of logistics: how did Metsu *see* the Vermeer canvas? On this point there is no really satisfactory answer other than to note that he seems to have had some contact with Delft during his last years.

Both this work and its pendant, *The Young Man Writing a Letter*, continue the interest in letters, and specifically love letters, found in Vermeer and Dutch painting of the seventeenth century. What is interesting about the mate to the present picture is the fact that it indicates the source of the letter. One might wonder if Vermeer's Washington *Lady Writing a Letter*, the partial prototype for the Metsu *Young Man*, did not itself once have a letter reader—an elegant young man—as a pendant.

Even without the pendant, however, the nature of the letter is made as abundantly clear in this Metsu as in the Amsterdam Vermeer. All the same essential symbolic elements are present, although with slight alterations. The seascape, suggested in Vermeer by Jan Harmensz Krul's 1640 book of love emblems, is here revealed by the maid pulling aside the protective curtain. Even though the lute is missing in the Metsu, two other added elements indicate the worldly nature of the scene: the mirror over the letter reader's head and the small lap dog. And here again, as the popular Dutch writer Jacob Cats noted, the dog's activities are significant. He is as attentive to the symbolic seascape as his mistress is to the love letter. Other specific elements—the shoe, the sewing basket, and the mode of dress, also present in the related Vermeer—functioned just as clearly as supporting emblems to the informed Dutch public.

The architectonic structure of this composition, the light-flooded room and the calculated placement of every detail in relation to the geometricized whole—certainly speaks for Vermeer's influence on Metsu rather than the reverse. Somehow, Vermeer, despite his limited output, seems to have had an unusually rapid impact upon other seventeenth-century artists, and nowhere more remarkably than in the present work.

149

JACOB OCHTERVELT
The Music Lesson
1671

Ochtervelt, like his more famous contemporary, Vermeer, was one of those artists who was neglected by seventeenth-century Dutch writers; much of our information about his life is a product of modern art historical research. Only Houbraken, writing early in the eighteenth century, broke the long historical silence, casually mentioning that Ochtervelt and Pieter de Hooch studied with Nicolaes Berchem at the same time, presumably in Haarlem. Since Ochtervelt was born in 1634, and thus was five years younger than de Hooch, this period of study must have been from about 1646 to about 1652. His earliest dated work, a hunting scene of 1652, would appear to confirm both the relationship with Berchem and the dates. Thus Ochtervelt, like de Hooch, began his artistic career painting works quite unlike his later and better-known genre pictures. By 1655 Ochtervelt was recorded back in his native Rotterdam, where he married and joined the painter's guild. He remained there at least until mid-1672. By 1674 he was living in Amsterdam, where he died at the age of forty-eight.

Exactly how or when Ochtervelt came into contact with the Delft style or Vermeer's works is uncertain. His early relationship with de Hooch may be part of the answer, although it obviously took place before de Hooch had moved to Delft and developed his own more characterisic style. Nevertheless, the present work clearly exhibits a knowledge of pictures such as Vermeer's *Soldier and the Laughing Girl* in the Frick Collection. The most obvious borrowed devices are the use of a shadowed foreground figure and the oblique placement of the figures in space. Even the map—here as in Vermeer a symbol of the worldly nature of the subject matter—is a real one, by C. J. Visscher. Although basically dependent on Vermeer, Ochtervelt also shows significant differences. His figures are excessively slim and elegant, recalling, to some extent, the works of Terborch. His color is also generally brighter and less subtle than that found in Delft or the works of Terborch. In addition, the size relationship between the man and woman, somewhat exaggerated in the Vermeer—perhaps due to his use of the *camera obscura*—is obviously moderated here. Unlike de Hooch, who quickly lost all traces of his training under Berchem once he moved to Delft, Ochtervelt continues to exhibit, as in this picture, qualities related to his teacher's fluid brushwork.

In subject, this charming interior scene follows the type of musical symbolism often found in the work of Vermeer and other Dutch genre painters of the seventeenth century. The lute-like instrument played by the man, and especially the presence of a viola da gamba on the table, suggest that rather than just a "music lesson" Ochtervelt is depicting the harmony of love. For that matter, the way in which the woman points to the open music book on the table seems to indicate that she is the one who calls the tune in this worldly duet.

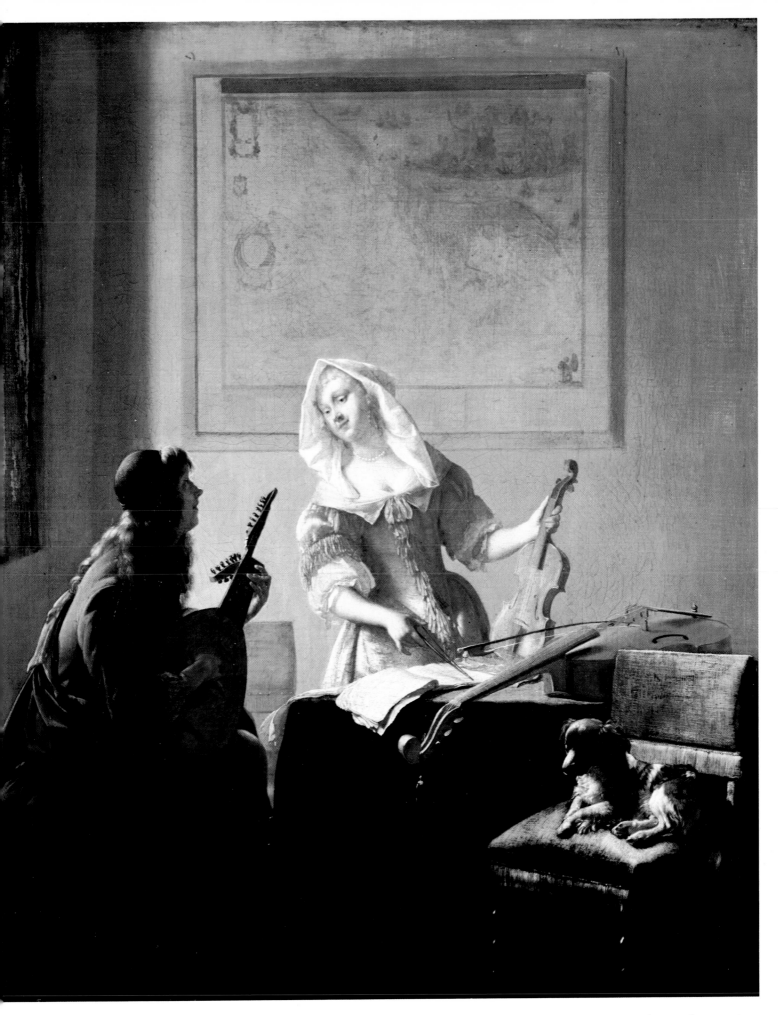

Panel, 31⅛ x 25⅜ in. (79 x 64.5 cm.) Chicago, The Art Institute

Canvas, 30½ x 41⅛ in. (77.5 x 104.5 cm.)
Rotterdam, Museum Boymans-van Beuningen

EMANUEL DE WITTE

Interior with a Woman Playing the Virginals

c. 1664–65

Despite a modern study on de Witte's tragic life, there are still many unanswered questions about his role in the development and dissemination of realistically painted architectural interiors. He was born in Alkmaar between 1615 and 1617 and entered the painter's guild of that town in 1636. Dutch sources tell us that he also worked with the Delft still-life specialist Evert van Aelst, and de Witte is indeed recorded in Delft by 1640. He became a member of the guild there the following year. His earliest work, a 1644 *Vertumnus and Pomona*, in Rotterdam, suggests that he began his career as a history painter. De Witte seems to have stayed in Delft just long enough to partake of the first flourishing that took place around Carel Fabritius. By January 1652 he was recorded as living in Amsterdam, where he spent the rest of his life. Nevertheless, Fabritius' influence still shows in several works executed during his early Amsterdam years.

Looking at this marvelous picture, it is difficult to understand de Witte's financial failure as an artist. On various occasions he was forced to put himself under contract to paint in return for his keep. It is therefore understandable that his late work is often quite uneven. Dutch sources tell us that he apparently committed suicide during the harsh winter of 1691–92, but that his body was found only after the canals thawed some eleven weeks later. He was buried in Amsterdam in 1692.

Although there have been recent attempts to make de Witte a key figure in the development of realistically painted church interiors, some with illusionistic curtains, there is no firm stylistic reason to date any of these interesting works before 1650. Indeed, his earliest dated painting of this type is from the year 1651. Since de Witte's Delft contemporary, Gerrit Houckgeest, executed similar works at about the same date, the question of de Witte's primacy must remain in doubt. Nevertheless, it seems clear that he did begin painting these architectural pictures before he left Delft. His *Oude Kerk in Delft* (c. 1650–51) in the van Horne collection, Montreal, and another view of the same church dated 1651, in the Wallace collection, London, both obviously document that fact.

The present picture is rather atypical for de Witte. Actually it was at one time—quite reasonably—given to Pieter de Hooch, whose forged signature is still to be found on the canvas. Since de Witte had left Delft before de Hooch arrived there, it is probable that the two painters met in Amsterdam where de Hooch was living by 1660. Documents concerning testimony de Hooch gave during a dispute over some de Witte pictures indicate

Canvas, 27⅛ x 22⅞ in. (70 x 57 cm.) Pittsburgh, Carnegie Institute Museum of Art

Panel, 27⁹/₁₆ x 22⁷/₁₆ in. (70 x 57 cm.)
Amsterdam, The Rijksmuseum

CORNELIS BISSCHOP
Girl Peeling an Apple
1667

This charming genre picture shows the high level even relatively minor artists were capable of achieving in seventeenth-century Holland. Although nearly forgotten today, Bisschop had a certain reputation in his own time, and the French collector de Monconys, who visited Vermeer's studio in 1663, sought him out.

Dutch sources inform us that Bisschop was born in Dordrecht in 1630. His artistic training, however, took place in Amsterdam under the Dordrecht-born Ferdinand Bol, a former Rembrandt pupil. By 1653 Bisschop was back in his home town, where he married. His early works continue to display the influence of his teacher and of other followers of Rembrandt. The Rembrandt connection, although once removed, appears to have brought Bisschop into contact with Nicolas Maes and Samuel van Hoogstraten, both of whom had studied with the great Amsterdam master before settling in Dordrecht. Through this association Bisschop was apparently brought into the mainstream of Dutch genre painting. Indeed, a description of a lost 1661 painting suggests a close resemblance to Maes' *Eavesdropper*.

For Bisschop, as for Maes, the innovative Hoogstraten seems to have been the critical factor. The present work, in fact, would seem to indicate that Bisschop transferred his artistic allegiance to that master after 1660, at which time Maes turned his efforts to portrait painting. Like Hoogstraten, Bisschop was intrigued by the possibilities of illusionism.

Houbraken, writing early in the eighteenth century, tells us that Bisschop was the first Dutch artist to create life-sized, illusionistically painted figures, which he cut out and placed in corners and doorways. In addition, de Monconys mentions various cabinets and armoires, apparently decorated with illusionistic elements, which Bisschop constructed. The king of Denmark, who is known to have been interested in such things, invited him to his court. Unfortunately Bisschop died in 1674, before he could take up his new post.

In composition and structure this complex picture is most dependent upon the works of Hoogstraten. The varied use of interior and exterior space recalls elements found in several Hoogstraten paintings as well as in his marvelous perspective box in London. Maes' work also may have been an influence here, although the execution and brighter color seem to support the Hoogstraten link.

The basic motif here, a girl peeling fruit, was a popular one in Dutch art. As in Gerard Terborch's 1661–62 *Woman Peeling an Apple*, in Vienna, the message, as indicated by emblem books of the period, reminds us that things easily obtained are held in contempt. Several secondary symbols support and further focus this moral concept. Bisschop has included a number of flying birds and strutting peacocks, which can be viewed through the outside doorway. Inside, however, hangs their antithesis, a birdcage. Birds, of course, have a long history as an erotic symbol, while their cages, appropriately enough, appear in Dutch emblems as restraining symbols of love and even marriage. The painting of a sleeping Cupid over the interior doorway, and the suggestively empty chair under the window, confirm both the symbolic orientation and the moral of this picture.

SUGGESTED READING

ON DUTCH SEVENTEENTH CENTURY IN GENERAL:
Jakob Rosenberg, Seymour Slive, and E. H. TerKuile, *Dutch Art and Architecture 1600-1800*, Harmondsworth and Baltimore, 1966.

ON VERMEER:
Monographs:
Lawrence Gowing, *Vermeer*, London, 1952.
Albert Blankert, *Vermeer of Delft*, Oxford, 1978.

SPECIAL STUDIES:
Charles Seymour, "Dark Chamber and Light-filled Rooms: Vermeer and the Camera Obscura," *The Art Bulletin*, XLVI, 1964, 323-31.
Heinrich Schwartz, "Vermeer and the Camera Obscura," *Pantheon*, XXIV, 1966, 170-180.
James A. Welu, "Vermeer: His Cartographic Sources," *The Art Bulletin*, LVII, 1975, 529-47.
John Michael Montias, "New documents on Vermeer and his family," *Oud Holland*, XCI, 1977, 267-87.

ON VERMEER'S CONTEMPORARIES:
Peter C. Sutton, *Pieter de Hooch*, Oxford, 1980.

ON DELFT:
John Michael Montias, "The guild of St. Luke in seventeenth century Delft and the economic status of artists and artisans," *Simiolus*, IX, 1977, 93-105.
John Michael Montias, "Painters in Delft, 1613-1680," *Simiolus*, X, 1978/9, 84-114.

ON PERSPECTIVE BOXES:
Susan Koslow, "De wonderlijke Perspeciefkast: An aspect of seventeenth century Dutch painting," *Oud Holland*, LXXXII, 1967, 35-56.

ON ICONOGRAPHY AND SUBJECT MATTER:
E. de Jongh, *Zinne-en minnebeelden in de Schilderkunst van de 17 eeuw*, n.p., 1967. (Moral and love emblems in the painting of the 17th century.)
E. de Jongh, *"tot Lering en Vermask,"* Rijksmuseum, Amsterdam, 1976. (To Educate and Delight.)